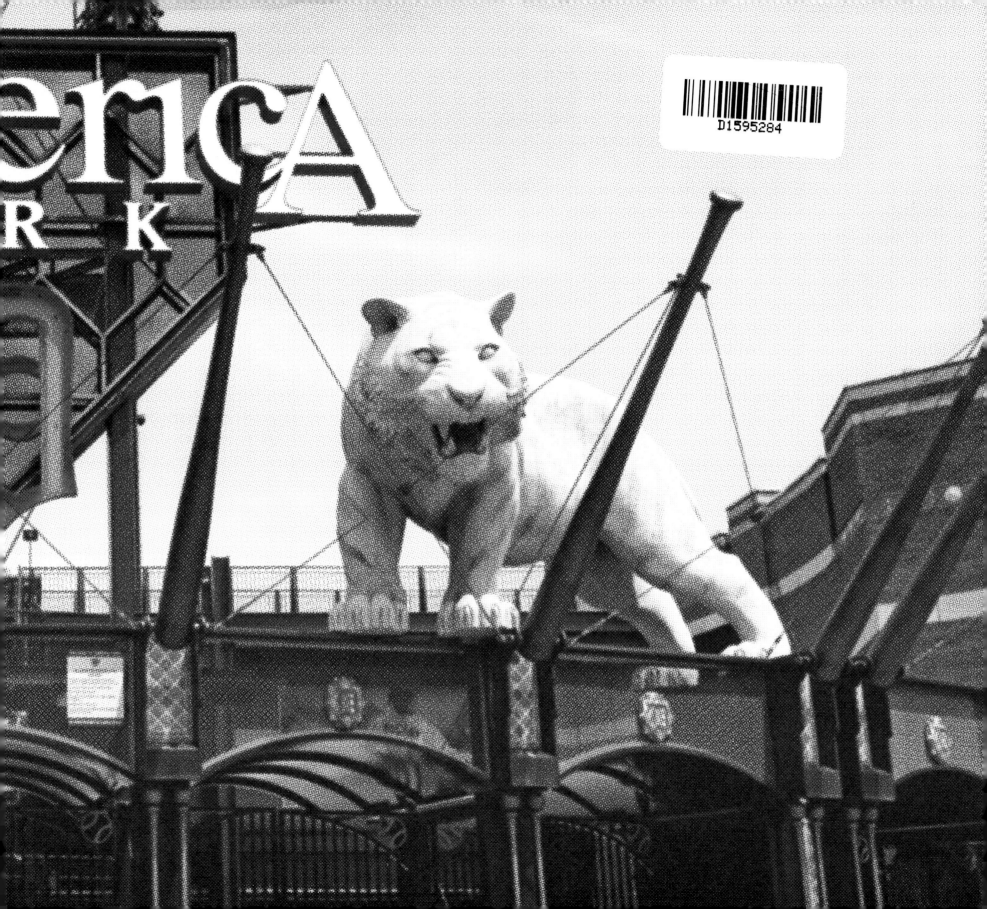

Ballparks

Publications International, Ltd.

Let's get social!
@Publications_International
@PublicationsInternational
www.pilbooks.com

TABLE OF CONTENTS

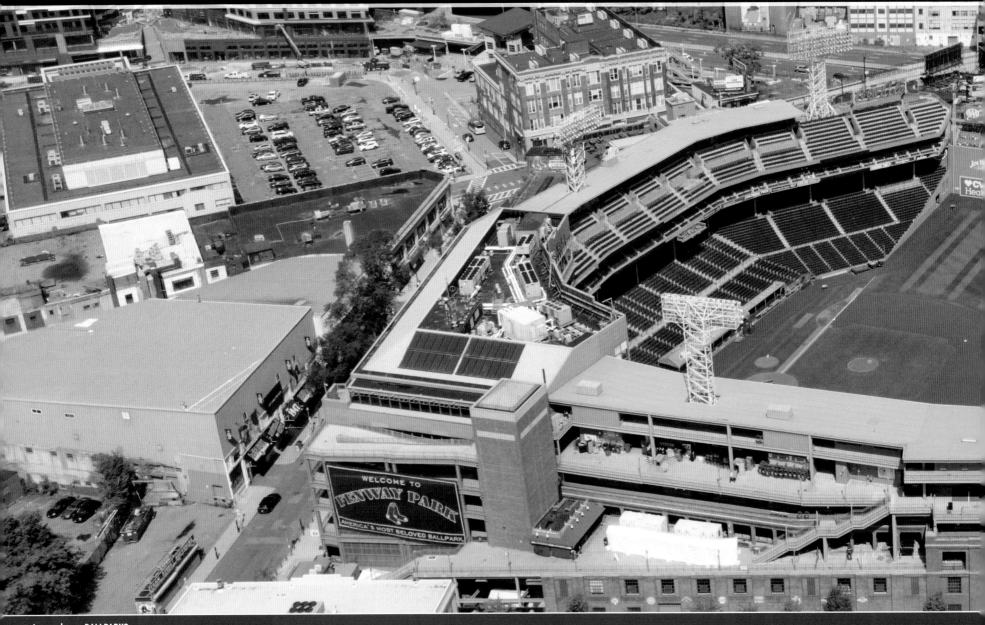

American League

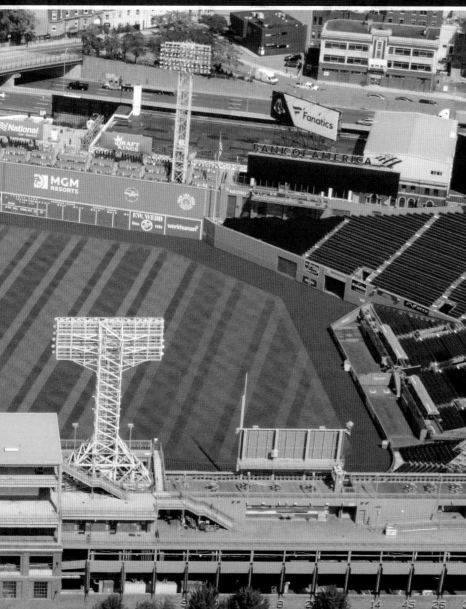

The American League is home to both the newest—and the oldest—ballpark in all of the major leagues, Texas's Globe Life Field and Boston's Fenway Park, respectively. Interleague play has been a part of the sport since the 1997 season. Prior to 1997, teams from the American League and National League would play only in exhibition games, and during the World Series.

One of the last distinguishing differences between the two leagues went by the wayside at the start of the 2022 season. From 1973 through 2021 the American League employed the designated hitter—or "DH"— who did not take the field on defense. The new, universal DH rule put an end to the quirk of playing by one set of rules regarding pitchers batting in NL parks and a different set for AL parks. Those in favor of universal DH applaud it for bringing consistency and uniformity across baseball while others complain that strategy is being removed from the game.

As with any other attraction or business, a ballpark is a reflection of the times. Every ballpark has had to adapt and upgrade to things fans expect like free Wi-Fi, HD video screens, booming audio and speakers, and more.

Following a pandemic, and a resolved work stoppage, getting fannies in the seats may be harder than ever. Enticing fans with top notch edible goodness can sometimes be enough. If you visit T-Mobile Park in Seattle, you'll find a stadium with a food program curated by a James Beard award winner, along with a bevy of beer selections to woo ale aficionados.

The American League does still boast the lone franchise located outside the United States in the Toronto Blue Jays. If you're looking for a change of pace, head to their stadium, the Rogers Centre, but don't forget your passport.

BALTIMORE ORIOLES

ORIOLE PARK AT CAMDEN YARDS

Completed in 1992, Camden Yards was the first of the magnificent retro-ballparks. Part of the urban landscape, the park is buffered by the hundred-year-old B&O Warehouse beyond the right-field fence. Inside, Camden Yards boasts comfortable seats, a dual-level bullpen, an ivy-covered wall, and even fresh flowers along the walkways.

Some fans come just for the beverages and food, which includes freshly squeezed lemonade and Boog Powell's succulent barbecue. "Boog's BBQ," owned by the aforementioned ex-Oriole first baseman and MVP, was the first in-stadium eatery serviced by an actual MLB veteran. In fact, Powell is on-site most games and available for photo ops.

Camden Yards invited baseball fans to return to childhood, to a time when a ballpark anchored a neighborhood like an old friend. Baltimore Orioles President Larry Lucchino had a vision for the team's new ballpark—how it should look, how it should feel. His disdain for the concrete slabs all around baseball was apparent. Lucchino was old-school; his team's ballpark would be as well. Baltimore, he knew, had just one chance to get it right. "We were not going to play in a ballpark we didn't want," Lucchino recalled.

Unlike many of the super-stadiums of the 1960s and '70s, Camden Yards was cut into its downtown. It mixed perfectly into the historic landscape, much like Fenway Park does in Boston.

The crux of design plans concerned the imposing and vacant Baltimore and Ohio Railroad warehouse—at more than 1,000 feet, it is thought to be the longest brick building on the East Coast. Despite his desire for an old-fashioned ballpark, Lucchino wanted the 19th-century eight-story behemoth brought down.

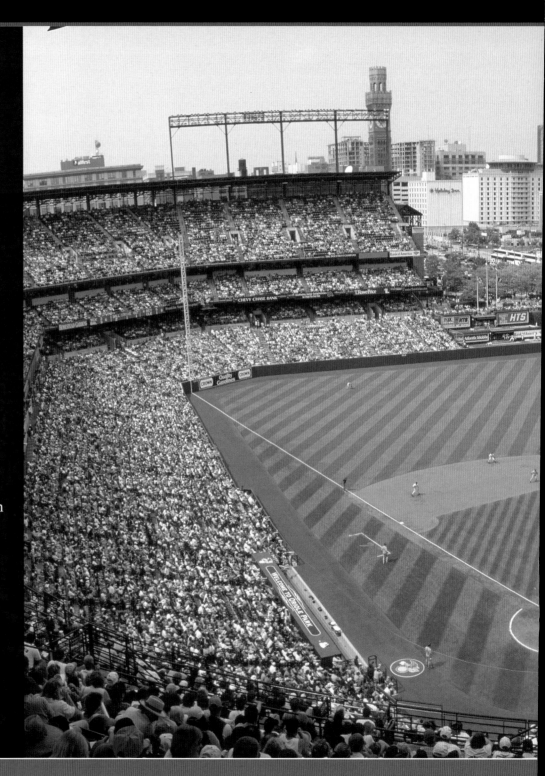

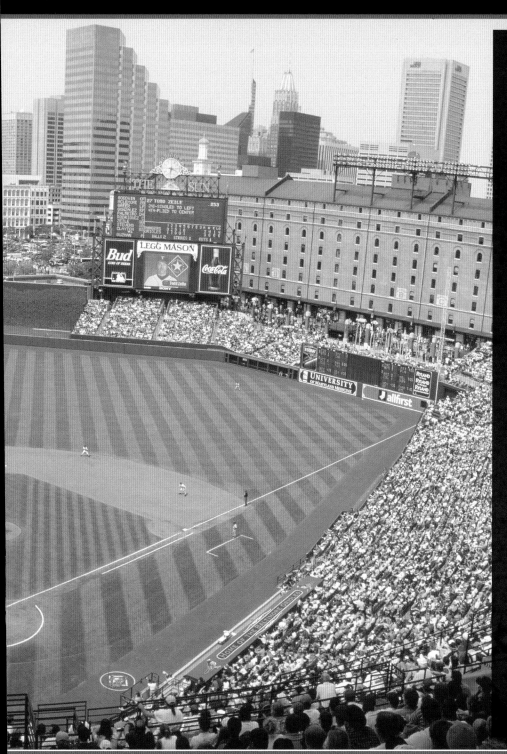

DEBUT MLB SEASON: 1992
FIRST ORIOLES HOME RUN: MIKE DEVEREAUX
CAPACITY: 45,971
SURFACE: GRASS
ROOF TYPE: OPEN

Eric Moss, an architecture major at Syracuse University, however, envisioned incorporating the warehouse into a ballpark as part of his senior thesis. Moss showed his idea to the Baltimore Planning Department, and they embraced the approach. Camden Yards' signature skyline vista beyond right field was created.

Instead of concrete, Camden Yards' outer facade is built of brick and iron, a throwback to Philadelphia's Shibe Park. Inside Oriole Park, visitors behind home plate can take in wide-open vistas of the stunning Baltimore skyline.

The B&O warehouse serves as a backdrop to Eutaw Street, a lively pedestrian walkway into Camden Yards that serves as a spot where fans can eat, drink, and converse. Inside the warehouse are three restaurants, a team merchandise shop, and assorted offices.

A statue of a young Babe Ruth stands outside the gate, which leads to a pathway that's marked with brass baseball-shaped plaques commemorating historic home runs.

Three decks of unobstructed hunter green seats engulf the playing field, bringing fans close to the action while creating an unmatched intimacy. Luxury suites and special seating cater to affluent fans.

Orioles' fans flocked to their new treasure in droves—more than 3.5 million fans came out that first season. For years thereafter, Camden Yards routinely sold out game after game, season after season. Other teams took notice. Retro, profit-generating downtown ballparks became all the rage. Never before had American sports witnessed a building explosion like the one ignited by Camden Yards.

The ballpark was the site of history in 1995, when Oriole great Cal Ripken Jr. eclipsed the once-thought unbreakable consecutive-games record of Lou Gehrig by playing in his 2,131st straight game.

In 1997, the O's won the AL East while drawing 3.7 million spectators. Few thought that the team had peaked, but as the years passed, the novelty of Camden Yards seemed to slowly wane. In 2008, the O's drew fewer than two million fans for the first time since the ballpark opened. Of course, much of this decline was due to the struggles of the Orioles at the time. They drew fewer than 10,000 fans to multiple games in 2010.

Amenities that have been added over the years include drink rails installed in portions of the club level seating bowl down the left field line, as well as bistro tables facing the field on the left field club level, and the Miller Lite Flite Deck in the corner of the right field club level. Cushions were added to the lower level seats between the bases.

The entire ballpark entertainment system, including the audio, video and scoreboards, have also been upgraded or replaced. The new system employs digital signal processing (DSP) that is significantly more advanced than what was previously used and allows for a much greater level of control. The result is a substantially more uniform listening experience throughout the seating area.

The Orioles continue to fight to stay on the winning side of the ledger, and bring contending baseball back to a magical park that *Washington Post* writer William Gildea called, "traditional yet modern, considerate of baseball's past but cognizant of the future."

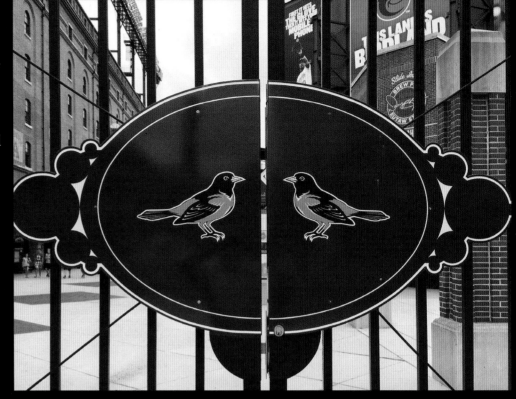

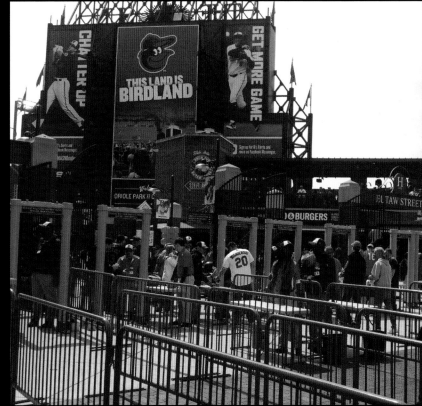

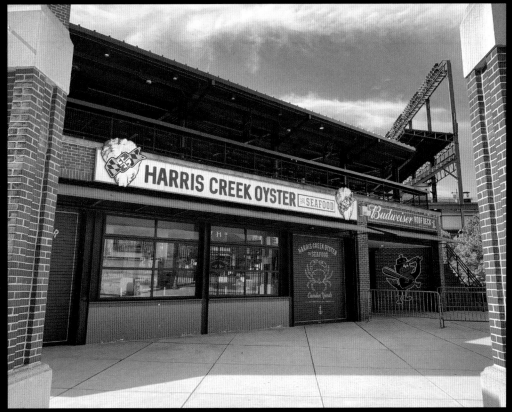

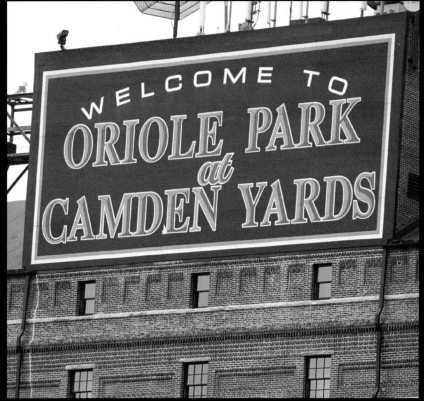

BOSTON RED SOX

FENWAY PARK

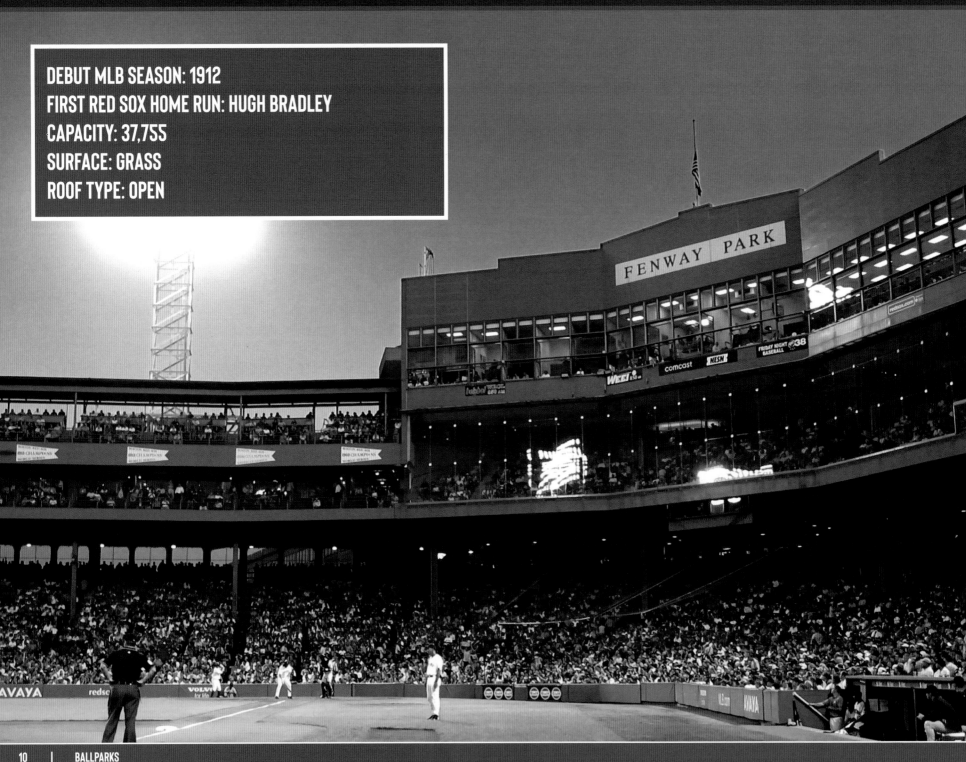

DEBUT MLB SEASON: 1912
FIRST RED SOX HOME RUN: HUGH BRADLEY
CAPACITY: 37,755
SURFACE: GRASS
ROOF TYPE: OPEN

In no place on Earth is the purity of the game and the fan's honest experience of it as powerful as in Boston's Fenway Park. Dating back well over 100 years, the legendary park hosted the 1912 World Series, Babe Ruth's first big-league game, and the immortal feats of Ted Williams.

Boston's deeply knowledgeable fans, between bites of a Fenway Frank, will tell you all about the team's legacy. The famed "Green Monster," which Carlton Fisk slayed in the 1975 World Series, stands like a national monument in left field.

Fenway Park is located in Back Bay, which is among Boston's most hallowed academic and artistic neighborhoods. Inside the park's stately brick exterior facade, there's green—real green, baseball green, Monster green.

After two significant fires, Fenway underwent a major reconstruction in 1934 that saw it become close to what fans visit today. Up, up, and up went a massive 37-foot wall, which was initially constructed of tin and supported by railroad ties. Its distance from home plate has always been questioned and various measurements have never agreed. More apparent were the unpredictable bounces that confounded many left fielders, as balls ricocheted off the wall's colorful ads that promoted Gem razor blades and Lifebuoy soap.

The Green Monster remains the unpredictable signature trademark of Fenway and perhaps all of baseball.

Until 2002, a 23-foot high net flapped above Fenway's monumental wall. However, in a landmark move, beginning April 12, 2003, the space above the Green Monster was converted to accommodate 269 barstool seats and more than 100 standing room spots. The new seating section was a smash hit, and continues to be one of the most coveted fan locales in all of sports.

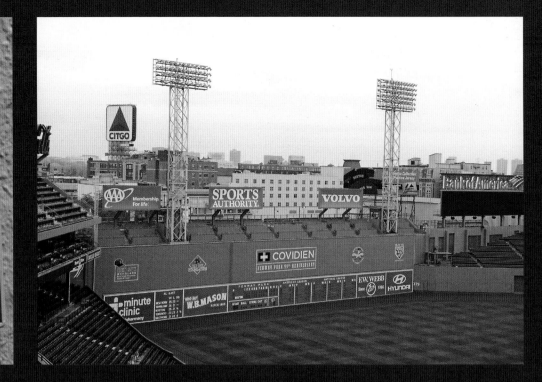

Foul territory? There's nary room for two fielders to stand side by side. And finally, for baseball fans, there isn't a bad seat from which to inhale it all.

An oddity for sure, "Pesky's Pole" can be found in Fenway's right-field corner. Named for Red Sox shortstop Johnny Pesky, the foul pole stands at a very batter-friendly distance from home plate, a mere 302 feet. Over the years, fans and players alike have inscribed messages on the pole that remain to this day.

Fenway—so named because of its location in a Boston marsh called "The Fens"—opened on April 20, 1912; it was yet another jewel in baseball's classic ballpark era. That day, the Sox defeated the New York Highlanders in 11 innings, 7–6. The park originally featured a deeply set single-deck grandstand and bleachers that accommodated 27,000 patrons. Its reception among critics paled in comparison to those received by the more ornate contemporary parks in Philadelphia and Pittsburgh.

Despite the fact that the Sox won (yet) another title in 1918, attendance at Fenway slumped, and owner Harry Frazee responded by holding a sale of his best talent—most shockingly Ruth—sending the franchise into a decades-long tailspin that's often called the "Curse of the Bambino." Frustrated fans avoided Fenway through the 1920s, and serious talks about the Red Sox vacating the ballpark to become tenants of their National League neighbors at the much larger Braves Field were held.

Despite Yawkey's best efforts, the Red Sox could not shake the Curse of the Bambino, though three pennant-winning teams—1946, 1967, and 1975—played in but lost World Series while Yawkey was alive.

It was not until 2004 that the Red Sox were able to exorcise some demons by staging a near-impossible comeback, winning four straight games after being down three games to none to the rival Yankees to win the ALCS. They went on to finish the deal by sweeping the St. Louis Cardinals in the World Series. The Red Sox have since won the World Series in 2007, 2013, and 2018.

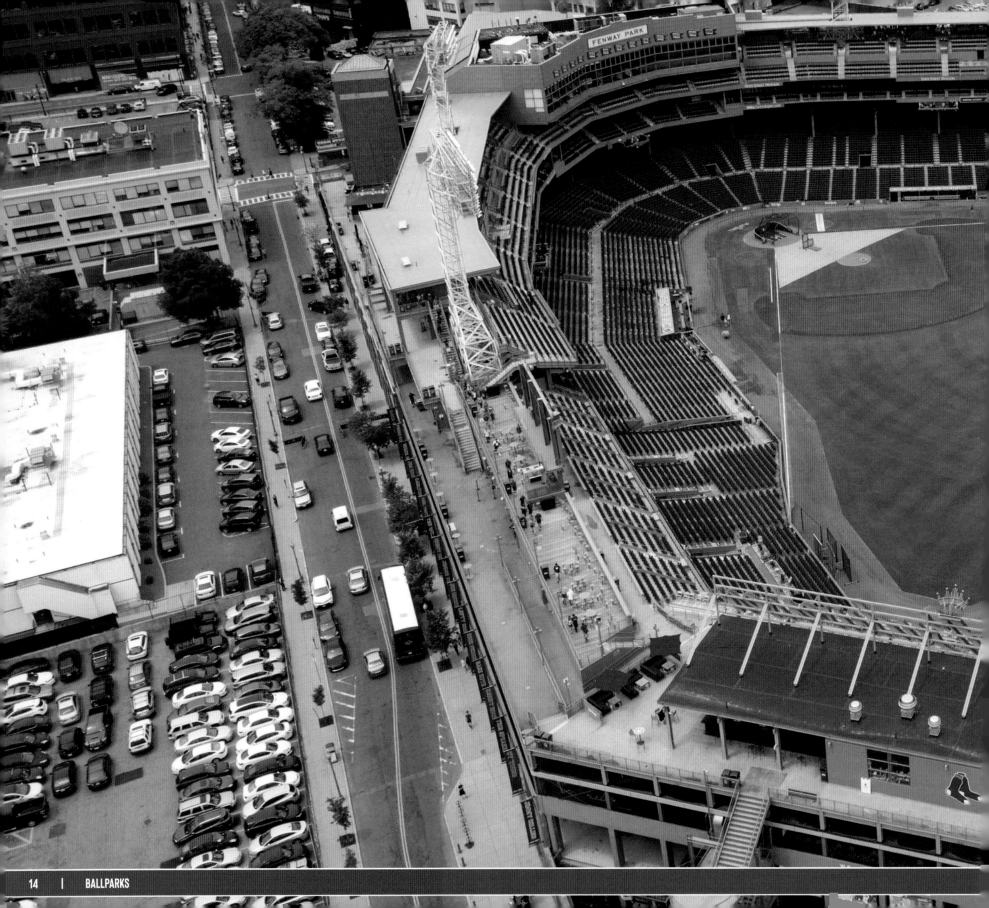

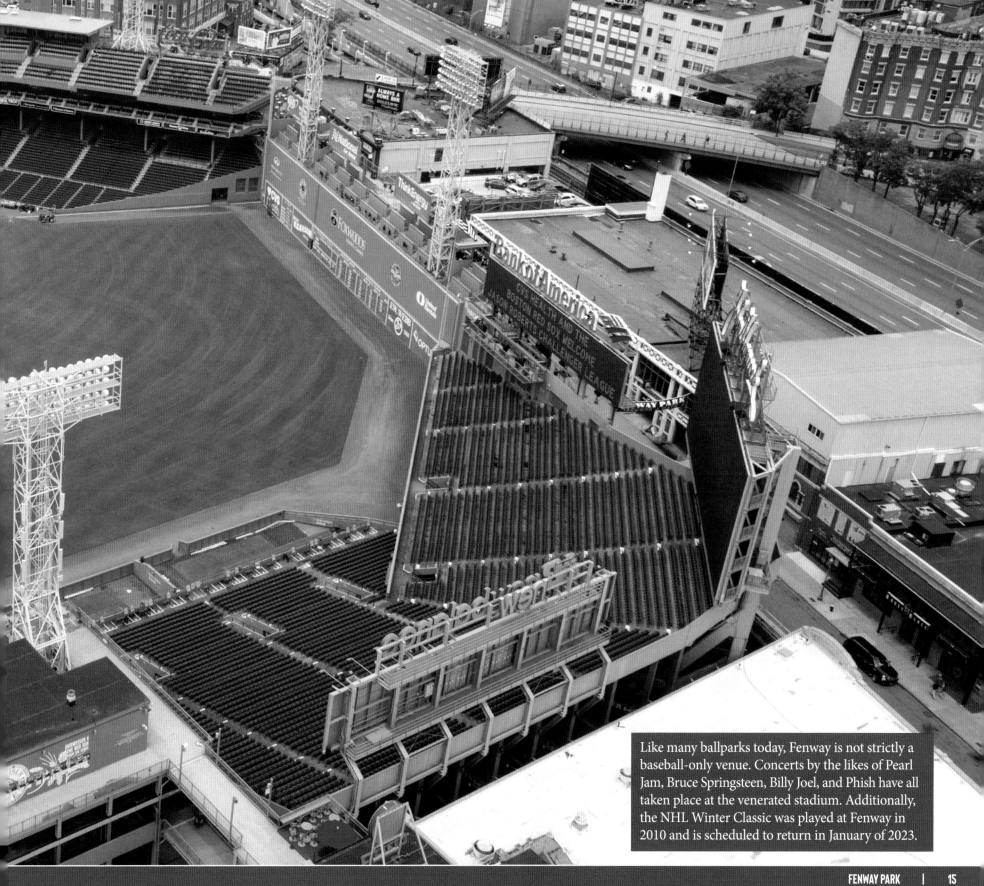

Like many ballparks today, Fenway is not strictly a baseball-only venue. Concerts by the likes of Pearl Jam, Bruce Springsteen, Billy Joel, and Phish have all taken place at the venerated stadium. Additionally, the NHL Winter Classic was played at Fenway in 2010 and is scheduled to return in January of 2023.

CHICAGO WHITE SOX
GUARANTEED RATE FIELD

In 1991, a new Comiskey Park replaced the legendary field of the same name on Chicago's South Side. Wrigley Field, America's sweetheart of ballparks, sits across town. In some ways, the criticism of Comiskey 2.0 was deserved. In other respects, well, let's just say there were early and frequent updates to improve the park.

The planners at HOK Sport got some things right when they transferred features of the old Comiskey Park into the new stadium. The new Comiskey sports arched windows to reflect the old Comiskey's outer facade, and the infield dirt was moved from the old park to the new one.

The wild erupting scoreboard created by Bill Veeck for the old park was duplicated and enhanced, pinwheels included.

On the downside, the upper deck was steep and far from the field. Fans also complained that other seats were further away than they had been at the old park. Ticket prices soared higher than a Frank Thomas home run, alienating the Sox's dogs-and-suds crowd. Despite this, attendance was strong the first several years there.

Less than ten years after the new Comiskey opened, the White Sox undertook a multiyear, multimillion-dollar series of renovations. All the seats were replaced, the scoreboard was revamped, restaurants and shops were opened, and a picnic area was added.

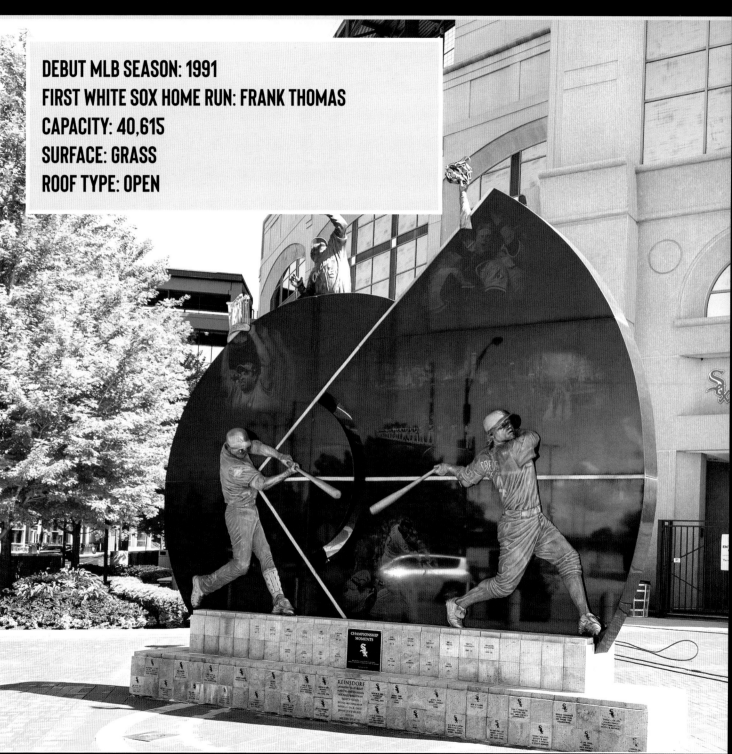

DEBUT MLB SEASON: 1991

FIRST WHITE SOX HOME RUN: FRANK THOMAS

CAPACITY: 40,615

SURFACE: GRASS

ROOF TYPE: OPEN

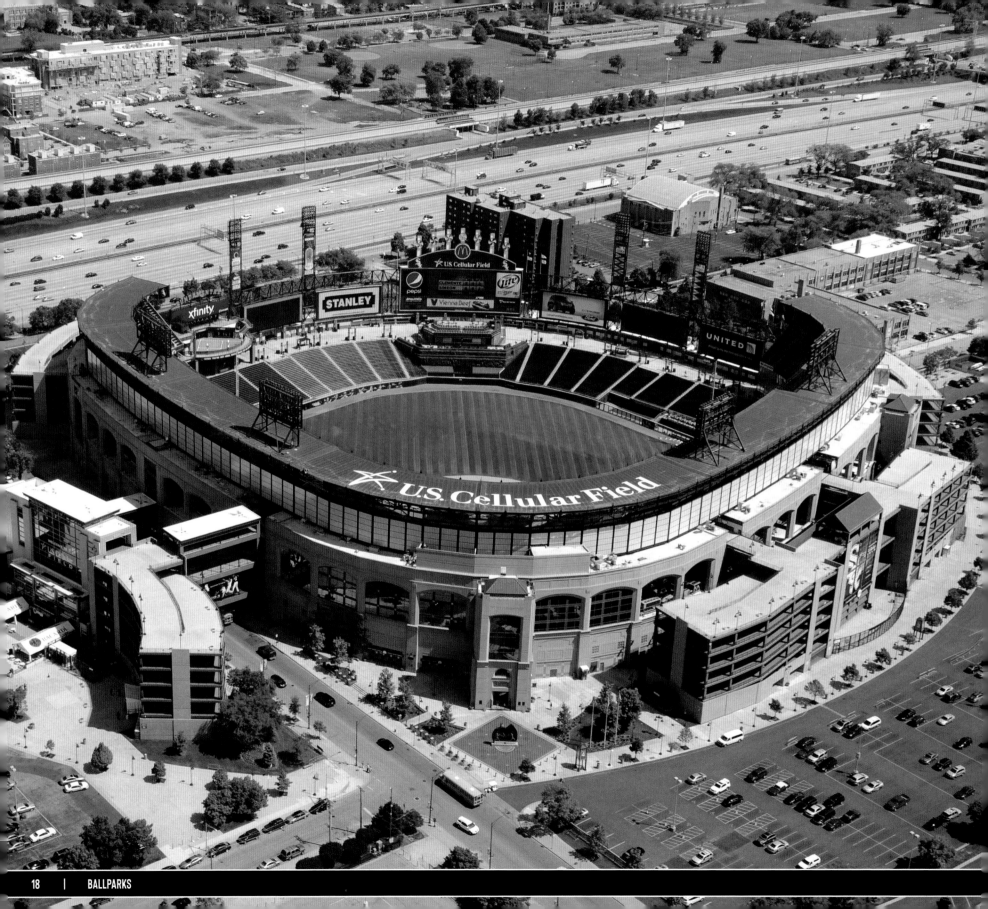

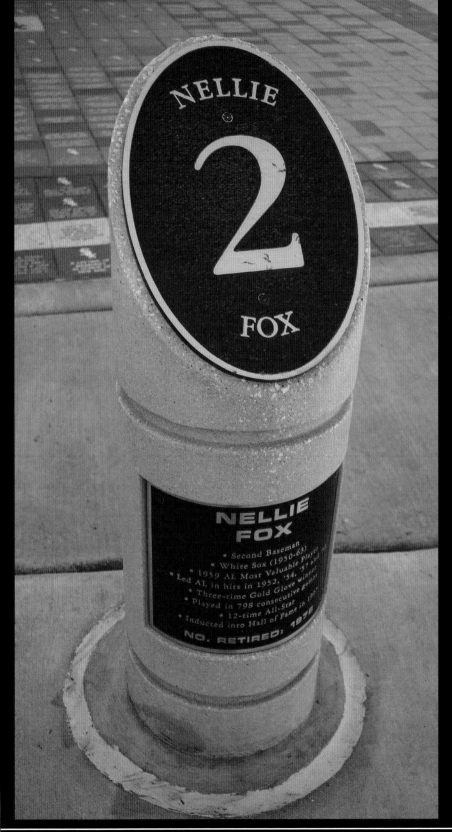

The park's symmetrical outfield fences were tweaked. Statues honoring Carlton Fisk, Harold Baines, Nellie Fox, Luis Aparicio, Billy Pierce, Minnie Minoso, and Sox founder and longtime owner Charles Comiskey were installed. The eight uppermost rows of seats were removed and an amusement area was built as the ballpark's capacity settled at 40,000.

The plastic surgery was partially funded by U.S. Cellular, which bought the stadium's naming rights—Comiskey Park became U.S. Cellular Field or "The Cell." In 2016, the stadium was renamed Guaranteed Rate Field.

Billed as the official postgame headquarters of the Chicago White Sox, ChiSox Bar and Grill is located at Gate 5 of Guaranteed Rate Field, and is open to all fans, with or without a ticket. There are more than 70 flat screen TVs there to keep you in the game while enjoying a pint or a snack.

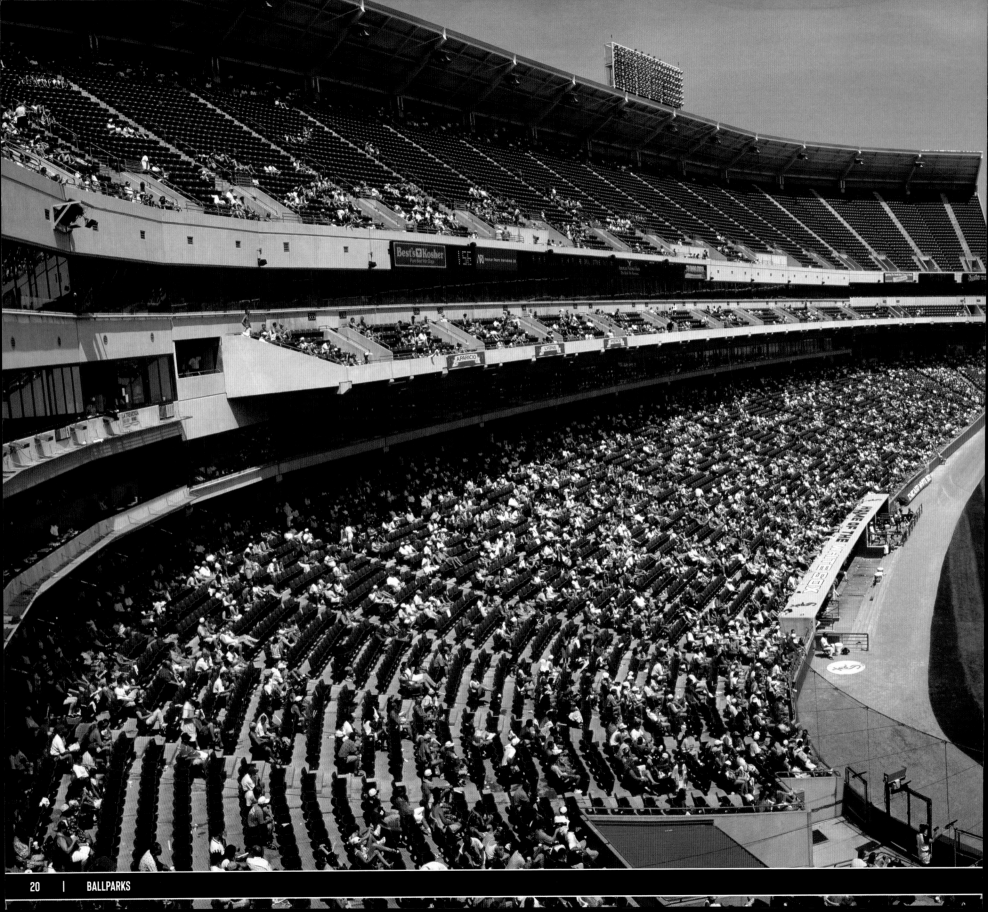

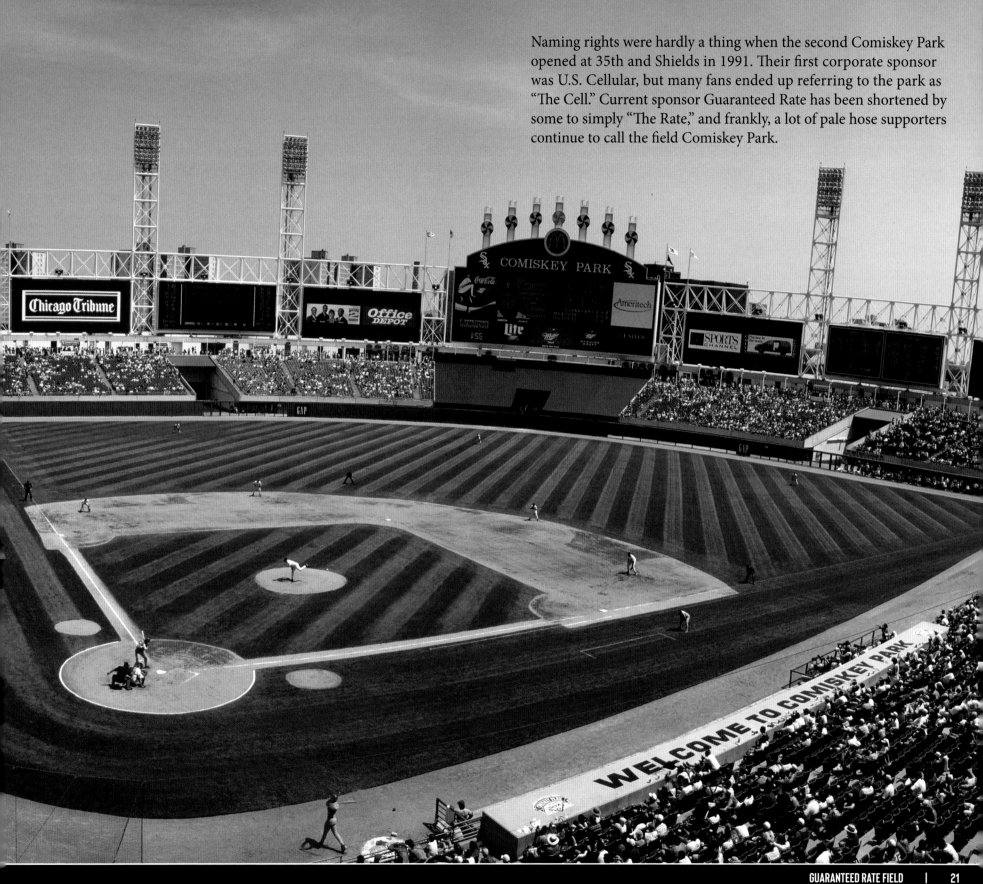

Naming rights were hardly a thing when the second Comiskey Park opened at 35th and Shields in 1991. Their first corporate sponsor was U.S. Cellular, but many fans ended up referring to the park as "The Cell." Current sponsor Guaranteed Rate has been shortened by some to simply "The Rate," and frankly, a lot of pale hose supporters continue to call the field Comiskey Park.

CLEVELAND GUARDIANS

PROGRESSIVE FIELD

DEBUT MLB SEASON: 1994
FIRST INDIANS HOME RUN: EDDIE MURRAY
CAPACITY: 34,830
SURFACE: GRASS
ROOF TYPE: OPEN

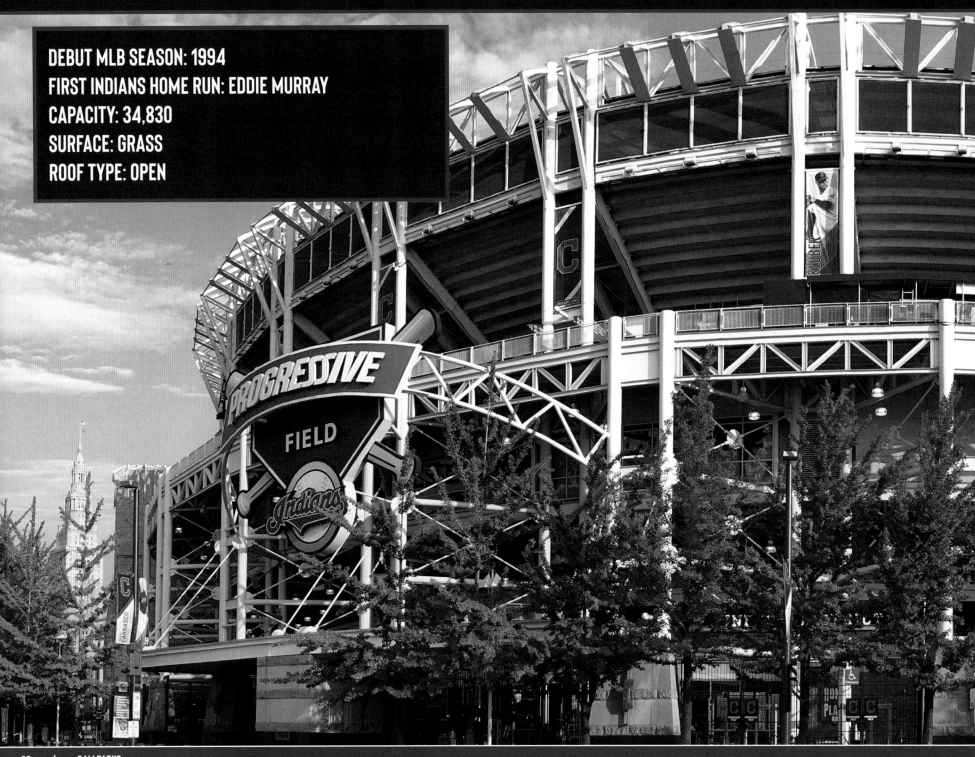

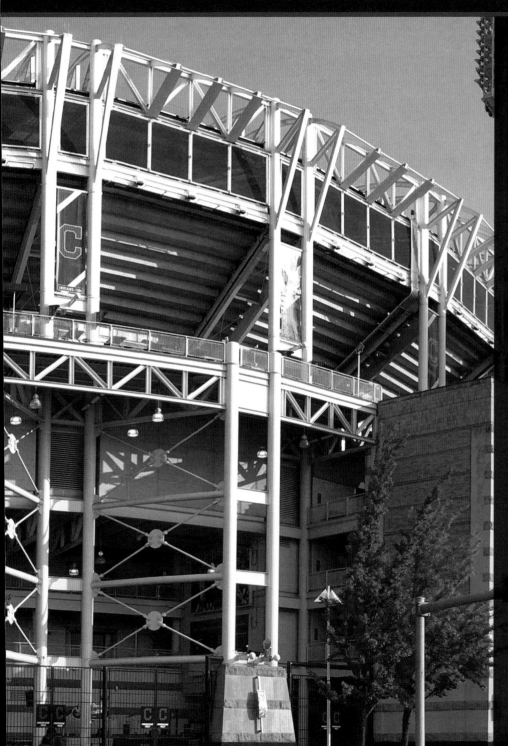

Opening in 1994, Jacobs Field—"The Jake"—replaced the cavernous, dark, and often vacant Municipal Stadium where the Cleveland Indians played (on and off) for more than 60 years.

Located at the corner of Carnegie and Ontario, The Jake ushered in a whole new era for Indians fans. When the ballpark's iron gates swung open in April 1994, a team—and, indeed, an entire city—turned a corner.

Cleveland owner Richard Jacobs set the wheels in motion in the late 1980s, when he collaborated with city and county leaders to correct the so-called "Mistake by the Lake" (as Municipal Stadium was called). Jacobs paid about $10 million for the naming rights, and he was able to convince voters to approve a funding proposal in which higher alcohol and cigarette taxes paid for construction. The Jake's price tag was set at $175 million.

While Jacobs handled the business end of the franchise, general manager John Hart crafted the Indians' fortunes on the field. Through shrewd trades and drafting, Hart laid the foundation for a spectacular lineup, the likes of which Cleveland hadn't seen in more than four decades.

Jacobs Field was the second facility built as part of baseball's "retro-classic" park movement, a trend that was to be followed by half of the major leagues' 30 teams. Its design followed the classic style of Camden Yards while integrating Cleveland's rich industrial history. A brick and exposed-iron exterior corresponds with its neighbors in the south-downtown landscape.

Looking out from home plate, one can take in a stellar view of the Cleveland skyline. Open-air concourses allow fans to walk around the lower deck, seeking choice concessions while still taking in the action.

The venue's capacity has been reduced from its initial maximum of 41,000 patrons. Details didn't evade the park's designers: Ornate iron carvings adorn aisle seats, and cup holders are within easy reach. The upper deck, although steep and distant, offers dramatic views of the city, both from the seating bowl and the terrace concourse. Nineteen light standards that are shaped like giant toothbrushes offer distinctive brightness.

The grass is Kentucky bluegrass, not painted dirt like at the old stadium after a Browns game. In the stadium's outfield, an asymmetrical fence juts in and out. A miniature version of Boston's Green Monster rises 19 feet in left field; atop it is a plaza where fans can stand along an iron railing. A set of 2,700 bleacher seats is situated next to the plaza, anchoring a massive 120-foot-tall scoreboard. In a concourse beyond center field sits a statue of the greatest Indians pitcher ever, Bob Feller.

In 1995, Jacobs Field began a sell-out streak that would last for a baseball-record 455 consecutive regular-season games, until April 4, 2001. Often during this stretch, all three million tickets were sold before the first game; sometimes they were gone before Christmas. Those without tickets paid a nominal fee just to tour the park. The team was that good.

"A new ballpark, an All-Star cast, and the end of a long history of losing all came together to inspire fans," wrote Cleveland columnist Terry Pluto in his book, *Dealing*.

The World Series came to town in the falls of 1995, 1997, and 2016. Sadly, each appearance in the Fall Classic only whetted the city's appetite for a championship. Cleveland went down to the Braves, the Marlins, and the Cubs respectively.

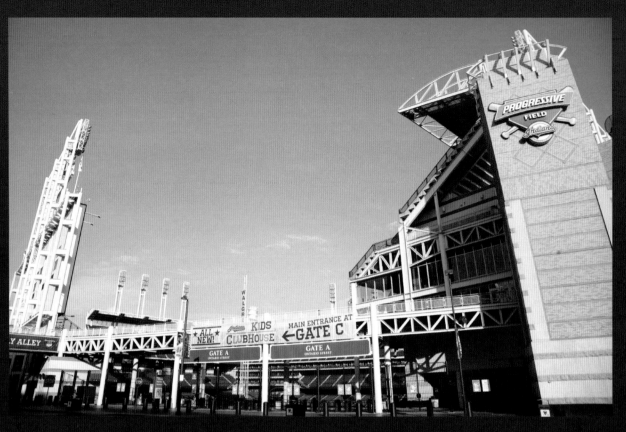

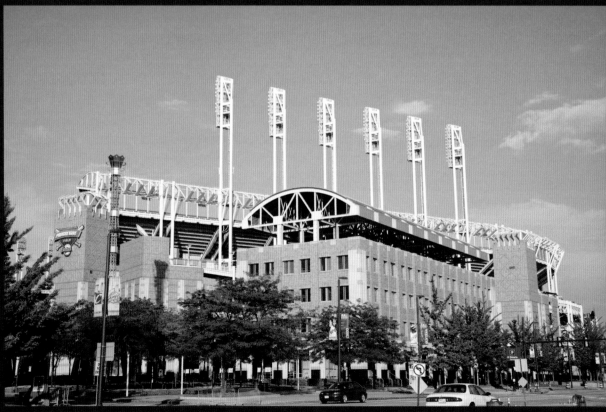

Richard Jacobs—who, along with his brother, David, bought the Indians for about $40 million in 1986—had exhausted the club's profit potential by 2000. That year, he sold the club to the Dolan family for $323 million. Larry Dolan said that Richard Jacobs achieved success in Cleveland baseball unmatched "since Bill Veeck in the '40s."

Over the years, Cleveland's home ballpark has undergone subtle changes while the team has endured major renovations. Progressive Insurance purchased the stadium's naming rights in 2008, after Jacobs's agreement had expired.

The ballpark hosted one of the most memorable Game 7s in World Series history in 2016. Unfortunately for Clevelanders, their Indians fell short against the Chicago Cubs in a 10-inning classic. The ballpark, however, remains far more than a victory for the city and its long-suffering fans. It's truly a crown jewel.

The Indians moniker has gone by the wayside. After the 2021 season, the Cleveland major league ballclub began operating as the Cleveland Guardians.

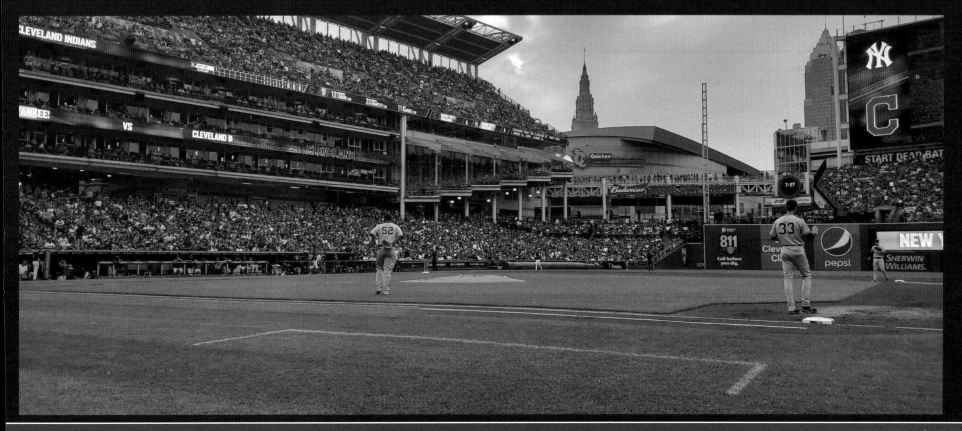

DETROIT TIGERS

COMERICA PARK

No city showed more affection for its classic ballpark than Detroit, whose fans fought to keep old Tiger Stadium alive. The debate was fraught with competing notions: If Tiger Stadium could not be spared, how could the cash-strapped city afford to spend hundreds of millions of dollars on a new ballpark? Conversely, since downtown Detroit needed to be revitalized, how could the city not afford a new park? In the end, Tiger Stadium fell, and the Tigers and Detroit fans hoped that the new Comerica Park, which was built in the city's downtown Foxtown district, would compel the same fierce loyalty its predecessor earned.

Comerica's uniqueness is illustrated by its amenities: the imposing tiger figures growling outside the gates, Ty Cobb's stainless-steel image sliding hard into third, the festive Ferris wheel, the dancing "Liquid Fireworks," and the nostalgia-inducing Walk of Fame.

Built for $300 million of mostly private money, Comerica Park sits alongside Ford Field (home of the NFL's Lions), an office building, and upscale housing. Comerica Park offers open skyline views beyond its outfield walls. Stick-figure light towers, which are patterned after those at Cleveland's Progressive Field, dot the awning above the upper deck.

Above the 23,000-seat lower bowl, luxury suites extend to the foul poles and into outfield seating. In all, the ballpark holds just over 40,000 spectators.

Tigers' owner Mike Ilitch led the planning of the ballpark with HOK architects. The designs included a flagpole that sat in play amid the deepest regions of left-center field, a salute to the pole that once stood at old Tiger Stadium. The plans also included distant outfield fences, which made the ballpark a pitcher's best friend. But while having a home field that surrenders few long balls is good news for pitchers, it was bad news for ticket-sellers in the home-run-happy era.

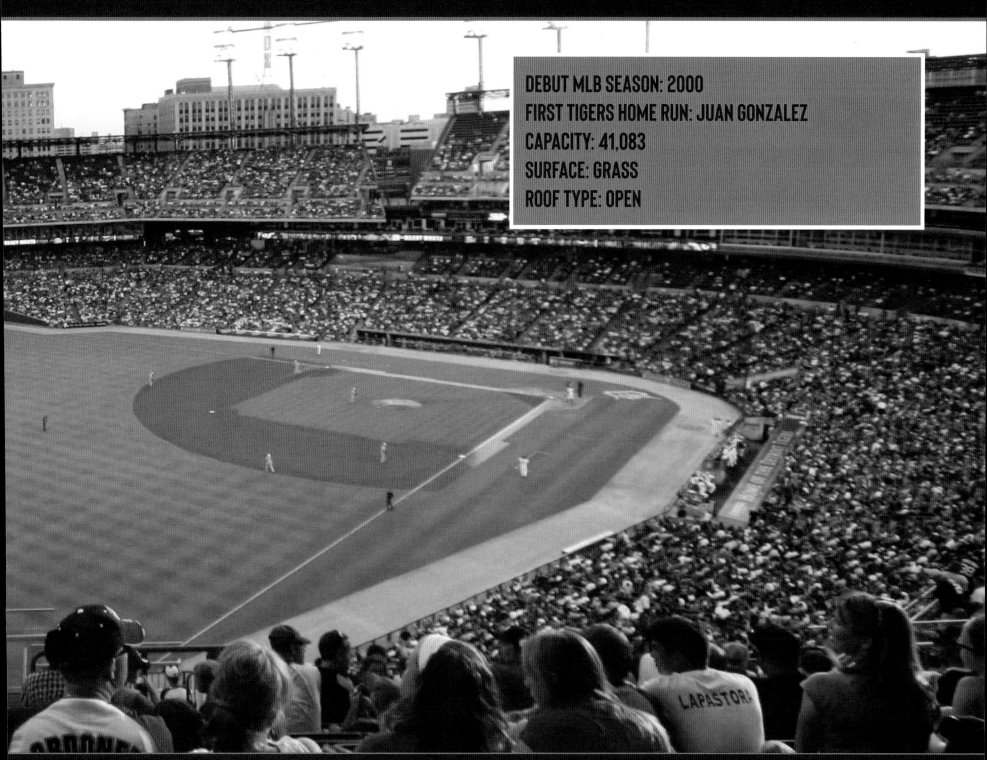

DEBUT MLB SEASON: 2000
FIRST TIGERS HOME RUN: JUAN GONZALEZ
CAPACITY: 41,083
SURFACE: GRASS
ROOF TYPE: OPEN

By 2003, the stadium had changed: The flagpole was moved off the field and the outfield fence in left center was brought in 25 feet. The impact was immediate. Observers estimated that 99 home runs hit in the first two seasons with the new fence configuration would have been fly-outs in previous years. In 2005, the Tigers replaced the bullpens in right field with 950 bleacher seats; new bullpens were placed in the gap created by the shortened fences in left field.

The main scoreboard at Comerica Park is one of the largest in baseball, measuring 127 feet wide by 48 feet tall. In addition, more than 1,000 feet of LED ribbon boards provide up-to-the-second statistical info and HD graphics, further enhancing the game day experience at Comerica Park.

In 2007, attendance at the Tigers' new home passed the three-million total for the first time. This mark came a season after the Tigers won the AL pennant, earning a spot in the World Series, which they lost to the St. Louis Cardinals.

Tigers owner Mike Ilitch could have sold out and made millions in profits. Instead, he showed a commitment to Detroit and its fans. In 2009, times in Detroit were tough—and the city's auto industry was especially hard-hit.

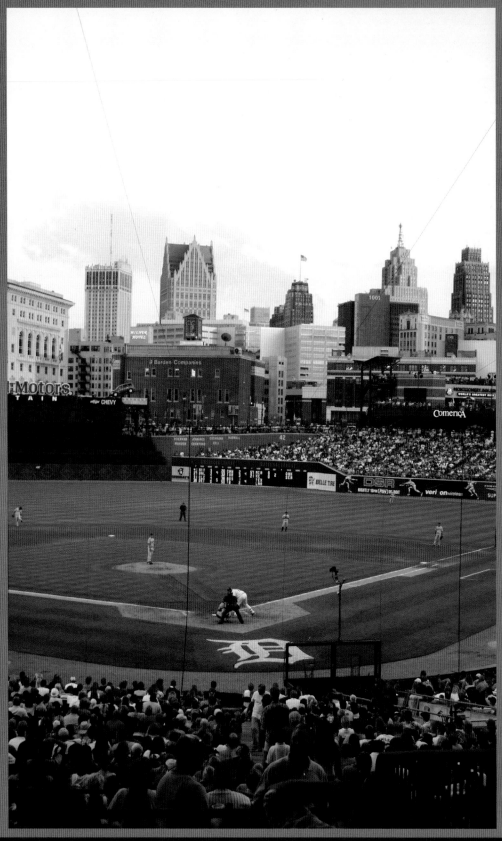

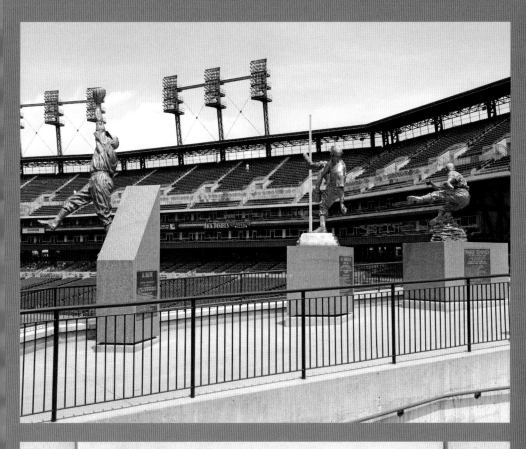

When General Motors, once the country's strongest corporation, fell into bankruptcy and could no longer afford to sponsor the "Liquid Fireworks" fountains at Comerica Park after nine seasons, Ilitch didn't allow someone else to pony up the estimated $2-million naming-rights fee. Instead, Ilitch had the logos of GM, Chrysler, and Ford mounted above the scoreboard during the 2009 season as a show of support. Attached was a sign that read, "The Detroit Tigers support our automakers." At a time when ballplayers and owners were reaping millions while blue-collar workers were standing in unemployment lines and facing foreclosures, the gesture was a public-relations grand slam in the Motor City. By the 2010 home opener, General Motors had returned as the fountain's sponsor.

The Tigers returned to the World Series in 2012, but came up short, losing to the Giants in a four-game sweep. Still, no ballpark offers a better view of a downtown skyline than Comerica Park with its unobscured vistas thanks to the park's signature lack of upper deck outfield seats.

For a swankier take on the Tigers, the membership-based MotorCity Casino Hotel Tiger Club features approximately 20,000 square feet of entertaining space. There is seating for 300 overlooking the playing field in right field, a bar for 200, a cigar bar, and banquet facility.

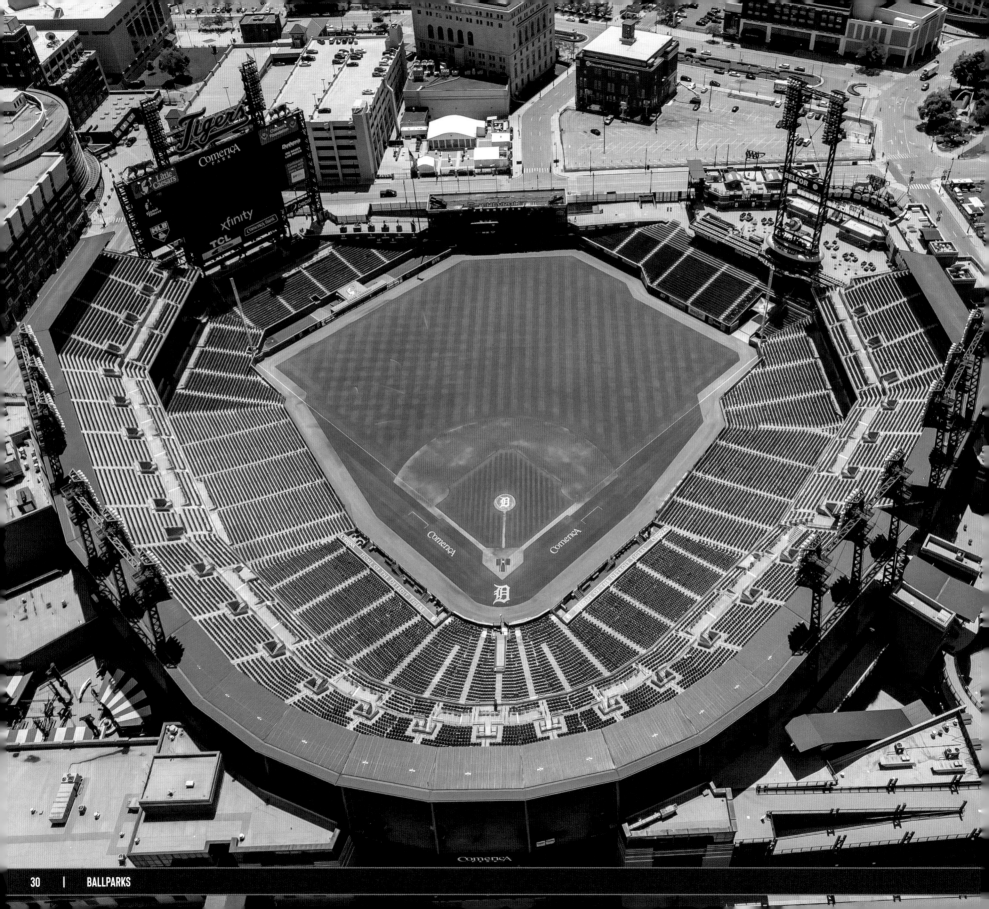

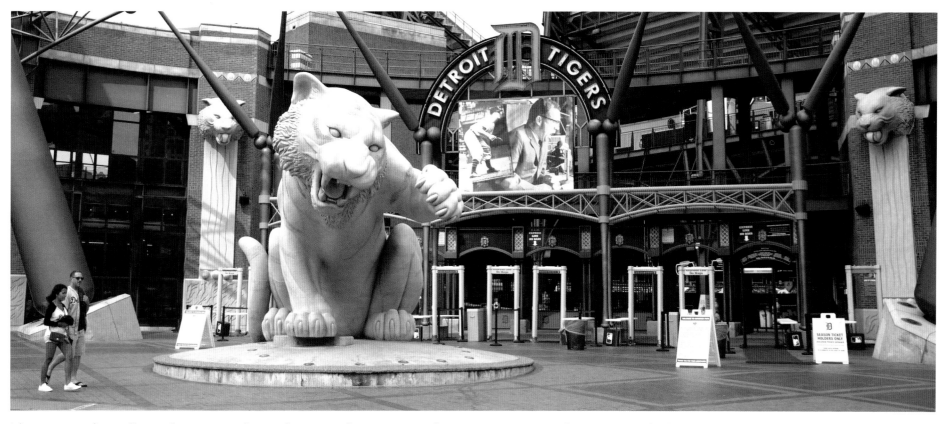

The giant 15-foot tall tiger looming in front of Gate A of Comerica Park is quite menacing. There are a total of nine tiger statues located around the park. Outside of Gate B, a pair of tigers greet Detroit loyalists entering Comerica Park. The naming rights were extended in 2018 meaning Comerica will retain its name through at least 2034.

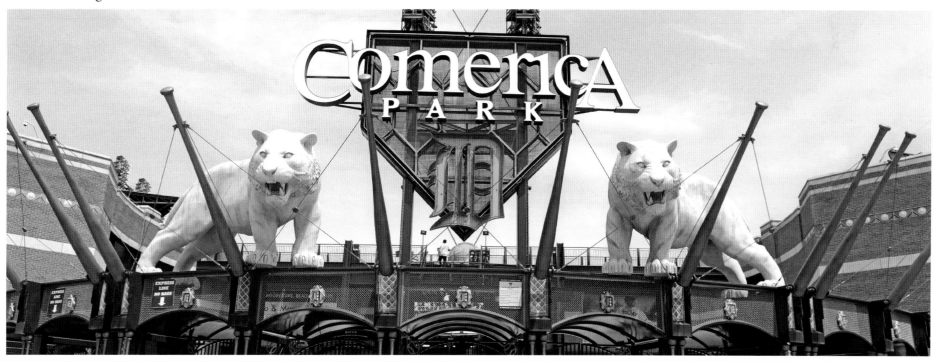

HOUSTON ASTROS
MINUTE MAID PARK

There's no mistaking Houston's ballpark, with its brick-and-limestone facade set in a rich, historic neighborhood. When it opened, it bore the name of energy giant Enron, but scandal at the company led the Astros to buy out the $100-million 30-year contract after two seasons and resell the naming rights to Coca-Cola. Shortly thereafter, the soft-drink company slapped its Minute Maid brand all over the ballpark.

Located at the corner of Crawford and Texas streets in downtown Houston, Minute Maid Park was built at a cost of nearly $250 million. Many fans attending games at Minute Maid pass through Union Station, the city's renovated century-old train depot, where the Astros' team store and a café are housed.

Like parks of the past, this 41,000-seat stadium was squeezed into its neighborhood, giving it a short home-run porch in left field that sits just 315 feet from home. It is so close to the plate that special dispensation was needed from Major League Baseball to allow it. Its 19-foot wall—which features a scoreboard below the 763 seats in the "Crawford Boxes"—makes hitters drool and pitchers pray. An old-fashioned gasoline pump on the "Phillips 66 Home Run Porch" keeps a running tally of Astro dingers that pass by. Don't miss it for a chance for a solid photo op.

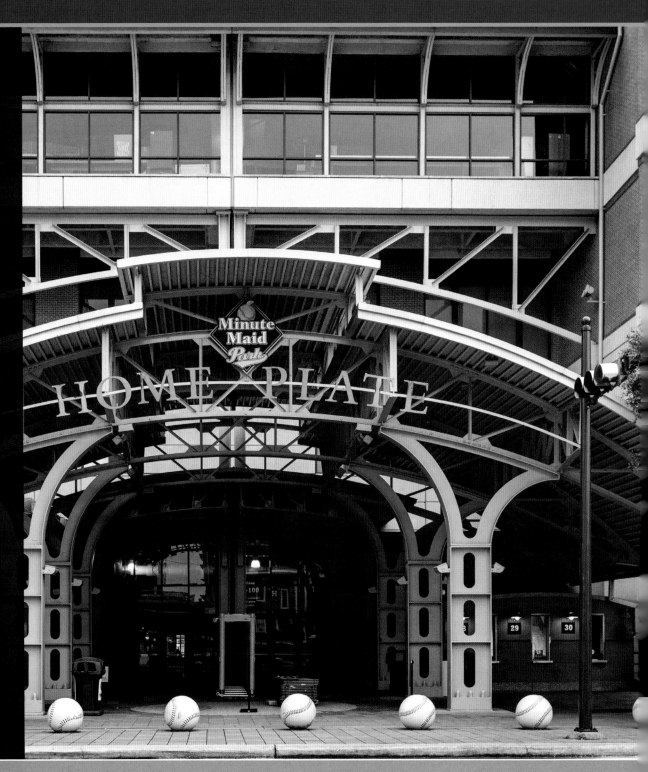

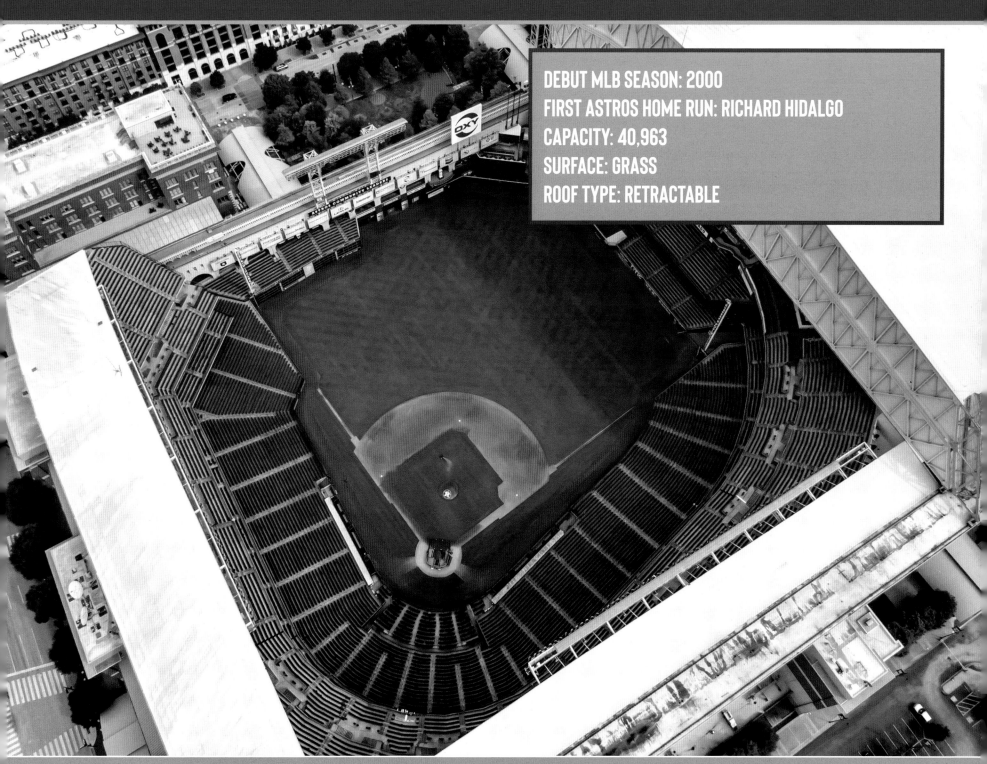

501 Crawford Street
Houston, TX 77002

DEBUT MLB SEASON: 2000
FIRST ASTROS HOME RUN: RICHARD HIDALGO
CAPACITY: 40,963
SURFACE: GRASS
ROOF TYPE: RETRACTABLE

Serving as a backdrop—and as a tribute to the city's railroad history—is an arched cream-color wall that stretches approximately 800 feet from left field to center. Above the wall, a replica locomotive chugs after Astro home runs. Pitchers did find solace in center field where the fence sat 435 feet from home, and beyond "Tal's Hill," a slope that paid homage to "Duffy's Cliff" at Boston's Fenway Park and the "terrace" at Cincinnati's Crosley Field. As if this rise wasn't quirky enough, a flagpole stood in fair territory atop the slope, an idiosyncrasy that was borrowed from old Tiger Stadium. The hill was leveled and removed after the 2016 season.

In right field there is a double-deck grandstand, a state-of-the-art scoreboard, and a popular four-level patio. The ballpark's retractable roof, which helps make baseball in Houston bearable, sits above the right-field stands when open. When the roof is retracted, Minute Maid Park has the largest open area of any ballpark with a movable roof in baseball. A total of 50,000 square feet of glass in the west wall of the retractable roof give fans a view of the Houston skyline, even when the roof is in the closed position.

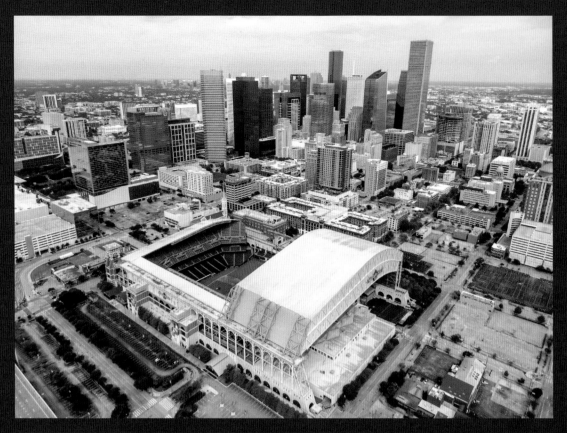

After a rocky start at their new park, the Astros quickly grew accustomed to Minute Maid, making the playoffs three times in their first six years there. A Houston-record three million fans visited the stadium in 2000, its first season.

Renovated for the 2017 season, the center field area offers fans a place to gather and indulge in popular food options, including Shake Shack, Torchy's Tacos and the Budweiser Brew House.

The stadium's second and third floors make up the AT&T Conference Center, open 365 days a year and providing a wide array of meeting rooms for businesses and organizations. The Houston Astros executive offices comprise the third, fourth and fifth floors. The sixth floor features the Roof Deck and Club House at Union Station, where private groups of up to 100 can enjoy the game with an incredible view of the Houston skyline.

In 2005, the Astros made their first appearance in the World Series, which they lost to the Chicago White Sox. In 2017 they returned, this time with a different outcome, beating the Dodgers in the deciding seventh game.

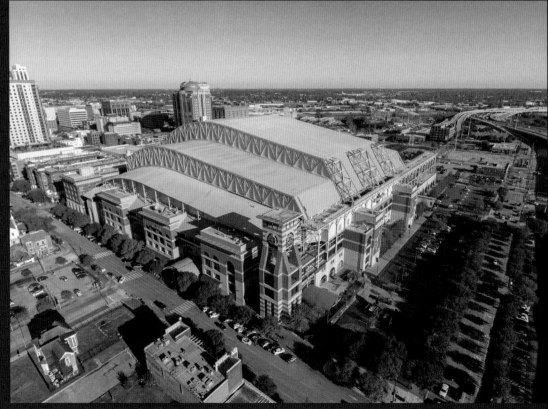

KANSAS CITY ROYALS

KAUFFMAN STADIUM

DEBUT MLB SEASON: 1973

FIRST ROYALS HOME RUN: JOHN MAYBERRY

CAPACITY: 37,903

SURFACE: GRASS

ROOF TYPE: OPEN

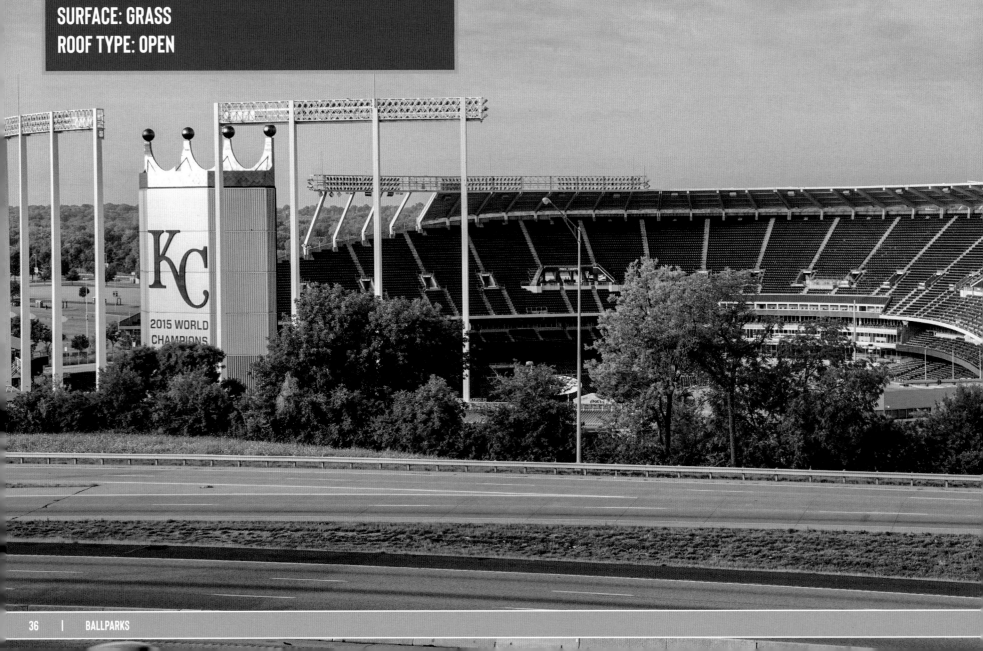

Baseball returned to Kansas City in 1969 with the expansion Royals. After four seasons at Municipal Stadium, though, the Royals left for the more refined setting of Royals Stadium.

At a time when modern but bland concrete stadiums were used abundantly around baseball, Royals Stadium was a *ballpark*. It hearkened back to days when one could recognize a city from the outfield skyline of its ballpark.

While its contemporaries were overstated bowls, Royals Stadium was intimate—it offered seating for 40,625, a small number by standards of the time. The city, which built the park alongside Arrowhead Stadium, didn't skimp on details. This is one reason the park survives today while others of the era have met the wrecking ball.

"This stadium still has the charm of 1973 when it opened," Royals great George Brett said.

Royals Stadium is a baseball-only park—every seat is unobstructed and faces second base. There are no bleachers or multiple decks in the outfield; instead, there are waves of grass that serve as a landscape to a mesmerizing 322-foot waterfall display. The water spectacular opened as the largest privately funded fountain in the world.

A 12-story-high royally crowned scoreboard stands in center field alongside an 8,900-square-foot high-definition video board.

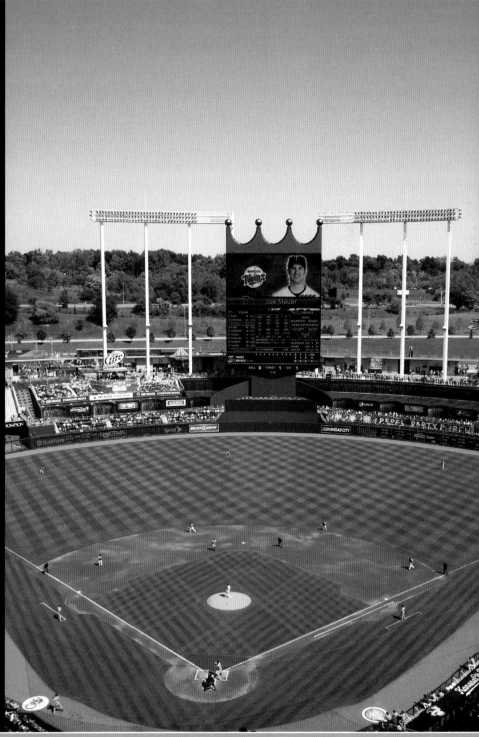

No ballpark is wart-free, however. Critics bemoan the stadium's remote location at a highway interchange, surrounded by parking lots and concrete. When it opened, it had artificial turf. (Grass was installed in 1995.) Prior to the 1999 campaign, additional field level seating, known as "Crown Seats," and four dugout suites were added.

As a team, the Royals adapted well to their surroundings, parlaying speed and defense into a World Series championship in 1985 and six division titles in their first 13 seasons at Royals Stadium. The team consistently drew more than two million fans per season in baseball's smallest market from the late 1970s into the 1990s.

Renamed Kauffman Stadium in 1993 in honor of long-time Royals owner Ewing Kauffman, the park underwent a $250-million renovation from 2007 to 2010 to ensure its status as one of baseball's classics. It also hosted another World Series champion as the Royals were crowned in 2015.

The Royals Hall of Fame is part of Kauffman Stadium's Outfield Experience located on the west side of the ballpark. Guests may enter the Royals Hall of Fame at no charge when the gates open for a game, and exhibits remain open until the top of the 8th inning. On display are the Royals' 1985 and 2015 World Series Championship trophies, as well as the 1980, 1985, 2014, and 2015 American League Championship trophies.

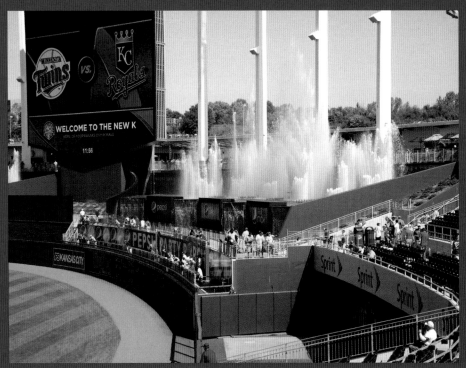

Also known simply as "The K," Kauffman Stadium is the only stadium in the American League named in honor of a person. Wrigley Field is the only other MLB park with a personal namesake attached to it.

LOS ANGELES ANGELS

ANGEL STADIUM

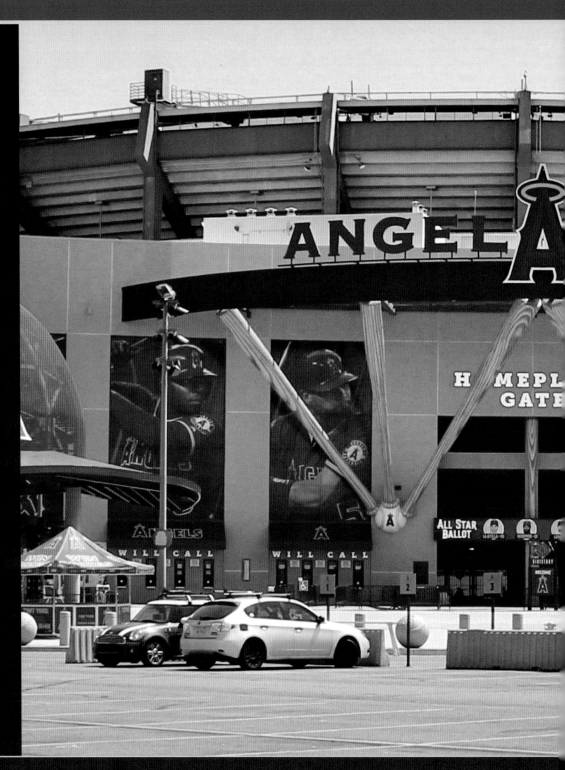

Just like a couple of Hollywood movie stars, Angel Stadium and the team that calls it home, the Los Angeles Angels, have reinvented themselves. Both were once unassuming and unpolished, but they are now among the finest in baseball.

Since opening as Anaheim Stadium in 1966, it has transformed from a nondescript baseball-only venue to a multipurpose facility and back. It is now one of baseball's most inviting ballparks in the league.

The Angels descended into major-league baseball in 1961 with a Hollywood owner, "quintessential good guy" Gene Autry. Their first season was spent at Wrigley Field, a minor-league park at 42nd Place and Avalon Boulevard in south-central Los Angeles that had once been owned by the same chewing-gum company that owned the Cubs. Beginning in 1962, the Angels became tenants at Dodger Stadium for four seasons.

Walt Disney is credited with steering Autry to Anaheim. It was there that Autry bought 148 acres of farmland that had produced alfalfa, corn, and eucalyptus and orange trees. In the early 1960s, Anaheim was a burgeoning suburb, as carloads of families were drawn to the Disneyland amusement park. Mickey Mouse and his gang helped promote the ballpark's groundbreaking. The Angels' new $24-million home was located two miles away from the "happiest place on Earth" and ready for the 1966 season.

The ballpark was easy to find from three different freeways; all one had to do was look for the 23-story "A" with a halo circling its top. The "A" was propped beyond left field and served as a stadium landmark, scoreboard, and advertising placard, all for $1 million. The sign gave the stadium its nickname: "The Big A."

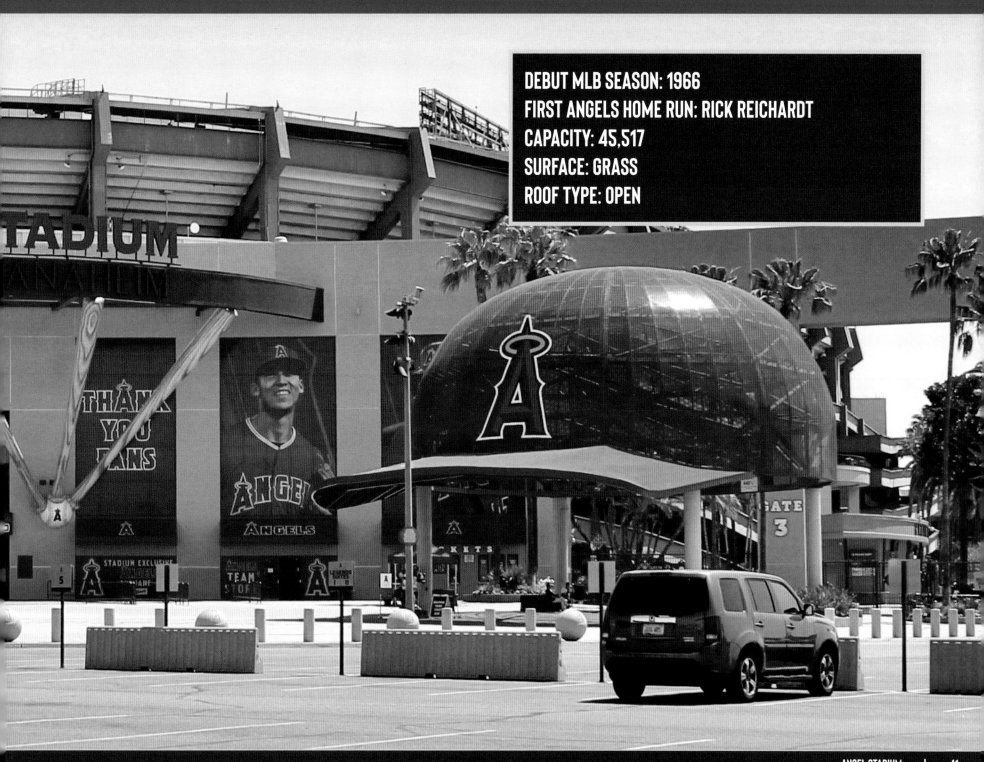

DEBUT MLB SEASON: 1966
FIRST ANGELS HOME RUN: RICK REICHARDT
CAPACITY: 45,517
SURFACE: GRASS
ROOF TYPE: OPEN

Anaheim Stadium originally held 43,000 spectators in a rounded, three-deck grandstand that ended in the rolling bluegrass outfield, providing a view of parked cars and the San Gabriel Mountains in the distance. While there were no outfield seats, there also were no obstructed sight lines. There were, however, plenty of runs, as the ballpark quickly earned a reputation as a hitter's haven. Before the franchise moved into the park, Angel Autry changed his team's name from the "Los Angeles Angels" to the "California Angels," a switch that reflected not only the team's new address but its desire to broaden its fan base.

The park's first transformation came in 1979, when the stadium was totally enclosed to offer expanded seating for the NFL's Los Angeles Rams; unfortunately, this move tainted Anaheim Stadium's quaintness as a baseball facility. As part of the renovation, the "Big A" sign was wheeled into the parking lot. The Rams left for St. Louis in 1995, however, so in the late 1990s, the stadium underwent a magnificent $118-million facelift that remade it as a baseball-only facility with seating for about 45,000. Under the ownership of The Walt Disney Company, the ballpark again became inviting, as the outfield sky view returned and a new retro facade welcomed patrons.

Included in the amusement-park-style design is the "Outfield Extravaganza," which features waterfalls and a geyser that shoots fireworks surrounded by imitation boulders that are designed to reflect the California coastline.

From 1997 to 2003, the park was renamed Edison International Field, thanks to the energy company's $50-million naming-rights agreement. At around the same time, the team changed its name to the "Anaheim Angels." In 2002, the Angels won their first World Series.

In late 2003, under new owner Arte Moreno, the ballpark was renamed Angel Stadium; after the following season, the team was dubbed the "Los Angeles Angels of Anaheim." Moreno quickly endeared himself to fans, three million of whom came to Angel Stadium in his first season. Not only did he finance a topflight team, he lowered ticket and concession prices. "If I have a stadium 90 percent full of kids, then I'm a happy guy," he told *USA Today*.

Mike Trout, who mans center field for the "Halos," has his own personal designated cheering section, the Trout Farm, located by the foul pole in left field. Make special arrangements with the team to score seats there, and you'll also receive a souvenir Trout Farm hat featuring a trout sticking out from it!

Grab some suds, too. Angel Stadium has its very own brewery, Saint Archer Brewing, serving up beers paired with a menu offering global street fare like Thai sticky ribs and salmon poke, alongside burgers, pizzas, and a braised short rib.

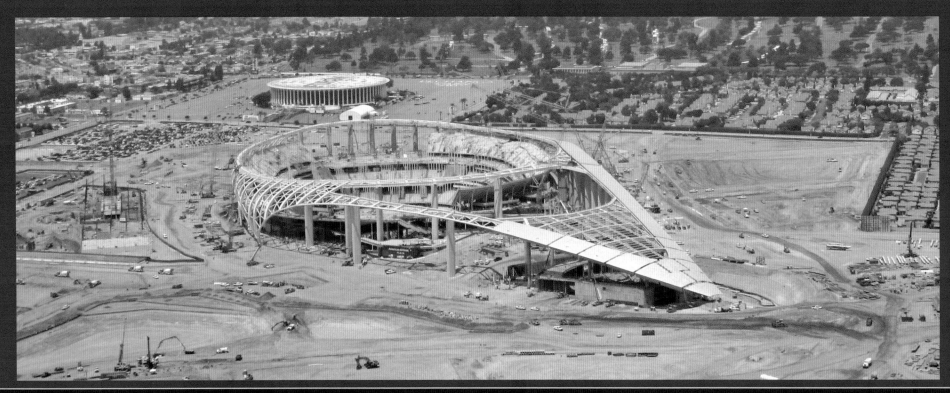

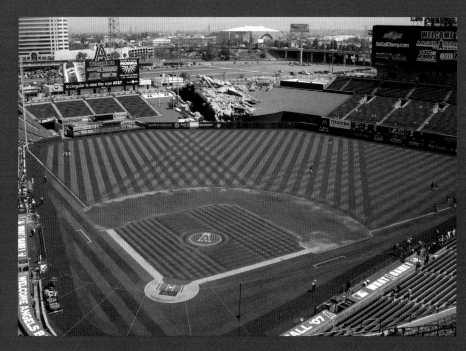

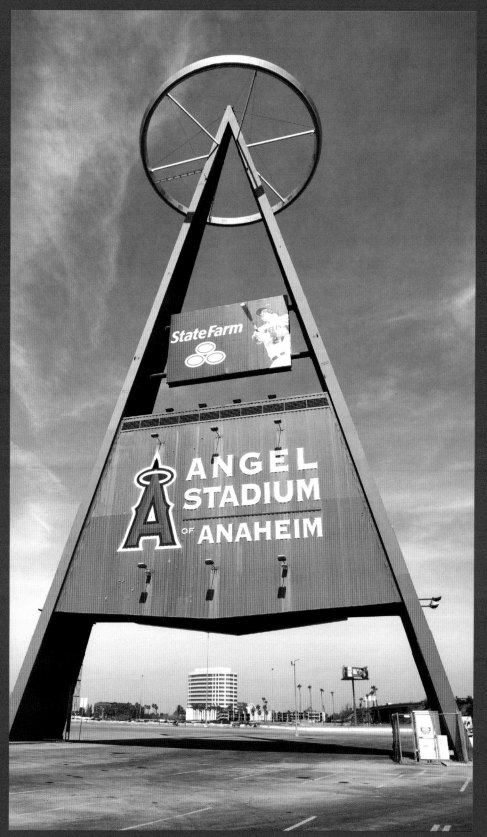

Thanks to the opening of Target Field in 2010, the Twins were able to leave the dank confines of the Metrodome to catch a breath of fresh air and a few rays of sunshine.

After 28 summers spent indoors—during which the Twins won seven division titles and two World Series championships—the team moved into Target Field in downtown Minneapolis's warehouse district and began to enjoy the outdoors. The ballpark's construction came after much haggling and even the threat that the team would be contracted out of existence. It took more than 20 years of pleas for a better venue from the Twins, but eventually the new stadium was built at a cost of $522 million, with both private and public money being used for funding.

Target Field uses locally mined limestone in a not-so-retro, not-so-modern design. It blends nicely with its surroundings, including the nearby intermodal Target Field train station. Another product of the architects of Populous (formerly known as HOK Sport group), the ballpark accommodates roughly 38,500 fans.

Bucking any fears of frigid Aprils, the Twins decided not to put a retractable roof on Target Field. The playing field includes sensors that turn on heat to help grass grow, and the grandstand has climate-controlled areas to which fans can escape in the event of inclement weather. An enlarged canopy soffit tops the roof to provide some protection from the unpredictable Minnesota weather.

Like many new ballparks, Target Field respects baseball history. Its gates are designated using the uniform numbers of the Twins' greatest players—Rod Carew (29), Kirby Puckett (34), Harmon Killebrew (3), Tony Oliva (6), and Kent Hrbek (14)—plus national hero Jackie Robinson (42, of course).

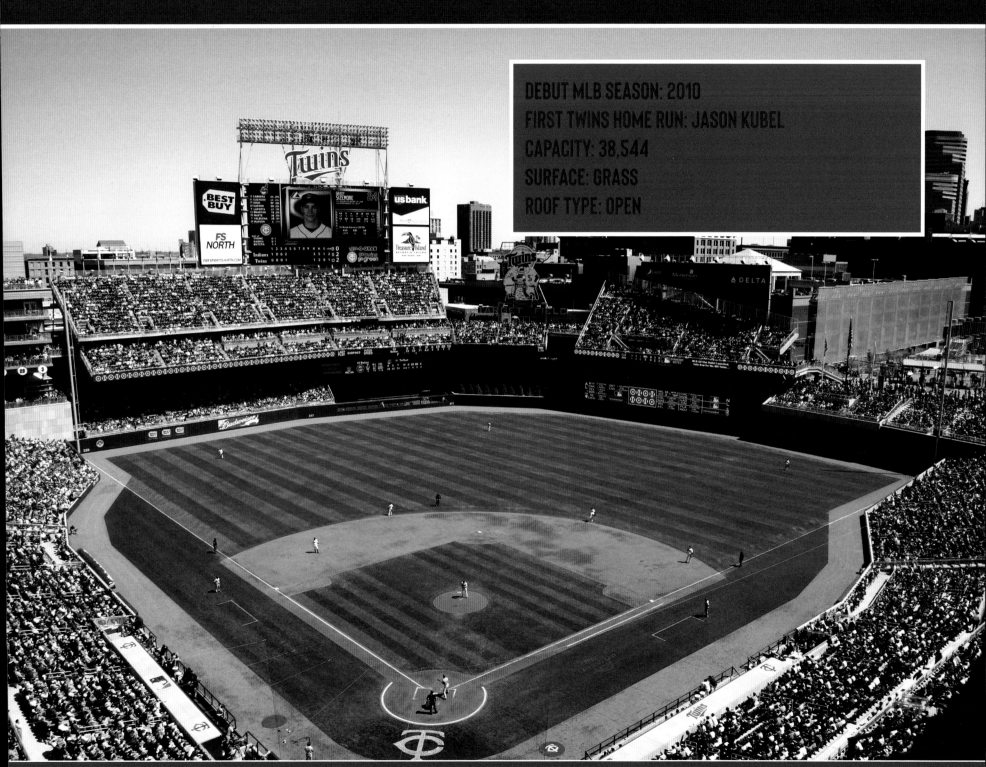

DEBUT MLB SEASON: 2010
FIRST TWINS HOME RUN: JASON KUBEL
CAPACITY: 38,544
SURFACE: GRASS
ROOF TYPE: OPEN

Truly On Deck is a great setting to meet for food and drink before, during, or after the game! Located at club level in right field, Truly On Deck offers both indoor and outdoor seating. One of your best bets—to sample local eats—is to try a Kramarczuk's sausage.

Target Field also recognizes Twins history with a modernized version of the "Minnie and Paul Shaking Hands" logo of the 1960s, which rises above center field; after every Twin homer, the sign lights up with strobes. Trees complement the outfield setting. Knotholes provide peeks from the 5th Street side of the park. And Kentucky bluegrass mercifully replaces the knee-destroying artificial turf of the old dome.

Nearly half of the ballpark's dark-green seats are in the lower deck. The main three-tier grandstand curls from home plate to both foul poles; between the decks are 4,000 club seats and 54 luxury suites. A double-deck grandstand is located in left field; above it stands a massive scoreboard. A rising deck sits in right field. All of the stadium's seats face home plate. Beyond the outfield is the downtown Minneapolis skyline.

Target Field is viewed as something of a pitcher's park, unlike the old venue, the "Homerdome." From home plate to the fence in dead center field is 404 feet. The park's shortest porch is 328 feet to right, where a 23-foot wall runs from the foul pole to right-center field.

The Twins opened their ballpark on April 12, 2010, with a 5–2 win over Boston. That day, Minnesota fans began lining up at 6 A.M. to get a glimpse of their new second home. Scalpers sold tickets for several times their face value. Minnesota players, meanwhile, lavished praise on their new work area.

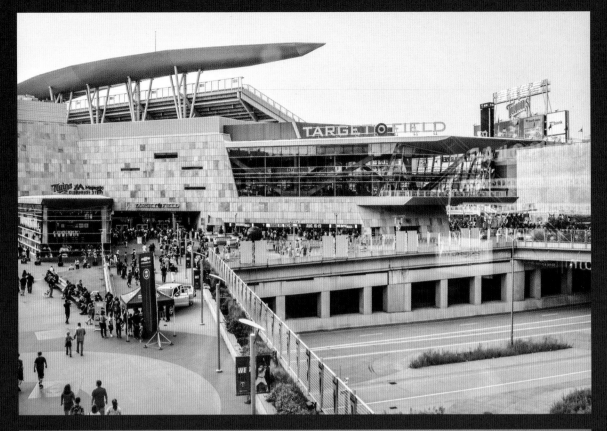

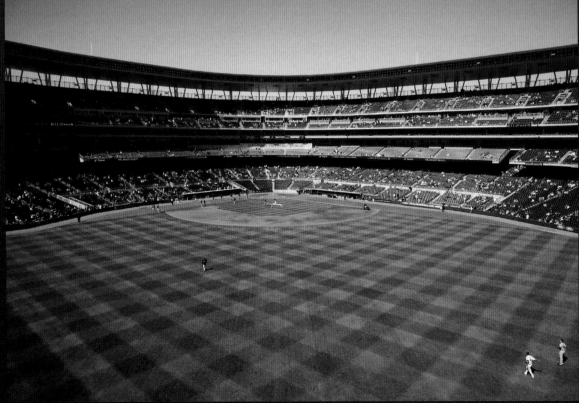

NEW YORK YANKEES

YANKEE STADIUM

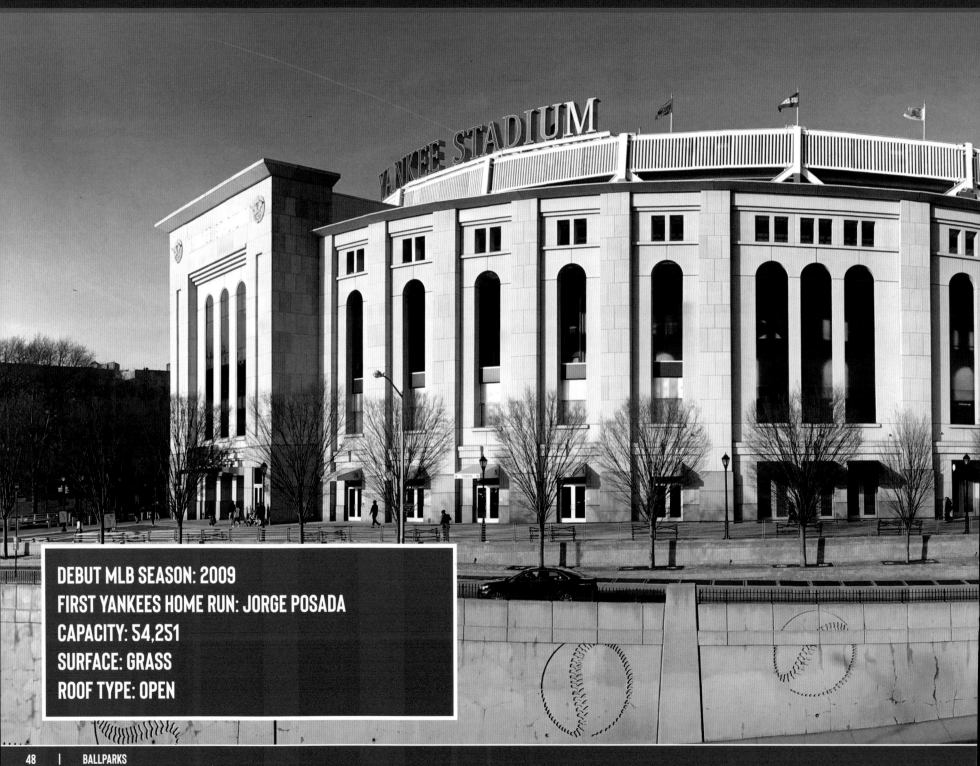

DEBUT MLB SEASON: 2009
FIRST YANKEES HOME RUN: JORGE POSADA
CAPACITY: 54,251
SURFACE: GRASS
ROOF TYPE: OPEN

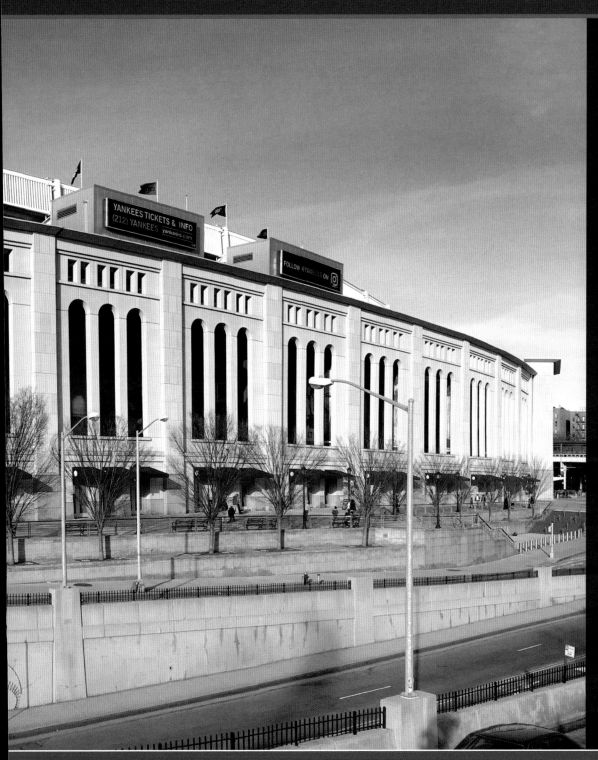

When it's time for one of their legends to move on, the Yankees somehow always have another waiting in the wings—from the Babe to Gehrig, DiMaggio to Mantle, Reggie to Winfield, and Mattingly to Jeter. The same is true of the team's homes: As one historic venue fell, "The House That George Would Build" rose to replace it.

In 2009, the stadium baton was passed as aging Yankees owner George Steinbrenner looked on, fighting his emotions. Just as the Yankees rarely miss a beat in maintaining their amazing dynasty, their new ballpark follows suit, echoing the past while acknowledging the future.

With Citi Field, the Mets' new ballpark, debuting at the same time, comparisons were inevitable. "Shea was old when it was new, and the old Yankee Stadium never got old," Tim McCarver said. "You could have gone on and on and on with the old Yankee Stadium."

New Yankee Stadium was built for $1.5 billion during a huge national economic downturn. Tax-exempt bonds were sold to finance the ballpark, which means that the Yankees will pay for it over time. Taxpayers were also asked to assume some of the burden. More bad news came when the price of the average ticket was revealed to be triple the cost of those in other cities. Furthermore, a "Legends Suite" infield seat was priced at $2,600. These mind-boggling figures led one fan to dub the park "The House That Loot Built." Regardless, the 30-month construction project, overseen by architects from Populous (the former HOK Sport group), ended with a near replica of the original 1923 stadium.

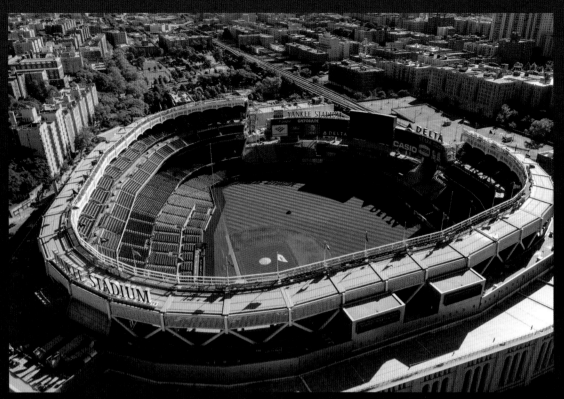
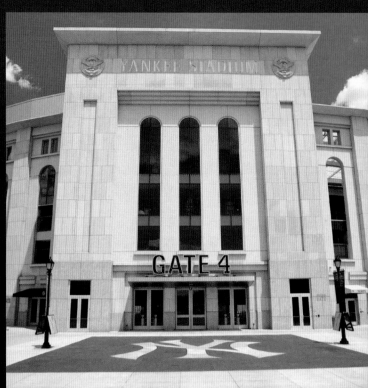
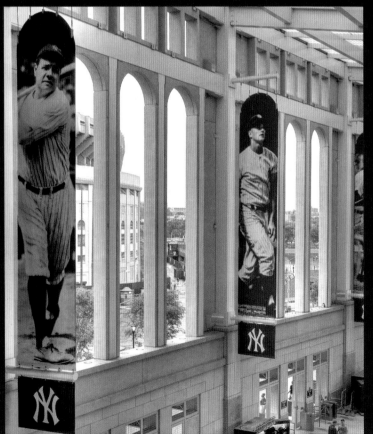
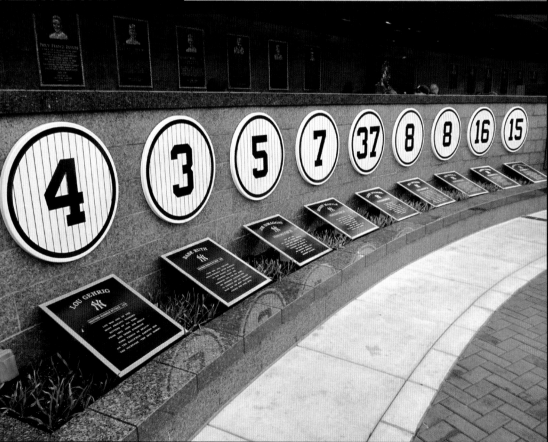

Subway

161 Street Station
Yankee Stadium

B D 4

New Yankee Stadium sits just off Babe Ruth Plaza. Its facade, with limestone and granite surrounding sky-reaching arched windows, commands respect. Above the main gate, the words "Yankee Stadium" are etched in imitation gold and flanked by bronze eagle medallions. Inside, fans are greeted by broad open-air concourses, a welcome contrast to the cramped confines of the old ballpark. Oversize posters of Yankee legends hang all around the Great Hall, which is located at the 31,000-square foot main gate. The Yankees Museum displays team memorabilia.

Circling the grandstand roof is the ballpark's trademark frieze, a throwback to an aspect of the original stadium that essentially disappeared during the renovations of the 1970s. Perched above the frieze are the flags of all 30 major-league teams.

New Yankee Stadium is 63 percent larger than its predecessor, but it manages to feel more intimate due to its 50,000-plus seats offering enhanced sight lines. As at old Yankee Stadium, grandstand seating reaches around the foul poles before giving way to outfield bleachers. Fans can fill four levels, but a majority of the park's seats are located in its lower bowl. The Kentucky bluegrass outfield ends at the warning track in front of fences that stand the same distances from home as at old Yankee Stadium, but seats encroach closer at the new facility.

Monument Park, the tribute to great Yankees of the past, moved from the old stadium to the new one and sits beyond center field with the old park's home plate. Above it looms the center-field high-definition scoreboard, which is 59 feet high and 101 feet wide.

During the new stadium's first season in 2009, a barrage of 237 home runs was hit. A study concluded that the shape and height of the right-field wall—and not a wind tunnel, as had been speculated—might have propelled the binge. Some consider the onslaught a mere fluke. Regardless, the Yankees honored the new stadium with a World Series championship that first fall. At the beginning of the 2010 season, Derek Jeter and manager Joe Girardi visited the owner's suite and personally presented George Steinbrenner his seventh (and final) ring as owner.

The Yankees are the only team in the majors that plays "God Bless America" at every single game. You will hear it during the seventh-inning stretch right before "Take Me Out to the Ballgame."

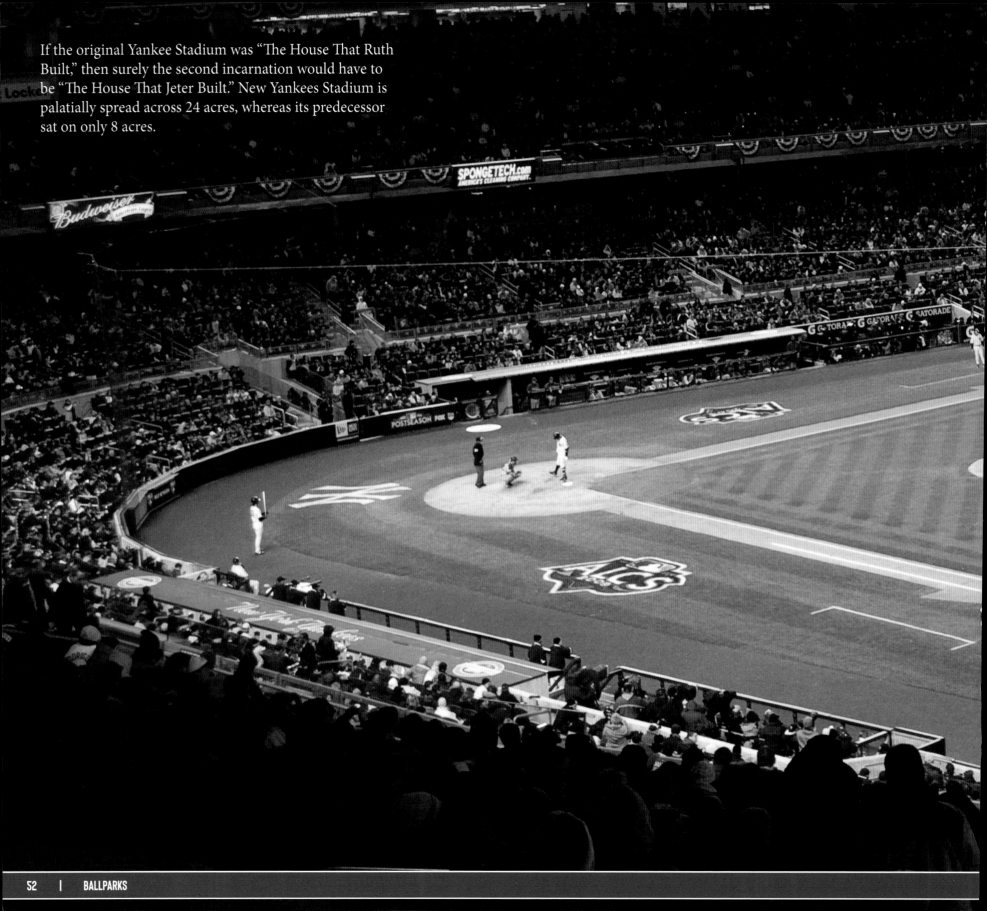

If the original Yankee Stadium was "The House That Ruth Built," then surely the second incarnation would have to be "The House That Jeter Built." New Yankees Stadium is palatially spread across 24 acres, whereas its predecessor sat on only 8 acres.

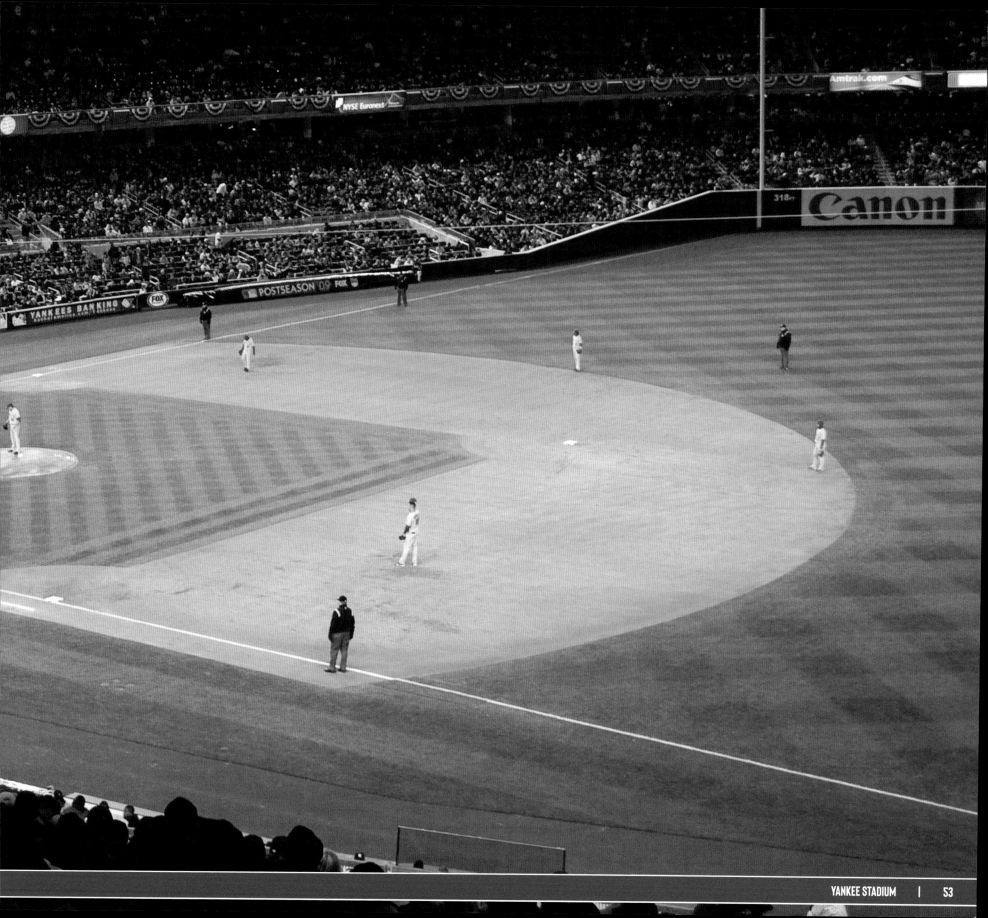

OAKLAND ATHLETICS
OAKLAND COLISEUM

In 1966 Oakland-Alameda County Coliseum opened for the Raiders of the American Football League. It wasn't meant for the A's, but nevertheless, they called it home after arriving from Kansas City for the 1968 season. Despite the wacky promotions of owner Charles O. Finley and three straight World Series titles in the early 1970s, Athletics attendance was simply awful. The stadium's foul territory is expansive, and the distance between the fans and the field of play is symbolic.

When football's Raiders returned from a 14-year stay in Los Angeles they demanded that more seats be added. As a result, in October 1995, the Coliseum began an extensive renovation. The $120 million project included the addition of 22,000 new seats, 90 luxury suites, two private clubs, and two state-of-the-art scoreboards. Nonetheless, efforts by the A's to persuade the city to build a baseball-only facility have consistently failed.

The Treehouse sits above the left field bleachers in the Oakland Coliseum. An awesome place for fans to relax and connect, the 10,000-square foot area features two full-service bars, standing-room and lounge seating, a TV wall, and pre- and postgame entertainment. Seek out its multiple pool, ping-pong, and foosball tables, or step out on the redwood patio deck to relax.

The A's Stomping Ground is an area for families and kids of all ages unlike any other in baseball. This fun and interactive space transformed part of the Eastside Club and the area near the right field flagpoles, and breathed new life into it.

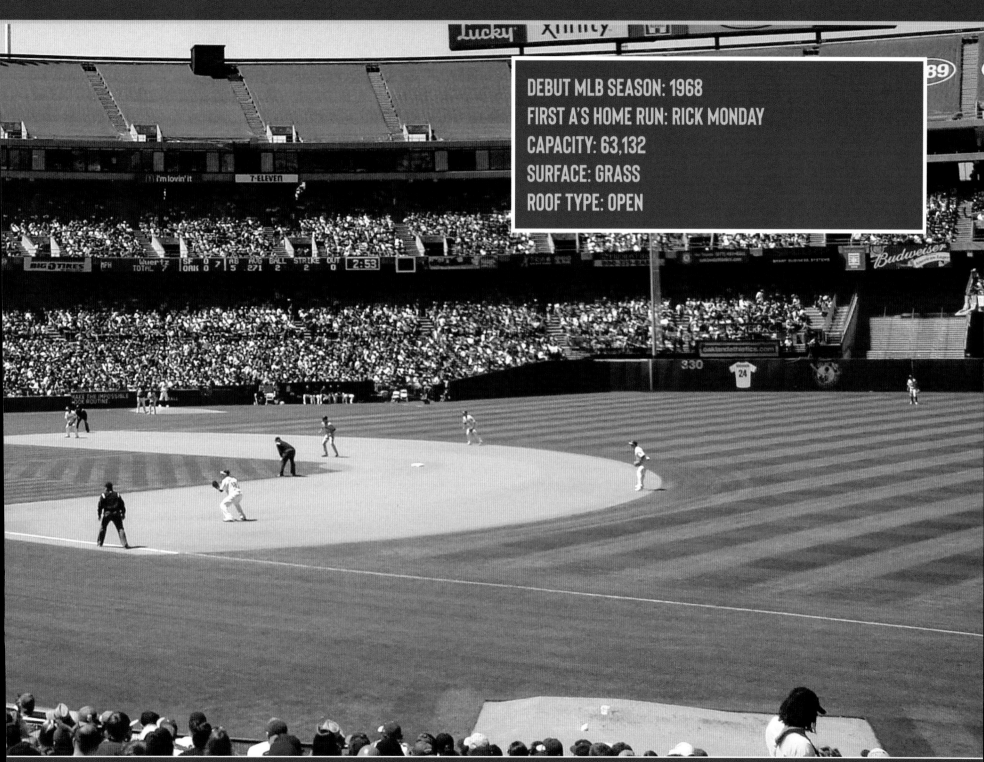

7000 Coliseum Way
Oakland, CA 94621

DEBUT MLB SEASON: 1968
FIRST A'S HOME RUN: RICK MONDAY
CAPACITY: 63,132
SURFACE: GRASS
ROOF TYPE: OPEN

The inside section of the A's Stomping Ground includes a stage and video wall for interactive events. Kids can race against their favorite A's players with a fun digital experience, visit replica A's dugouts, or partake in simulated hitting and pitching exercises.

The area outside the Eastside Club doors includes elephant structures, play areas, an AstroTurf grassy seating area for families to watch the game, drink rails for parents, and picnic tables.

Shibe Park Tavern revisits the Athletics' history in Philadelphia by, quite literally, incorporating actual brick from Shibe Park courtesy of the Philadelphia Athletics Historical Society. The tavern is open from gate time until the end of each game. The bar features local beer and has over 50 beers on tap. The food at Shibe Park Tavern takes a swing at appealing to the taste buds of the masses while keeping in mind their "foodie" fans.

In 2017 the playing field was named in honor of Oakland's Hall of Fame stolen base king, Rickey Henderson. Henderson joined the class in Cooperstown without a hiccup. Unfortunately, history hasn't been as kind to the Bash Brothers (McGwire and Canseco). The A's also made the somewhat unlikely jump from page to screen when *Moneyball* hit theaters. Brad Pitt as A's GM Billy Beane. Who'd have thought?

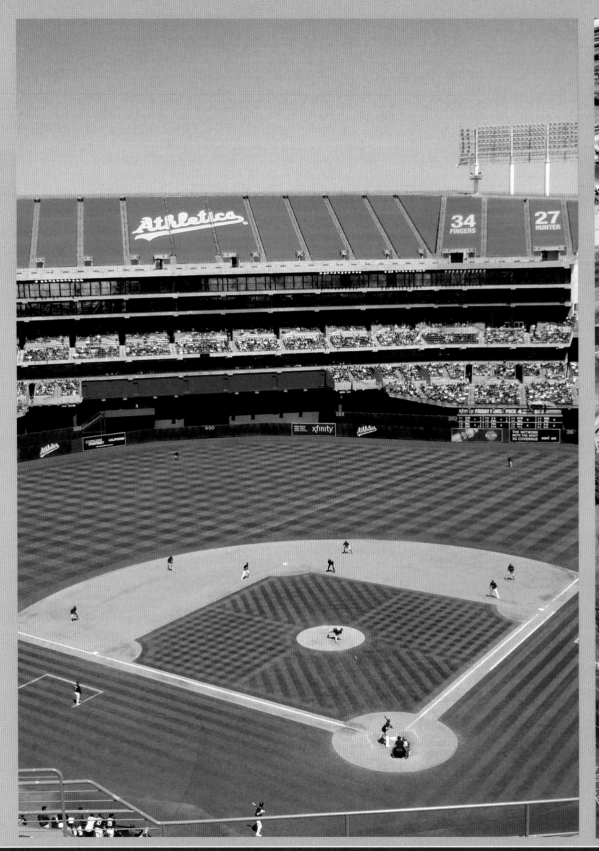

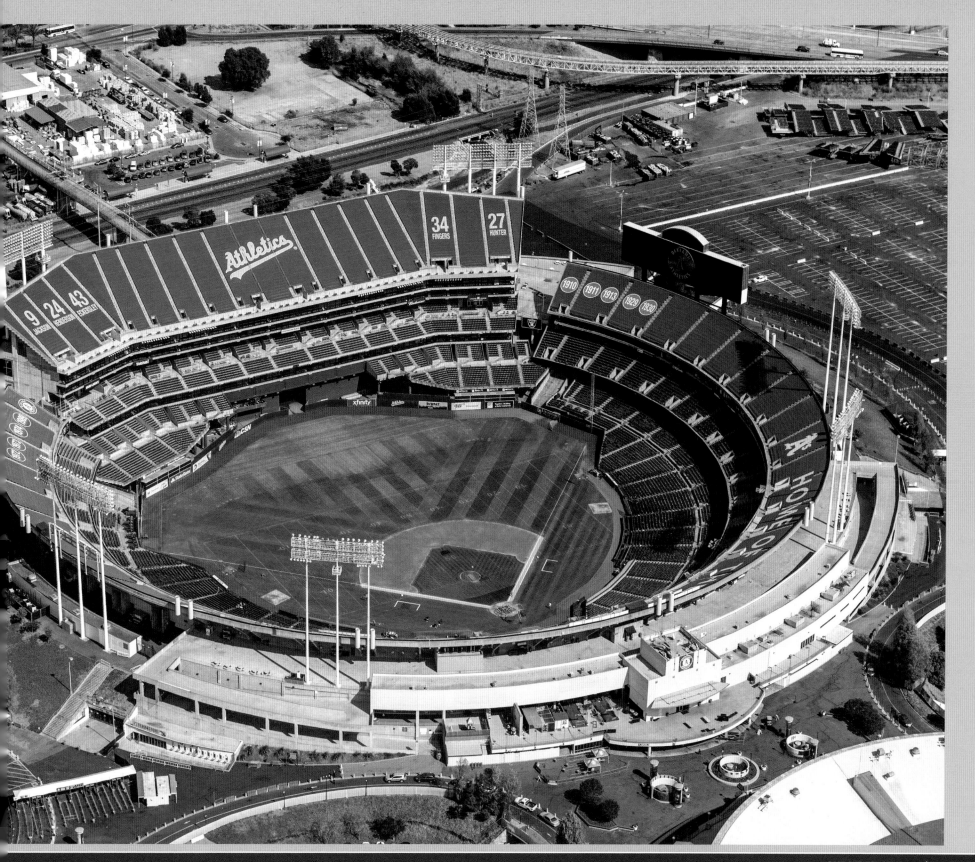

SEATTLE MARINERS
T-MOBILE PARK

Going from the tomblike grayness of the Kingdome to the brilliant greenness of T-Mobile Park was Seattle's journey to baseball nirvana. T-Mobile offers fresh Puget Sound air, which circles the sparkling ballpark. It features sun-cast shadows over real grass, the city skyline in the distance, and the whistling of passing trains. "A day this good, in a stadium this lush, makes baseball feel like a newly discovered form of theology," wrote *Seattle Times* columnist Steve Kelley. "This is almost heaven."

Mariner fans found happiness at T-Mobile Park, another installment in baseball's "retro-classic" stadium frenzy. The ballpark began its existence as the object of financing controversy, as Washington politicians approved a tax plan to fund its construction almost immediately after voters rejected a similar proposal. Regardless, the $517-million ballpark opened in 1999 in midseason to sellout crowds—tickets were scalped for hundreds of dollars over their face values. (T-Mobile replaced Seattle-based insurance company Safeco in 2019 as sponsor, part of a 25-year partnership.)

The stadium was praised by ballpark aficionados as much for its brick-laden exterior as for the innovation, artwork, and attention to detail that lie inside. The main rotunda, circular and stately, is reminiscent of parks gone by and fits into Seattle's "SoDo" downtown district. The exterior's more than 600,000 bricks surround glass windows and exposed steel.

Inside, T-Mobile Park is the anti-Kingdome. Its field is composed of blended grass, modern seating is available for more than 47,000 baseball fans over four decks, and a traditional hand-operated scoreboard tracks balls and strikes. The park also has loads of amenities, museums, and play areas.

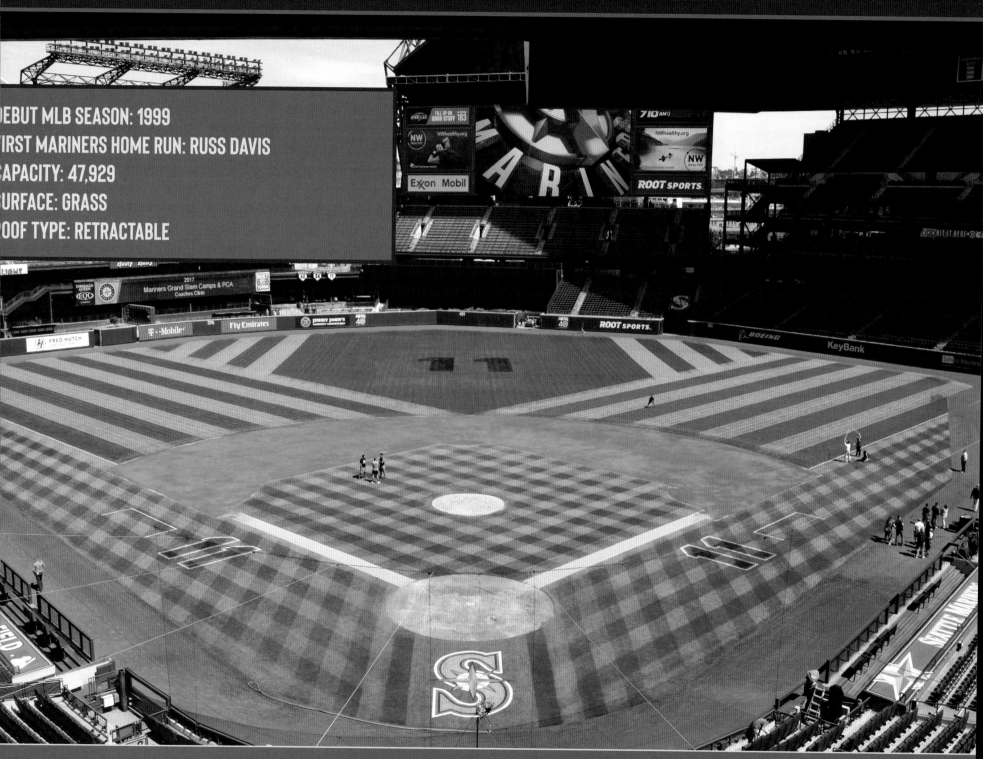

DEBUT MLB SEASON: 1999
FIRST MARINERS HOME RUN: RUSS DAVIS
CAPACITY: 47,929
SURFACE: GRASS
ROOF TYPE: RETRACTABLE

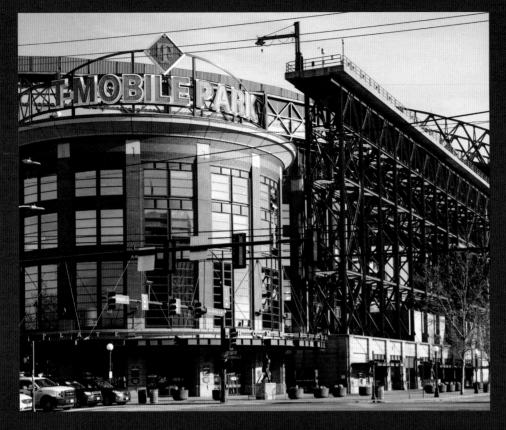

To beat back the cold and rain that is notorious in the Pacific Northwest, T-Mobile Park was built with a telescoping retractable roof that acts like an umbrella—shielding but not enclosing the playing field. The roof covers nine acres, and the Mariners claim that it contains enough steel to build a 55-story skyscraper. When the roof is retracted, it sits over the tracks of the nearby BNSF Railway, one of four remaining transcontinental rail lines. The park's proximity to the tracks offers sights and sounds of days when trains connected America's coastlines. On occasion, Mount Rainier can be seen in the distance.

In the team's first 18 seasons—1977 to 1994—the M's never finished higher than third in their division. All that changed in 1995, as superstar sluggers Ken Griffey Jr. and Edgar Martinez, along with frightening southpaw hurler Randy Johnson, led the way to a first-place finish at the Kingdome. Success followed the M's to T-Mobile. In 2001, the team won a record-tying 116 games. Yet that year, for the third time in seven seasons, the M's lost the AL Championship Series. At the gate, however, the Mariners were champions, drawing more than three million fans each year from 2001 to 2003.

A chandelier sculpture called *The Tempest* hangs above the ornate main concourse rotunda, and it tells all that T-Mobile Park is not just a palace for athletes—it's also a showcase for artists. The chandelier, which is composed of more than a thousand translucent baseball bats illuminated with incandescent lights, is just one of dozens of pieces of artwork on display throughout the ballpark. The collection includes paintings, prints, and photographs from Seattle-area artists.

One of the most notable pieces at T-Mobile Park is a six-foot-tall sculpture of an umpire making a safe call. The work by Scott Fife portrays Emmett Ashford, the first African American umpire in the Pacific Coast League. Other popular pieces include Ross Palmer Beecher's metal "quilts," two of which are made from discarded materials and "stitched" to old Washington license plates recreating the logos of baseball's 30 franchises.

The Seattle Mariners Hall of Fame is located on the main concourse of T-Mobile Park, along with the Baseball Museum of the Pacific Northwest. While perusing the concourse, stop by section 105 to pay homage to a statue of Mariners announcing legend Dave Niehaus. His statue, sculpted by Lou Cella, and the railing behind it, feature several of Dave's unforgettable phrases. There is an empty seat next to the statue so fans may sit next to Niehaus and pose for photos.

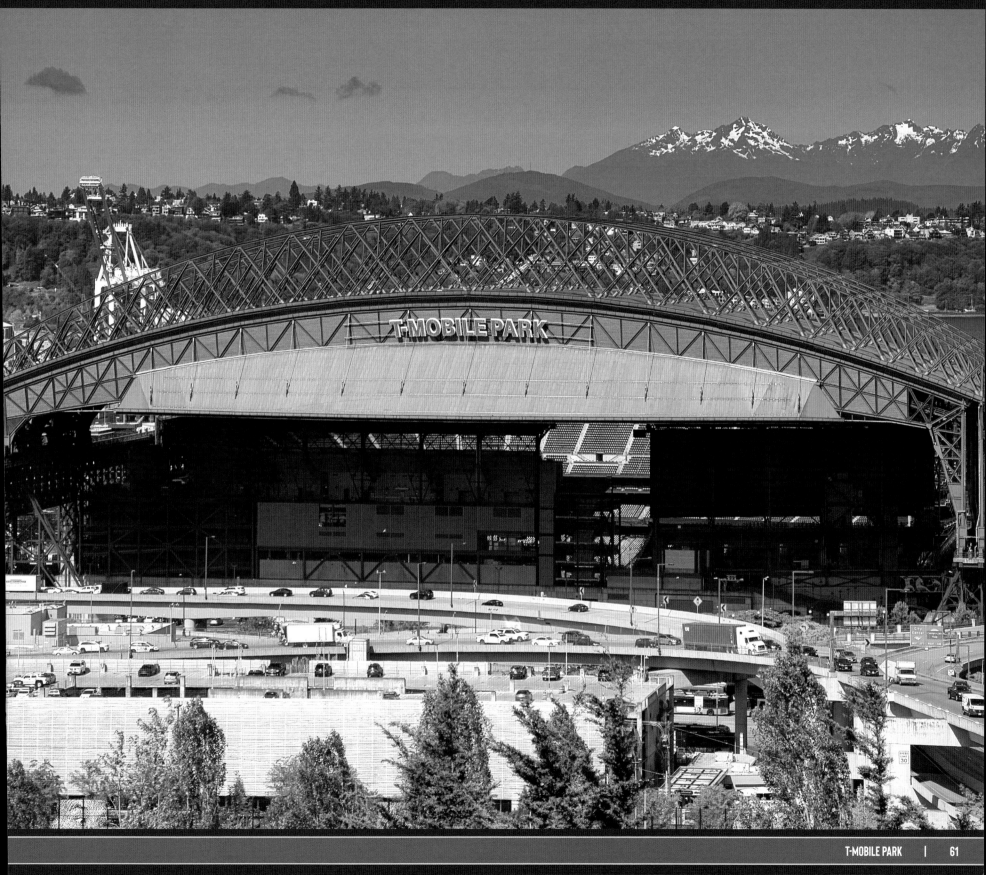

TAMPA BAY RAYS
TROPICANA FIELD

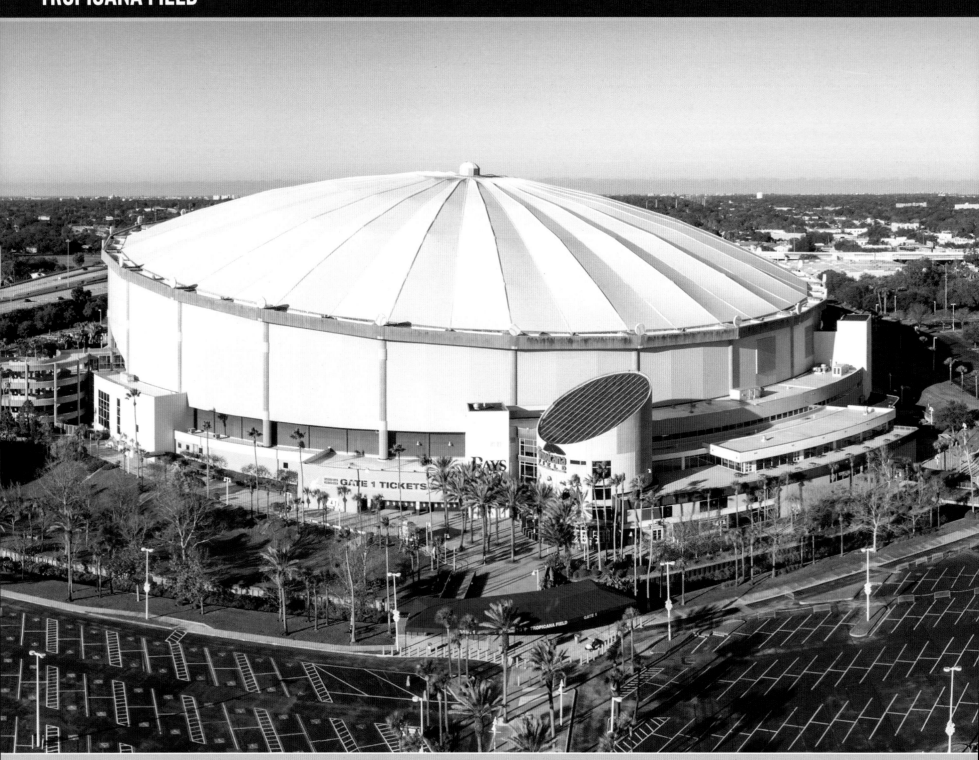

1 Tropicana Drive
St. Petersburg, FL 33705

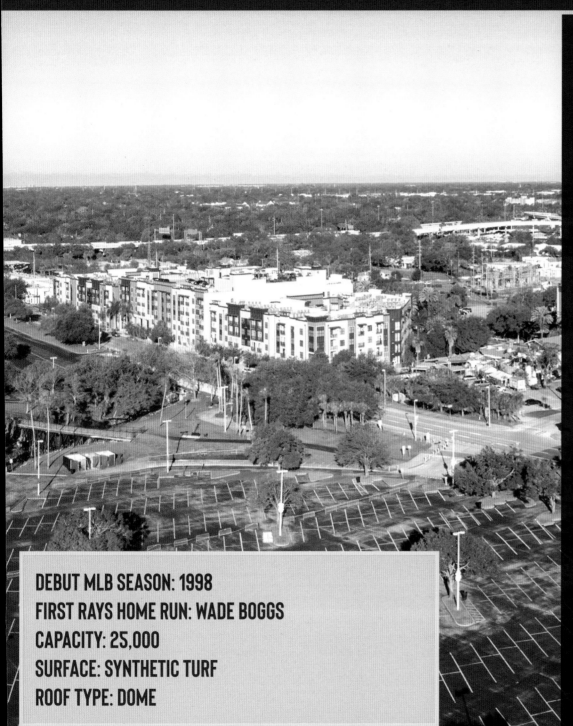

St. Petersburg opened a stadium in 1990 to try to lure teams from Chicago, Seattle, and San Francisco. Unfortunately for residents, those cities opted to build new ballparks for their teams. Then, eight years after the stadium opened, major-league baseball splashed down in St. Pete when the expansion Tampa Bay Devil Rays arrived, in 1998.

Since renamed Tropicana Field ("The Trop"), the stadium was built for $138 million—with a renovation in 1996 that cost another $85 million. The (one-time) 43,000-seat stadium features a five-story rotunda modeled from blueprints that were used to create the grand entrance of Ebbets Field, which leads fans through a 900-foot mosaic walkway made of more than 1.8 million tiny ceramic tiles.

The outfield fences are artificially asymmetrical. The "grass" is synthetic. The Rays use Shaw Sports artificial turf which allows The Trop to have all-dirt basepaths.

The dome features the world's second-largest cable-supported roof, which is made of translucent fiberglass. Over second base, the ceiling rises to 225 feet; above center field, it dips to 85 feet. The four catwalks that hang above the diamond have been known to confound outfielders. The dome's lid is tilted for better cooling and hurricane protection, and it is illuminated in orange after Rays victories.

The Trop offers many amenities, including tanks with more than 30 live rays that sit just beyond right-center field, near a children's play area. "Center Field Street" features a bar and restaurant from which to view games. The Ted Williams Museum and Hitters Hall of Fame was relocated to beyond center field in 2006 after its original location in Hernando, Florida, closed.

DEBUT MLB SEASON: 1998

FIRST RAYS HOME RUN: WADE BOGGS

CAPACITY: 25,000

SURFACE: SYNTHETIC TURF

ROOF TYPE: DOME

Lousy Tampa Bay teams did not initially help attendance at The Trop. In their first ten seasons as the Devil Rays, the team lost many more games than they won. In 2008, however, their fortunes and team name changed. Now existing as the Tampa Bay Rays, the 2008 club battled their way into the World Series. They lost, but returned to the World Series again in 2020, ultimately losing to the Los Angeles Dodgers.

Beginning with the 2019 season, Tropicana Field closed its upper decks, as part of efforts to "create a more intimate, entertaining and appealing experience for fans." This reduced the stadium's capacity to around 25,000–the lowest in the league. The numbers, however, don't lie. The team's average attendance in the 2018 season was just over 14,000 patrons per game.

Should you find yourself taking in a ballgame at Tropicana Field, you will surely see and hear plenty of cowbells. Why? In 2006, Rays principal owner Stuart Sternberg decided to play a popular *Saturday Night Live* skit on The Trop's video screens featuring Christopher Walken as a music producer insisting that he "needs more cowbell!" It was a hit, and suddenly fans started bringing cowbells to the stadium, and a tradition was born. The Rays do have some cowbell guidelines. According to the team, fans are only supposed to ring their cowbells when a Rays player reaches base or scores, when a Rays pitcher has 2 strikes on a batter, or whenever the scoreboard asks for "more cowbell!"

The team has gone back and forth over the past several years in trying to decide on a location and feasible plan for a much-needed new ballpark. Additional talk of playing part-time in Montreal has also never gotten off the ground. Yet the team is still more than competitive. In a division that includes the opulent New York Yankees and equally-wealthy Boston Red Sox, the financially-challenged Rays managed to make the playoffs four times between 2012 and 2021. That's beyond respectable.

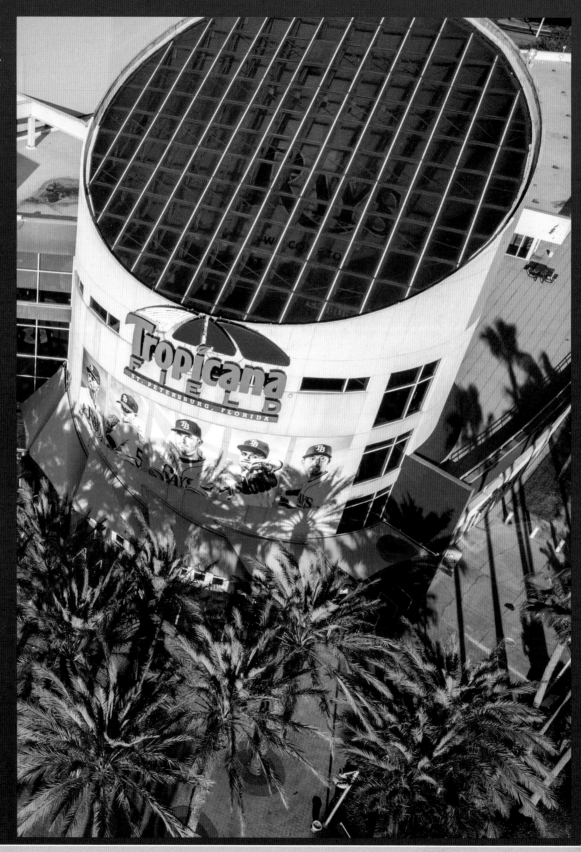

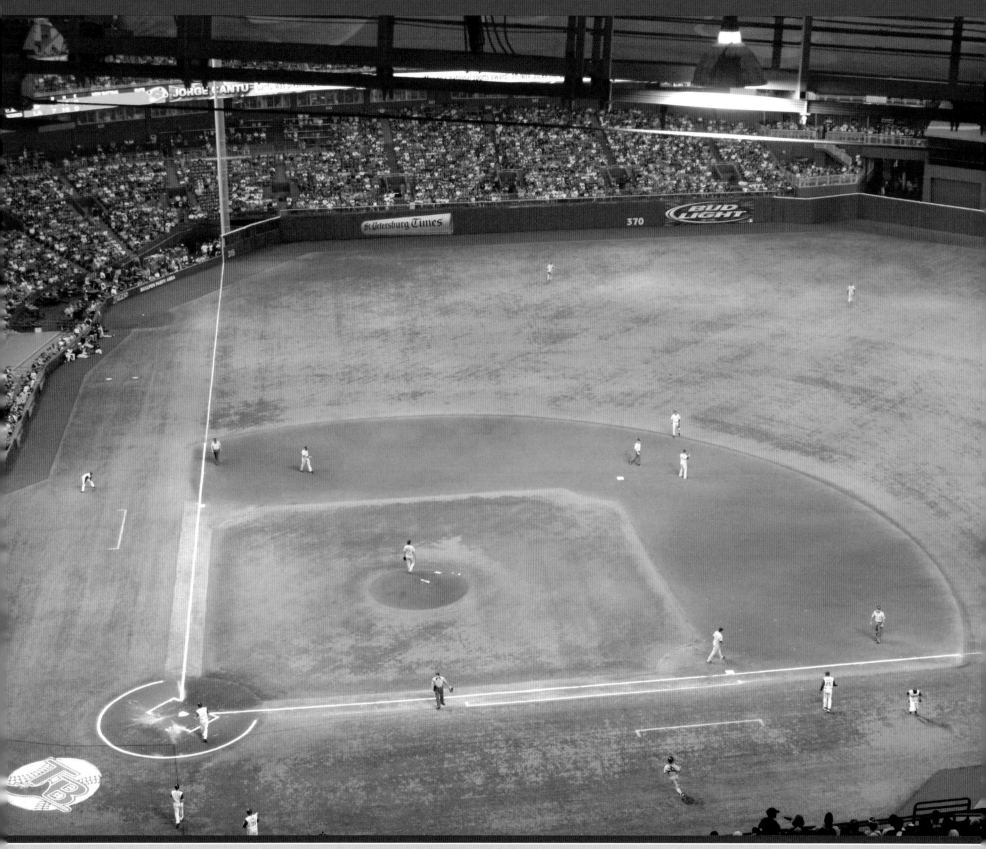

GLOBE LIFE FIELD

G lobe Life Park—formerly The Ballpark in Arlington, Ameriquest Field, and Rangers Ballpark in Arlington—survived a mere 26 years. In baseball, a game rich in history and tradition, that's an exceedingly short span of time.

Was Globe Life Park really so bad? Apparently so, depending who you ask. Turns out, it came down to the Texas climate. Rangers brass decided that a change to an enclosed stadium that also provided air-conditioning would suit Rangers fans best moving forward. An indoor park would protect not only against the heat, but also against tornado threats and thunderstorms.

In a mildly confusing shift, the new, Globe Life Field replaced the old, Globe Life Park. Got it? Good. Then, in March of 2020, the sports world came to a standstill due to the coronavirus pandemic which delayed the debut of the brand-new ballpark.

Globe Life Field did open in July 2020, but didn't welcome dedicated Rangers fans formally until the 2021 campaign. The one-of-a-kind, Covid-shortened, 2020 MLB season was challenging for many health and logistical reasons. When it came to the postseason, Globe Life Field was chosen to host the NLDS, NLCS, and the World Series, making Globe Life Field the first neutral site in World Series history. The Los Angeles Dodgers won the Series in six games over the Tampa Bay Rays.

On Monday, April 5, 2021, the Rangers welcomed fans at Globe Life Field at 100 percent capacity, marking the first professional sporting event to operate at full capacity since the start of the pandemic. (Major League Baseball allowed roughly 28 percent capacity for the NLCS and World Series games played at Globe Life Field in October of 2020.) The Rangers lost to Toronto 6-2.

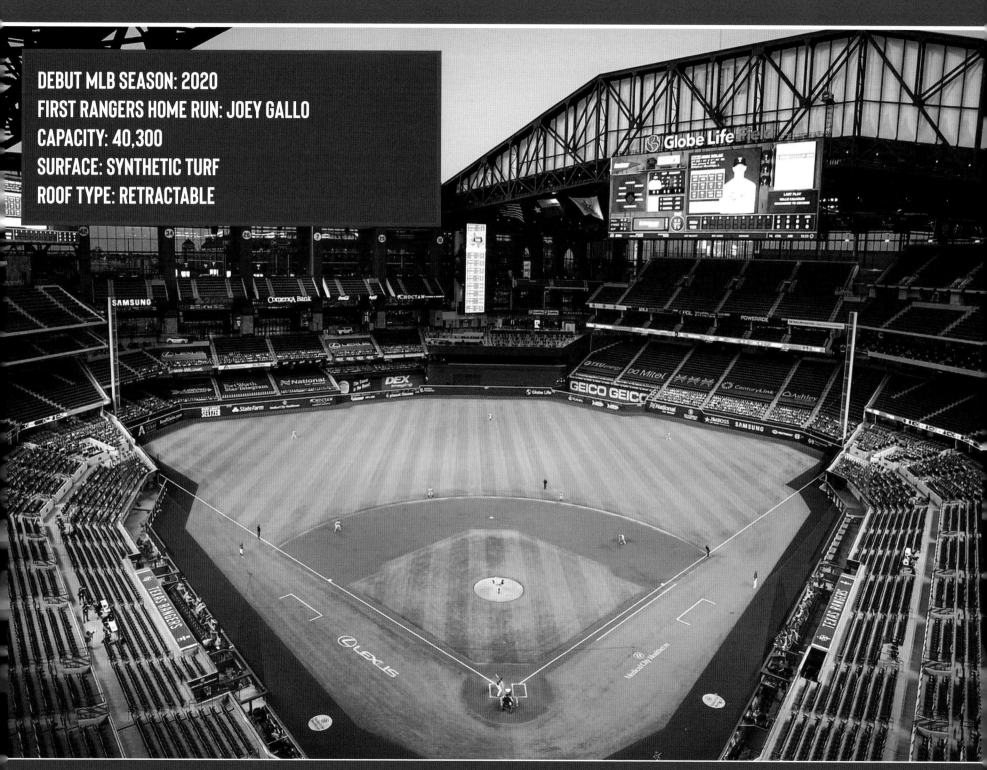

734 Stadium Drive
Arlington, TX 76011

DEBUT MLB SEASON: 2020
FIRST RANGERS HOME RUN: JOEY GALLO
CAPACITY: 40,300
SURFACE: SYNTHETIC TURF
ROOF TYPE: RETRACTABLE

Outside the stadium fans will find several new statues. "Going to the Show," depicts the embrace between Rangers catcher Bengie Molina and closer Neftali Feliz following the pitch that sent the Rangers to their first World Series in 2010. The southwest entrance to Globe Life Field welcomes fans with a statue of Rangers catching legend, Ivan "Pudge" Rodriguez suited up, on one knee.

Inside, chow down on "The Broomstick," a two-foot hot dog, or "The Stack," a mountain of tostadas swimming in nacho cheese. Don't discount the all-important, climate-controlled comfort found at Globe Life Field. Maintaining 71 degrees, versus 100-plus degree North Texas summer days, makes an immense difference.

Globe Life Field is part of the Arlington Stadium District that also features "Texas Live," 200,000 square feet of restaurants, retail and entertainment venues; a full-service 300-room Loews hotel; 35,000 square feet of meeting/convention space; and a 5,000-capacity outdoor event pavilion. You could almost say that they brought the neighborhood to the stadium, rather than vice versa.

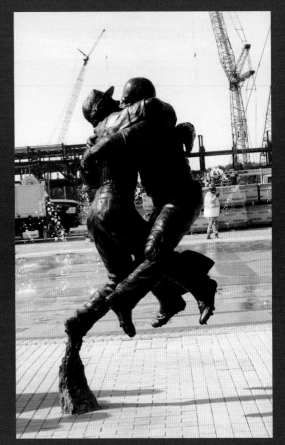
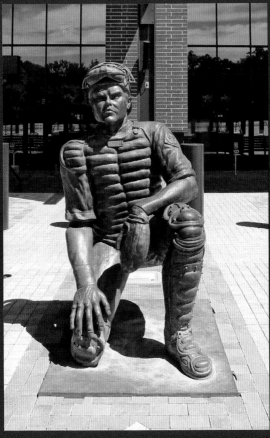

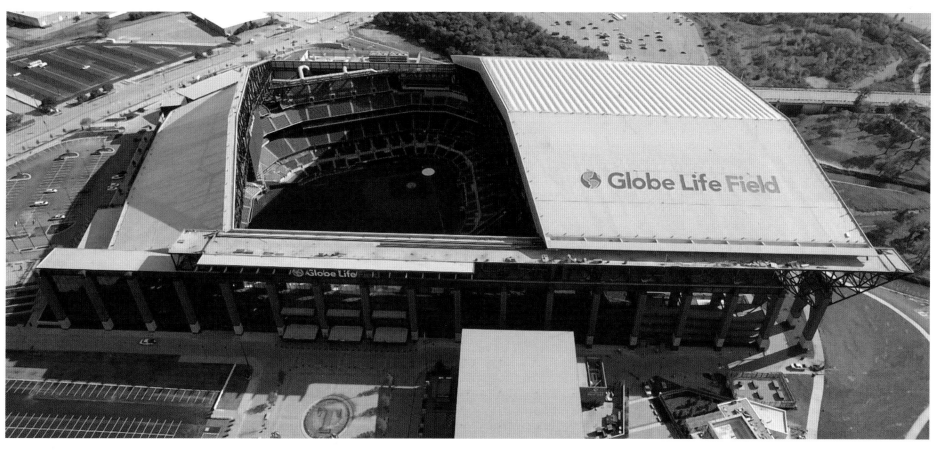

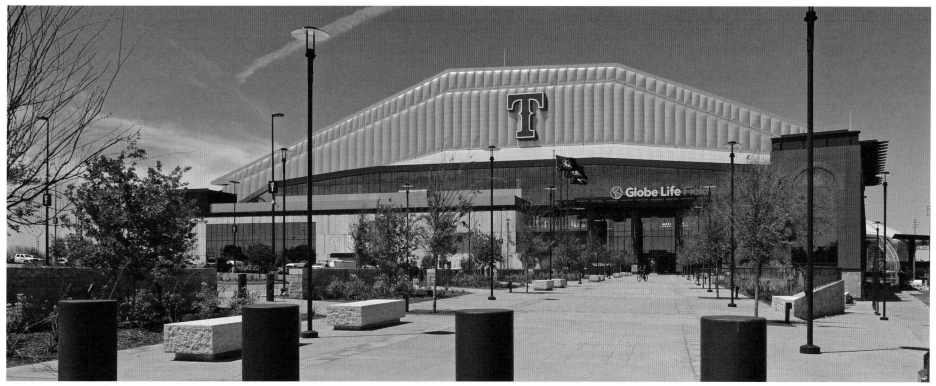

ROGERS CENTRE

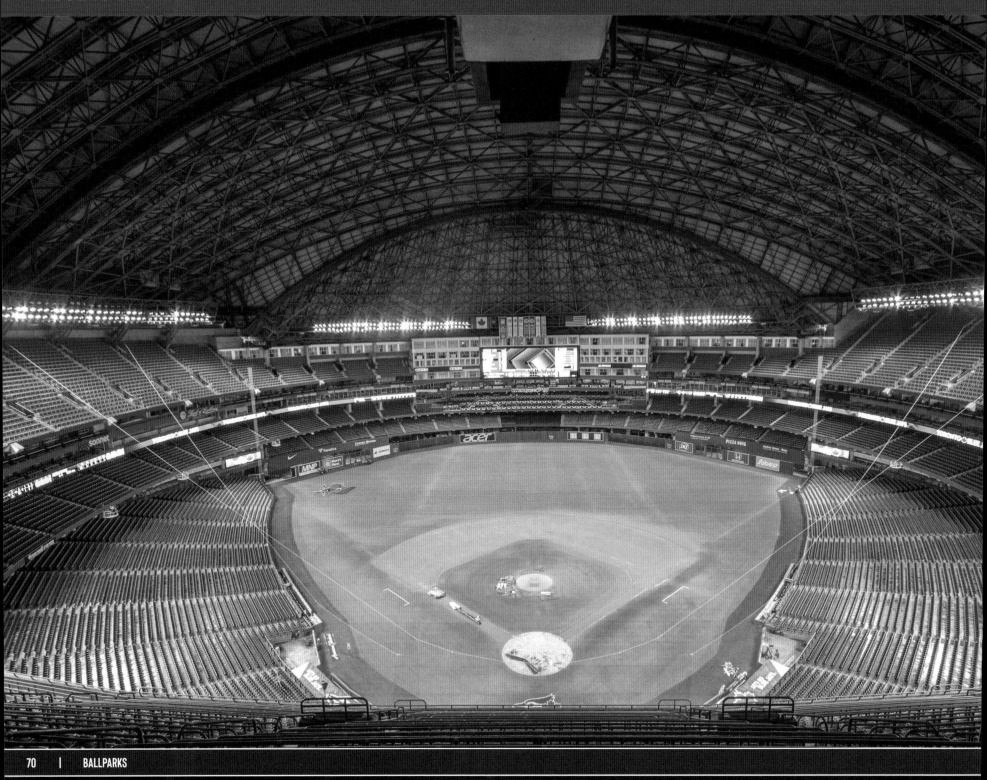

DEBUT MLB SEASON: 1989

FIRST BLUE JAYS HOME RUN: FRED MCGRIFF

CAPACITY: 49,282

SURFACE: SYNTHETIC TURF

ROOF TYPE: RETRACTABLE

Rogers Centre, originally called "SkyDome," is a stadium and entertainment center in Toronto that opened in 1989 to host the Blue Jays and the Toronto Argonauts of the Canadian Football League; it cost more than $500 million to build. Under its retractable roof—and amid 348 hotel rooms, a Hard Rock Cafe, a 500-seat McDonald's, rows of luxury suites, a 300-foot bar, a miniature golf course, and $5 million worth of artwork—was a ballpark "like no other in the world."

SkyDome had everything under baseball's first-ever retractable roof. And despite failing to live up to its billing as the standard-bearer for future stadiums, SkyDome did blaze new trails—it was the first ballpark at which baseball seemed to be more of a sideshow in the face of so many other offerings.

Since their inaugural season in 1977, the Blue Jays had endured playing home games at Exhibition Stadium. But in midseason 1989, the Jays moved to SkyDome. The facility's opening caused a media blitz, as reporters and fans alike gushed over what they found. It had taken seven years for the plans of architects Roderick Robbie and Michael Allen to come to fruition. Baseball had never before seen such a litany of amenities: restaurants, first-class shopping, 161 private skyboxes, and even a hotel with rooms overlooking the playing field.

SkyDome's most notable engineering achievement was 31 stories above the ground. The stadium's $100-million four-panel retractable roof can open or close in a mere 20 minutes. Made of steel and aluminum, it provides a sky view for the artificial-turf playing field and 90 percent of SkyDome's about 50,000 seats. The CN Tower rises beyond the right-field stands.

When the stadium was unveiled, the $17-million JumboTron scoreboard—33 feet high and 110 feet wide—was the world's largest. Toronto used SkyDome to support its claim as a world-class metropolis.

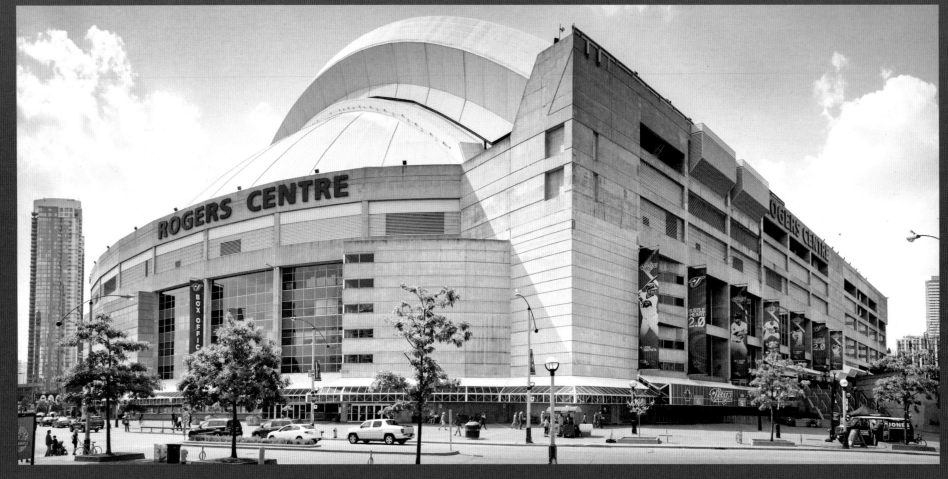

The Blue Jays produced amazing exploits at SkyDome almost immediately, winning World Series titles in 1992 and '93. The 1993 championship was won at SkyDome with Joe Carter's legendary ninth-inning walk-off home run. Fans responded—more than four million attended in 1991, '92, and '93, and the Blue Jays led the American League in attendance in each of the first six years of their residence at SkyDome.

In 1998, with the Blue Jays tumbling toward the bottom of the AL East and attendance sagging, SkyDome's ownership group went into bankruptcy. In 2000, Rogers Communications purchased the team; then, in 2005, it bought the facility at the bargain basement price of $25 million—not much more than the original cost for the JumboTron alone—and renamed it "Rogers Centre." Several other clubs have since used the retractable-roof idea. But somehow, the extras that made SkyDome so intriguing more than 30 years ago now seem extraneous.

The Blue Jays Level of Excellence celebrates the names, and, in some cases, uniform numbers of ten distinguished individuals with historical ties to the club. These are displayed upon the facing of the 500 Level in Rogers Centre, in recognition of their tremendous efforts and achievements. They are Paul Beeston, George Bell, Joe Carter, Tom Cheek, Carlos Delgado, Tony Fernandez, Pat Gillick, Cito Gaston, Roy Halladay, and Dave Stieb. The number 4,306 beside Tom Cheek's name represents the number of consecutive regular season games he called on the radio.

In December of 2021, the Blue Jays announced a $200 million renovation plan that promises to completely redesign the stadium's lower bowl, modernize the Rogers Centre, and keep the team at 1 Blue Jays Way. One thing that does not seem to be under consideration at this time is replacing the artificial turf with natural grass. The Blue Jays are expected to follow similar construction methods employed by the Chicago Cubs and Los Angeles Dodgers. When their parks underwent extensive renovations in recent years, they were completed in stages over multiple off-seasons.

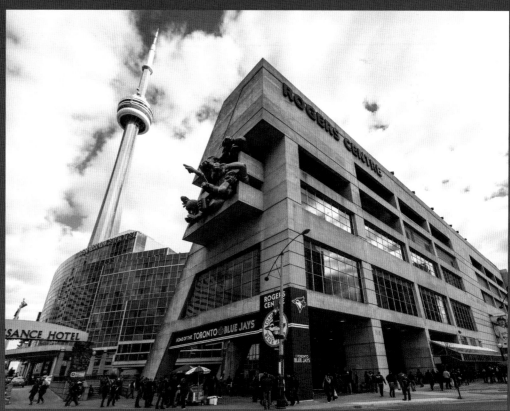

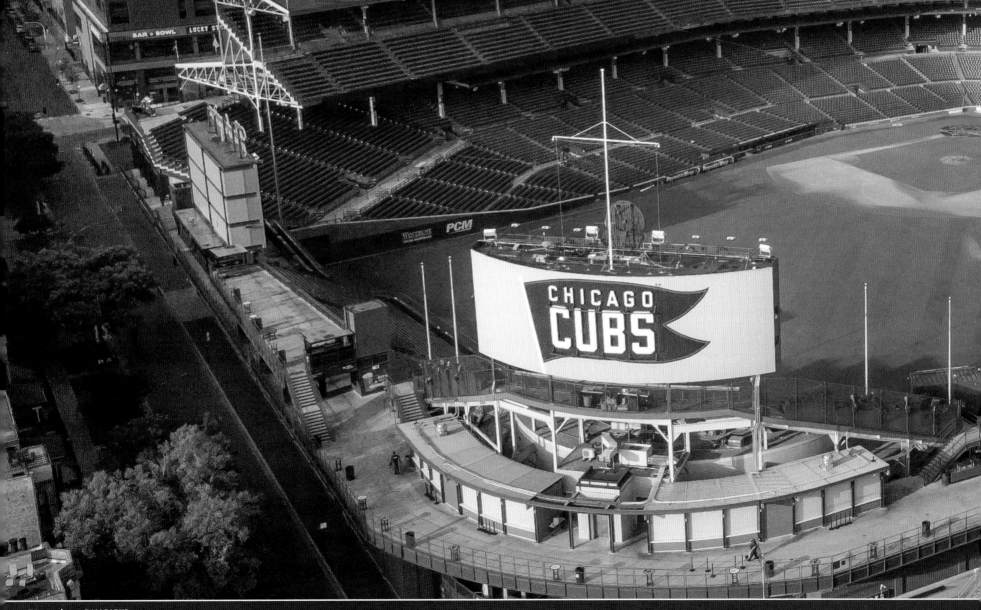

National League

Founded in 1876 and sometimes referred to as the "Senior Circuit," the National League predates its counterpart, the American League, by 25 years. Teams have actually come and gone over the years, most recently when the Houston Astros defected for the American League in 2013. This helped to balance the two leagues creating three divisions of five teams each.

Built in 1914, Chicago's Wrigley Field with its signature bricks and ivy remains the oldest National League ballpark. On the other end of the spectrum, Atlanta's Truist Park is the latest entry to the National League pantheon of ballparks. Since 2000, a staggering eleven new National League ballparks have opened. And those that do stick around require seemingly endless maintenance and upkeep. Wrigley Field and Dodger Stadium, we're talking to you.

While the old Houston Astrodome may have been called the eighth wonder of the world at one time, enclosed stadiums have come a long way. Fans of yesteryear could only have dreamed of the conveniences offered by the retractable roof at LoanDepot Park. This engineering marvel has the ability to move a combined 19 million pounds within 13 to 15 minutes, traveling at a speed of 39 feet per minute. Rain delay? No way! Not to mention the luxury of air-conditioning that accompanies enclosed ballparks. In the case of Milwaukee's American Family Field, the retractable roof is sometimes used to protect against freezing temperatures and falling snow during chilly Aprils.

Crack some shelled peanuts and join us for a whirl around National League ballparks.

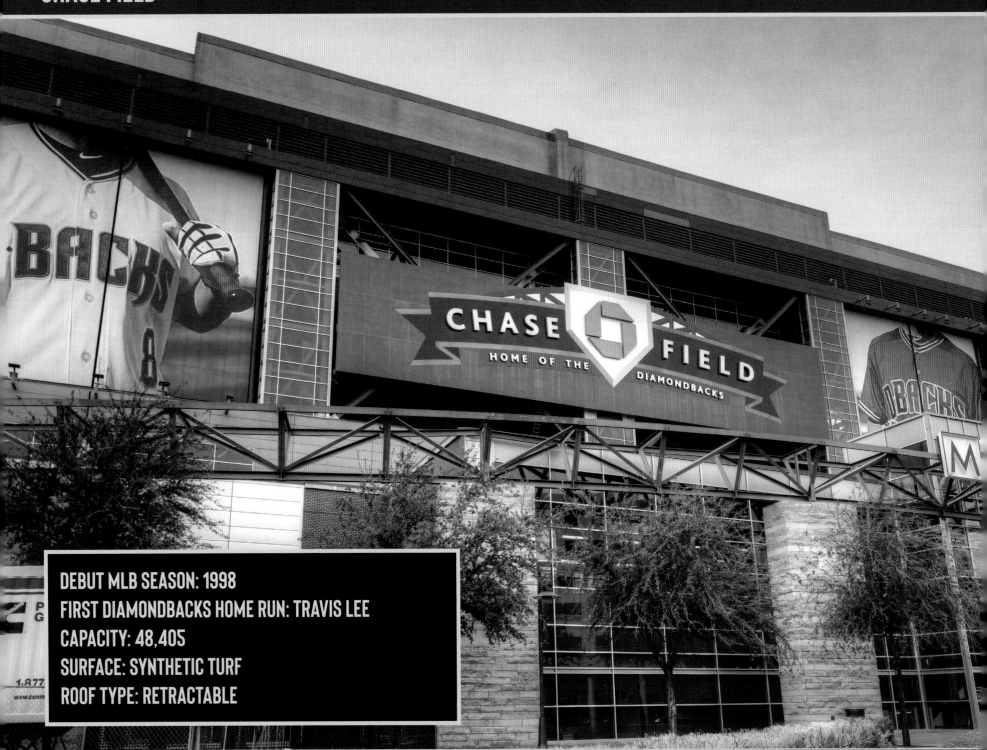

ARIZONA DIAMONDBACKS
CHASE FIELD

DEBUT MLB SEASON: 1998

FIRST DIAMONDBACKS HOME RUN: TRAVIS LEE

CAPACITY: 48,405

SURFACE: SYNTHETIC TURF

ROOF TYPE: RETRACTABLE

At the Arizona Diamondbacks' home, amenities—some might call them distractions—are plentiful: the retractable roof that moves to its own musical tune, a blinding 136-foot-wide scoreboard, and a swimming pool that sits behind the wall in right-center, 415 feet from home plate.

Originally named Bank One Ballpark, or "The BOB," when it first opened, the stadium boasts modern conveniences and engineering feats while simultaneously attempting to reach back into baseball's rich history. Its $354-million price tag (which was footed by taxpayers), however, was ultramodern. Diamondback fans nevertheless embraced the ballpark (which seats over 48,000) and the expansion team when they debuted in 1998. More than one million fans passed through the turnstiles in the stadium's first 22 games. The facility hosted more than three million attendees in both of the franchise's first two seasons.

Like many of the "retro-classic" stadiums, Chase Field was incorporated into its downtown neighborhood. With its red brick and exposed steel, the building fits nicely into the city's historic warehouse district. In fact, the former Arizona Citrus Growers' Packing House is kept in partial use as the ballpark's concession-stand commissary. Colorful murals decorate the exterior.

Inside, the original natural grass and dirt pitcher's path between home plate and the mound were removed (in 2019), and replaced with synthetic turf. The outfield at Chase Field features a mostly symmetrical fence.

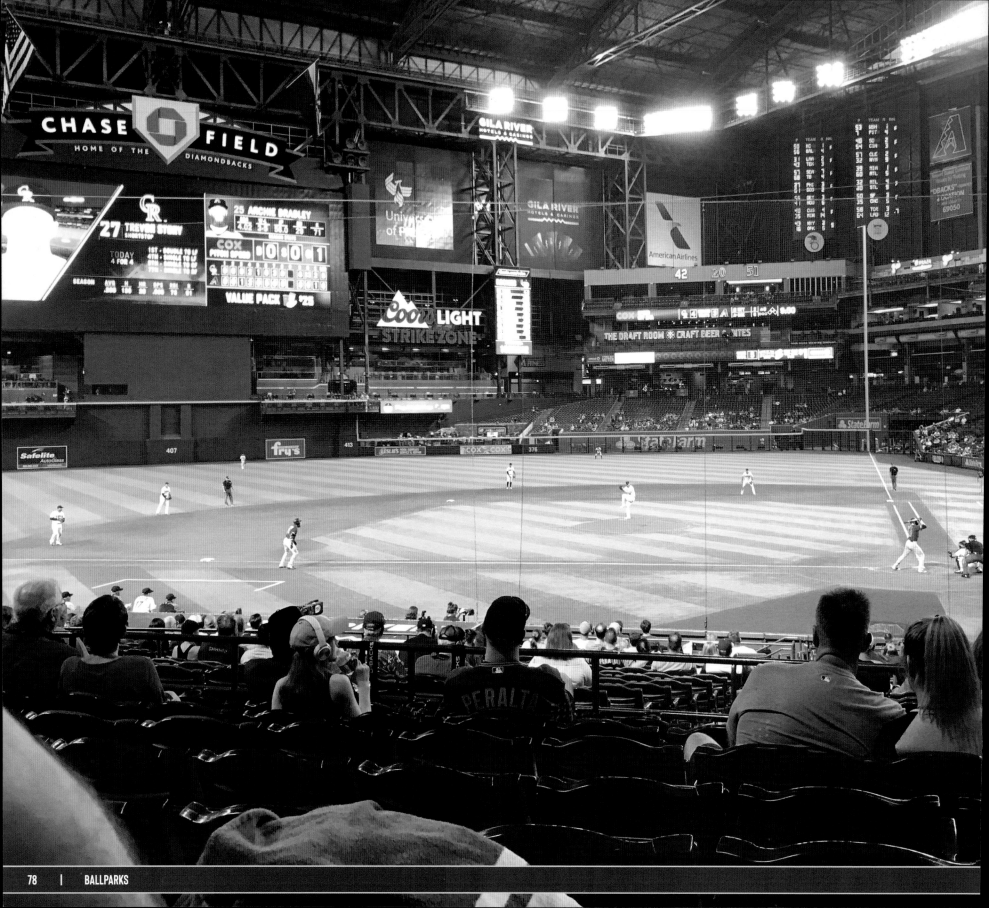

No ballpark built under the blazing Arizona sun would be complete without a roof and air conditioning, both of which Chase Field offers. The nine-million-pound steel roof opens and closes to the sound of music that is timed to accompany the four-and-a-half-minute move. The weather dictates whether the roof remains open or is shut for a game. The ballpark's air-conditioning unit can cool the building in a matter of three hours. This versatility has allowed the park to be used for football, soccer, and basketball, in addition to baseball.

The D-backs found success in Chase Field almost immediately, winning their division in just their second season of play. A World Series title followed in 2001, a year in which the D-backs boasted pitching aces Curt Schilling and Randy Johnson. Arizona became the first team in Series history to rally from a ninth-inning deficit in Game 7 to win the crown without needing extra innings.

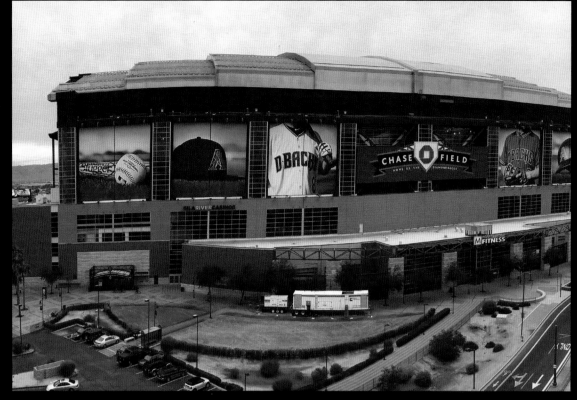

The swimming pool sitting beyond the park's right-center-field fence has room for up to 35 fans to take a refreshing swim for a not-so-refreshing $5,500 a game. A home run hit by Mark Grace of the Cubs was the first to reach the water on the fly on May 12, 1998. On April 3 of that year, however, Diamondback third baseman Matt Williams hit the first "ground-pool double" when his batted ball bounced over the fence and into the three-foot-deep water. Oh, and there's also a hot tub out there.

While the pool gets the majority of the attention, there are other noteworthy diversions at Chase. Located just outside the main gates of Chase Field, the APS Solar Pavilion is an open concourse area with large shading, and room to accommodate 2,000 guests. There is even a gym/fitness center, open to the public, located inside Chase Field.

For youngsters, the Sandlot, located in the upper reaches of left field, is a destination promoting a healthy and active lifestyle. Stop by to visit Baxter's Den, batting cages, a miniature replica of Chase Field, as well as slides, and a baseball glove tunnel.

ATLANTA BRAVES

TRUIST PARK

After just two decades of largely great baseball at Turner Field, the Atlanta Braves moved to the suburbs (technically where Atlanta meets the suburbs in neighboring Cobb County) in 2017. And the new park was greeted with one three-letter word: "Wow."

"I mean, look at that video board. Look at the LED lights, the incredible green grass, this incredibly orange clay," raved former Braves great Chipper Jones on Opening Day at Truist Park. "They watch how balls fly out of here and they see the skyline and everything, and they say, 'Wow.' I said it. Everybody else is going to say it. This is very impressive."

That goes to show that when it comes to the modern-day sports experience, size does not matter nearly as much as ambiance, convenience, proximity to the action and fun, forward thinking that puts the fan first. Truist Park seats just over 41,000 fans—down from the 50,000-seat capacity of Turner Field. Those fans, however, have options that dwarf those at most other parks in the country.

Children can enjoy a rock-climbing wall in an area of the park that also includes a zip line. Grown-ups can watch the game and socialize at the three-story Chop House bar, where one of the craft beers available has been aged with actual wood from Mizuno baseball bats.

Those with a taste for art can eye some 300 pieces of Braves-themed art around the stadium, including a statue of former manager Bobby Cox and a magnificent, nine-foot photo of Hank Aaron hitting his then-record-breaking 715th career home run.

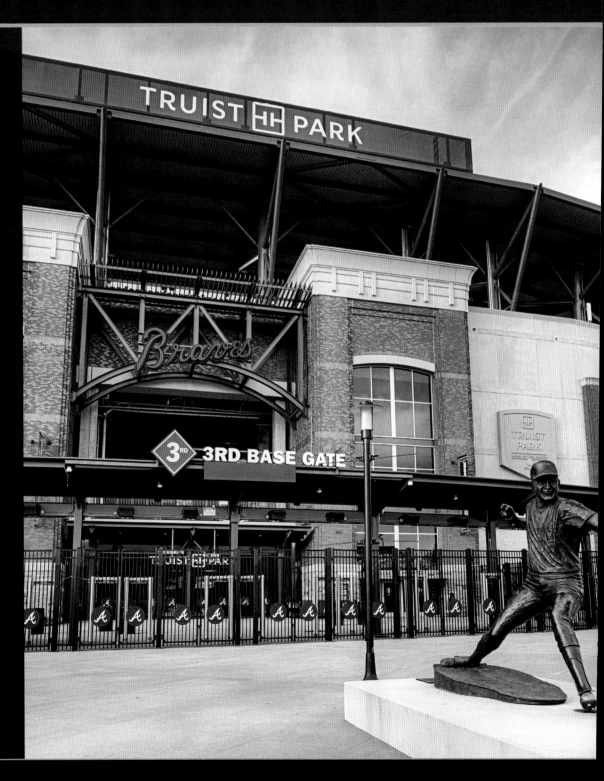

DEBUT MLB SEASON: 2017
FIRST BRAVES HOME RUN: ENDER INCIARTE
CAPACITY: 41,084
SURFACE: GRASS
ROOF TYPE: OPEN

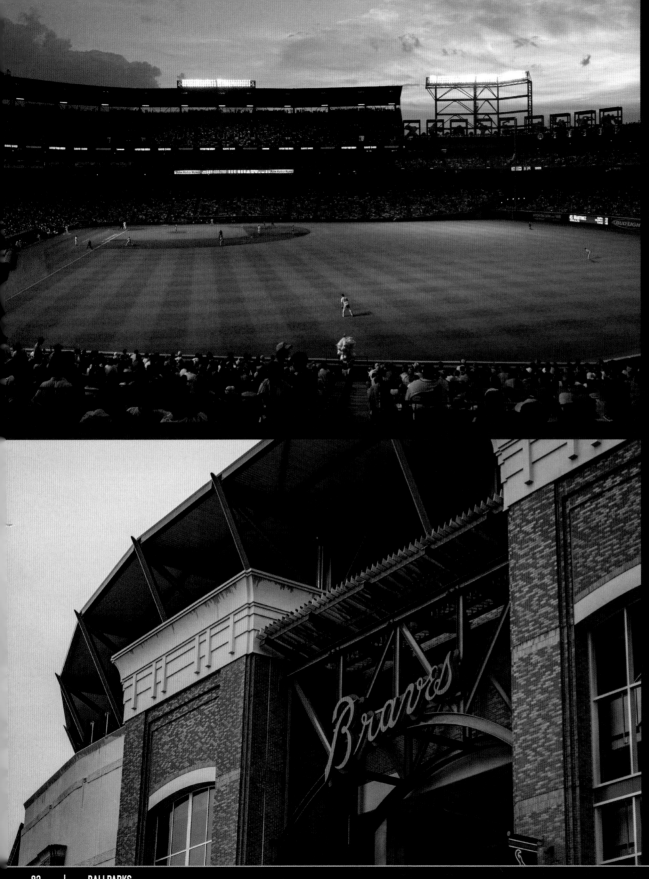

"I'd like to welcome you to baseball's newest gem," major league commissioner Rob Manfred told fans on Opening Day—a crowd that included Jones, Cox, Aaron, Tom Glavine, Dale Murphy, Phil Niekro, John Smoltz and former President Jimmy Carter.

The Braves played at Atlanta-Fulton County Stadium from 1966-96 before moving to downtown Turner Field, where they won 100 or more games in five of their first seven seasons. However, Braves president John Schuerholz announced in 2013 that the team would be relocating, citing "hundreds of millions of dollars" in needed renovations to Turner Field. Around the same time, city money was being funneled toward a downtown stadium for the city's NFL and MLS teams. The result was Mercedes Benz Stadium, which opened in 2017. Thus, the Braves looked outside of town, and—thanks largely to about $400 million in supporting public funds— wound up with a solution that resulted in Cobb County hosting not only the team, but a unique surrounding area that was still growing as the Braves were getting used to their new stadium.

Truist Park is located within a neighborhood called The Battery. The Braves tout it as "the first of its kind—a destination that will simultaneously build and integrate a state-of-the-art Major League Baseball ballpark with a multiuse development and community." It features housing, restaurants, retail stores and a 4,000-seat live music venue— plenty to keep fans entertained before or after ballgames.

"The secret sauce of what's going on here is the synergy between The Battery and Truist Park," Braves chairman and CEO Terry McGuirk said midway through the team's first season at Truist, with attendance up about 37 percent compared with that point during their final year at Turner Field. "We think it has succeeded brilliantly."

It's once fans are inside the park, though, that the fun truly begins. The right field corner of the venue is a party from start to finish, with rooftop cabanas featuring ping-pong tables, foosball and other games, along with a Waffle House restaurant.

The "batter's eye" area just beyond the center-field wall features three evergreen trees. The area includes boulders and a water feature nicknamed "Chattahoochee Falls." Undoubtedly inspired by a similar setup at Coors Field, a fountain shoots streams of water 50 feet into the air, toward the main video board, from the upper pond. The feature comes alive after Braves home runs and wins.

The cost of the entire project, including The Battery, is estimated to have topped $1 billion. Based on early reviews, the fans seem to be getting their money's worth from a trip to the park.

"It's a lot more intimate," Braves first baseman Freddie Freeman said, comparing Truist Park to Turner Field. "When you're out there playing, it feels like the fans are kind of right on you, which at Turner Field, it was more relaxed. They were pushed back a little bit more. It's going to be a better experience for the fans and obviously for us, too."

Asked to name his favorite feature of the new park, Freeman did not hesitate. "375 to right-center," he said. The wall in that power alley is 15 feet closer to home plate than it was at Turner Field. Other than that, the dimensions are similar, so time will tell if Truist develops a reputation as a pitcher's park—like Turner Field was—or a hitter's haven like Fulton County Stadium. Chances are the numbers will place it somewhere in between.

In terms of fan experience, there is nothing "in between" about Truist. Lead designer Joe Spear said baseball has been very responsive in addressing the things patrons want—great sightlines, food and beverage options, and opportunities to enjoy a game even when out of their seats. To the latter end, Truist features several gathering spaces where fans can socialize while taking in the action. The Xfinity Rooftop above right field, the Hank Aaron Terrace in left, the Home Depot Clubhouse beyond left-center and the State Farm Deck below the main video board join the Chop House as hot spots for that purpose. "Below the Chop" puts fans almost in the right fielder's back pocket.

"You can have a conversation with the right fielder," Spear said. "He's going to be right there. You can hassle him if you want or cheer him if you want."

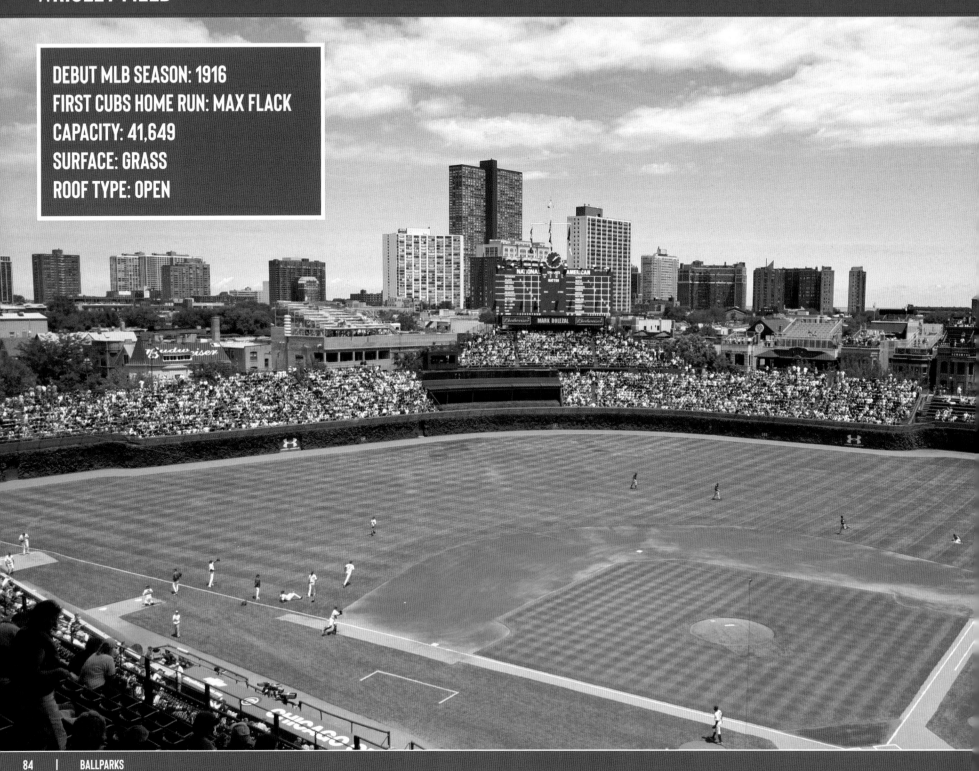

WRIGLEY FIELD

DEBUT MLB SEASON: 1916
FIRST CUBS HOME RUN: MAX FLACK
CAPACITY: 41,649
SURFACE: GRASS
ROOF TYPE: OPEN

"Lucky Charlie" Weeghman didn't yet own the Chicago Cubs when he built the ballpark at Clark and Addison on the city's yet-to-be-developed North Side. He named the stadium after himself, and Weeghman Park opened in 1914 to host his Chicago Chi-Feds, an entry in the fledgling Federal League. The park was originally a single-deck affair that sat 14,000 fans, cost $250,000, and featured a beautiful pasture of lush Merion bluegrass. While the Chi-Feds (becoming the Whales for the 1915 season) thrived, at times outdrawing Chicago's Cubs and White Sox, the league didn't—it died after two seasons, taking "Lucky Charlie's" team with it.

After his failed venture with the Whales, Weeghman purchased the Cubs and relocated the franchise from the ancient West Side Park for the 1916 season.

Weeghman strove to make baseball fan-friendly. We have him to thank for the tradition of allowing fans to keep souvenir foul balls and for concession stands. Weeghman's dance with lady luck ended in 1918, the same year the Cubs won the pennant in a season shortened by World War I. Struck by financial disaster, he sold the club to William Wrigley Jr., heir to the Wrigley chewing-gum fortune.

Wrigley saw to a seating expansion of the park—he cut the grandstand, put half on rollers to move it, and filled the gap with more grandstands. He moved the entire playing field to the southwest, added an upper deck, and finally, in 1926, changed the park's name to "Wrigley Field."

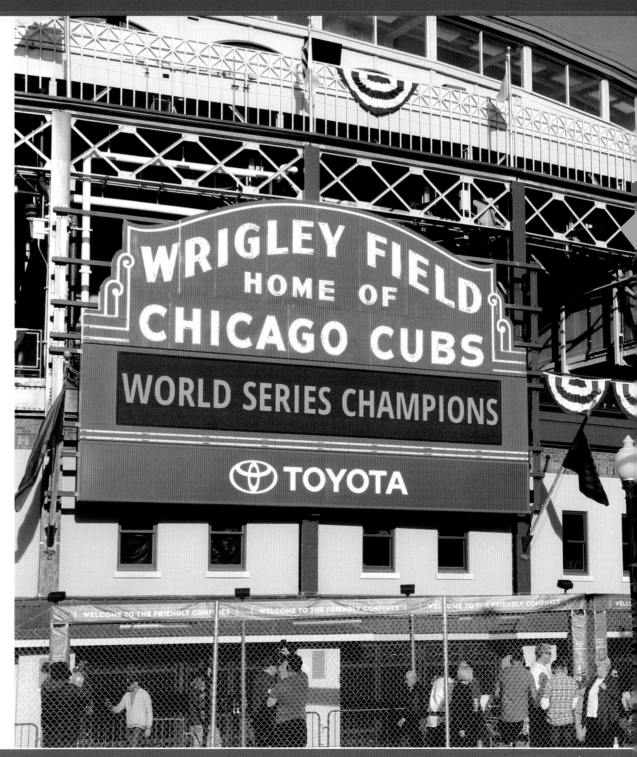

Cub fans had World Series games to attend in 1929 and witnessed the historic 1932 Fall Classic, in which Babe Ruth is said to have pointed to the center-field bleachers, promising to smack a homer off Cubs pitcher Charlie Root. The Bambino delivered.

P. K. Wrigley took over for his father in 1932. The young Wrigley had some help from an up-and-coming baseball executive named Bill Veeck Jr. Wrigley Field's fabled bleachers came to life in 1937, along with the Boston ivy that still covers its brick outfield walls.

The bright-green manually operated scoreboard, which still posts numbers today, also made its debut in 1937, towering 85 feet above the field and atop the center-field bleachers. At the time, Wrigley fans were the only to track the scores of games from other cities. In 1941, organ music sounded Cub rallies for the first time.

A group of ten "Bleacher Bums" made their first appearance in 1966. They quickly grew into thousands. Although Chicago's rowdier side had revealed itself in the bleachers for decades, this collection of die-hards made its mark with acrimony, vigor, and humor. It wasn't long before Wrigley bleacher-dwellers began the tradition of throwing opponents' home runs back onto the field.

One amenity that didn't come to Wrigley Field at the time was lights. It wasn't until 1988 that Cubs brass and their tradition-minded fan base relented and allowed lights to be installed.

When the Ricketts family took ownership of the Cubs in 2009 they were fully aware the aging beauty at Clark and Addison needed extensive structural repair and updating. The 1060 Project, which started following the 2014 baseball season, included structural upgrades, improved player facilities, fan amenities, outfield signage, two outfield video boards, premier clubs, an upper-level outdoor concourse, expanded concessions, improved restroom facilities, and improved connectivity and Wi-Fi services.

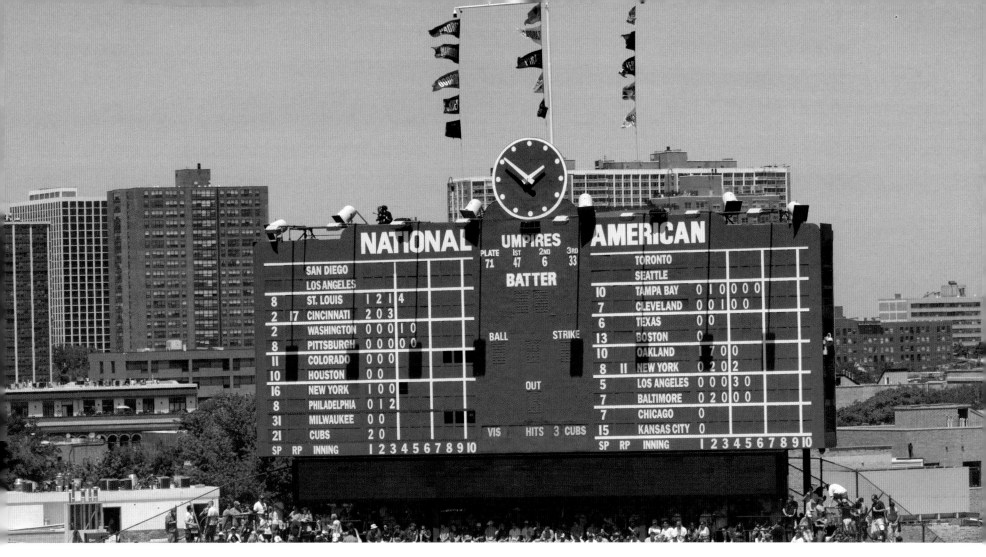

Fans embraced their celebrated status as "Loveable Losers," reveled in "Take Me Out to the Ballgame" renditions and jubilantly sang "Go Cubs Go" for years, but were long overdue for a celebration by 2016. Emerging victorious in one of the most epic World Series Game 7s in history, generations of Cubs fans hardly knew what to do when their 108-year drought ended in a championship.

Renovations to Wrigley and the "Wrigleyville" neighborhood around it have changed the landscape to a large extent. But the Wrigley Field experience retains the feeling of walking into a Rockwell drawing, back to simple worries and American dreams—all in the shadow of a 2016 championship banner.

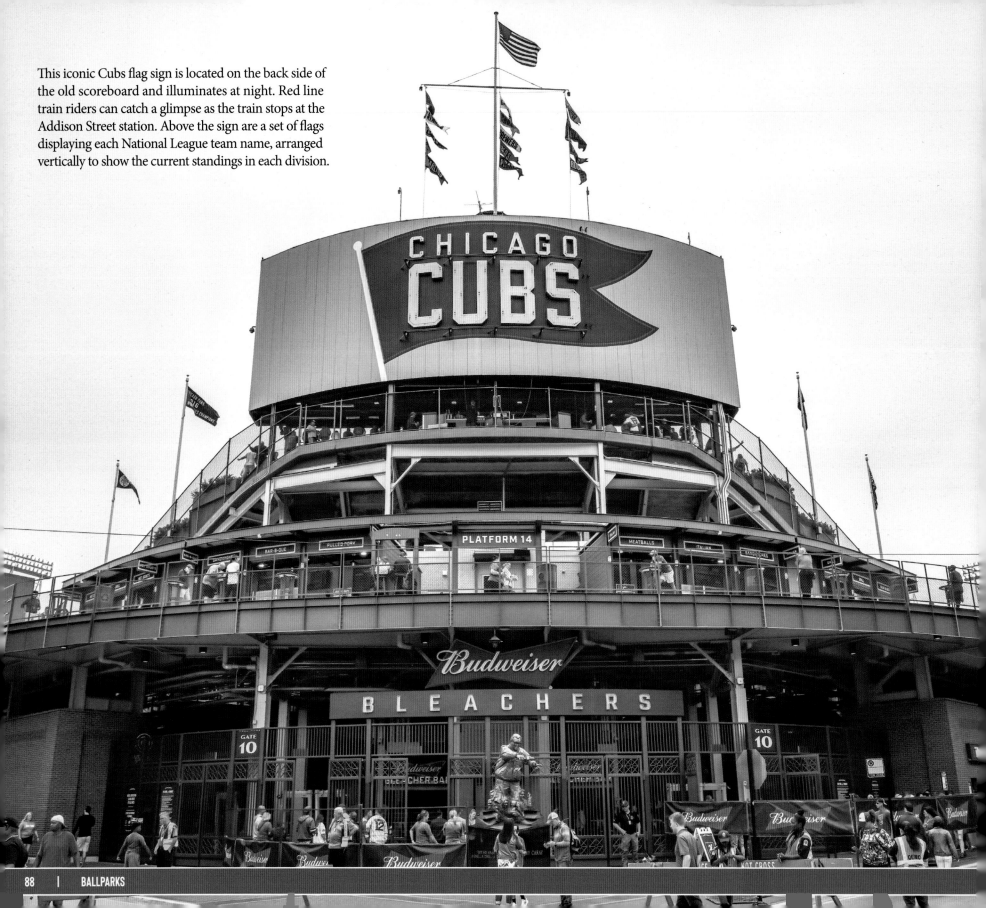

This iconic Cubs flag sign is located on the back side of the old scoreboard and illuminates at night. Red line train riders can catch a glimpse as the train stops at the Addison Street station. Above the sign are a set of flags displaying each National League team name, arranged vertically to show the current standings in each division.

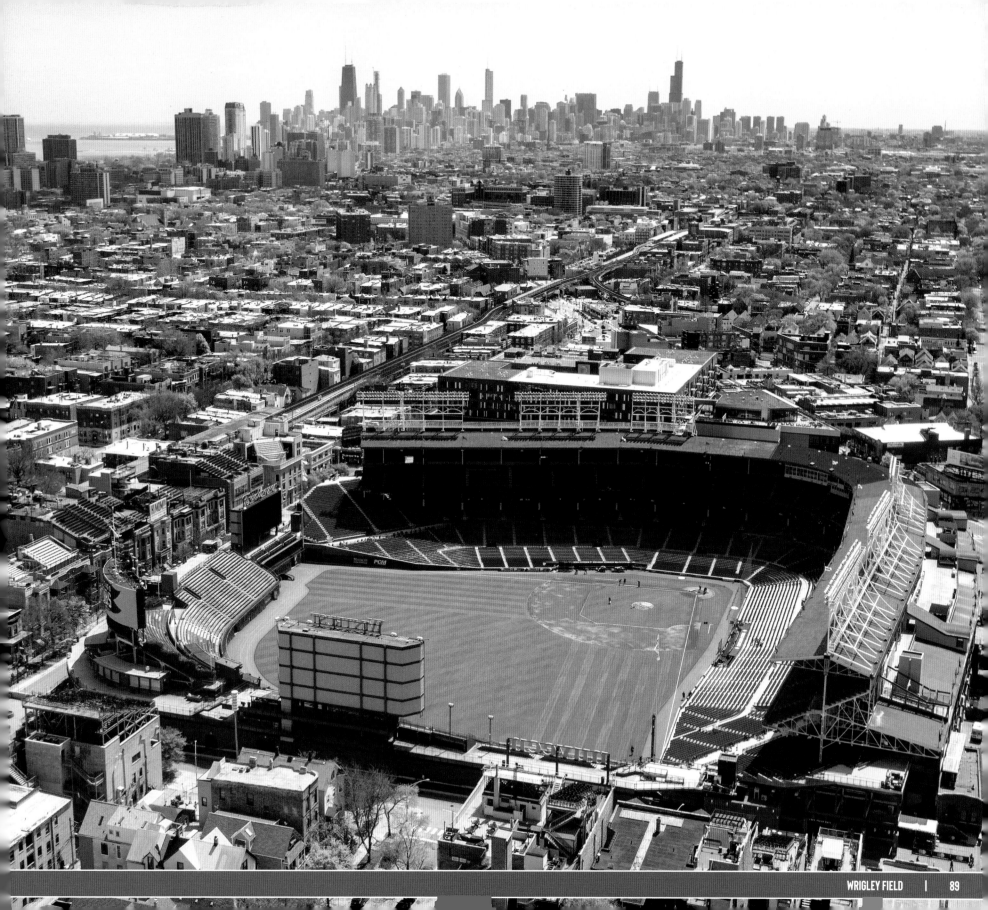

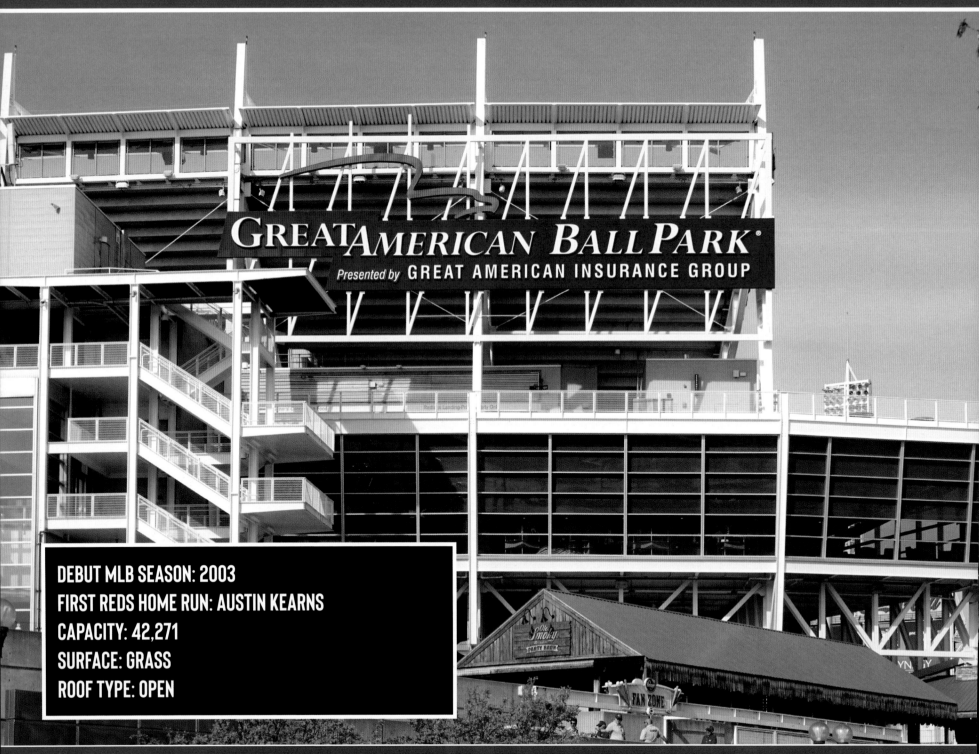

CINCINNATI REDS
GREAT AMERICAN BALL PARK

DEBUT MLB SEASON: 2003
FIRST REDS HOME RUN: AUSTIN KEARNS
CAPACITY: 42,271
SURFACE: GRASS
ROOF TYPE: OPEN

For 17 summers, Reds captain Barry Larkin, a native Cincinnatian, toiled on the often-blistering artificial turf that was rolled over the concrete of Riverfront Stadium. This hardship was over, finally, when Cincinnati's Great American Ball Park opened on March 31, 2003. "This ballpark is beautiful," Larkin gushed like a rookie to *The Cincinnati Enquirer*. "There's definitely some character here."

Compared to the faceless round concrete slab that was Riverfront Stadium, Great American Ball Park was a welcome sight. It wasn't easy, though—building the new field was a ten-year trek from conception to first pitch.

Both the Reds and the NFL's Bengals sought a divorce from Riverfront provided they could secure separate sport-specific venues. Ultimately, Queen City citizens made the Reds' baseball-only gem a reality, first by agreeing to pay for it through taxes and then by ensuring its idyllic location on the banks of the Ohio River, where it stands along Sawyer Point and Yeatman's Cove as the centerpiece of an ambitious economic-development plan for the downtown area.

In many ways, Great American Ball Park's design borrows from Crosley Field. Unlike the simple Crosley, however, Great American came with a $280-million price tag and seating for just over 42,000. Fans and players alike loved the new facility, but some critics claimed that it tried too hard to satisfy too many.

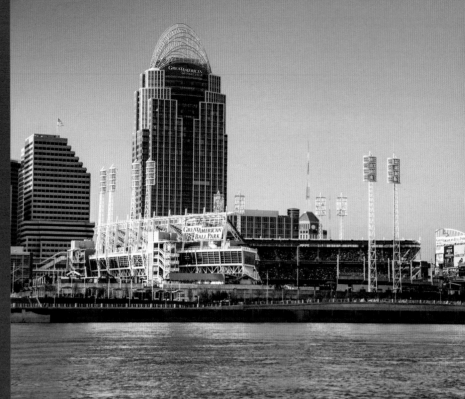

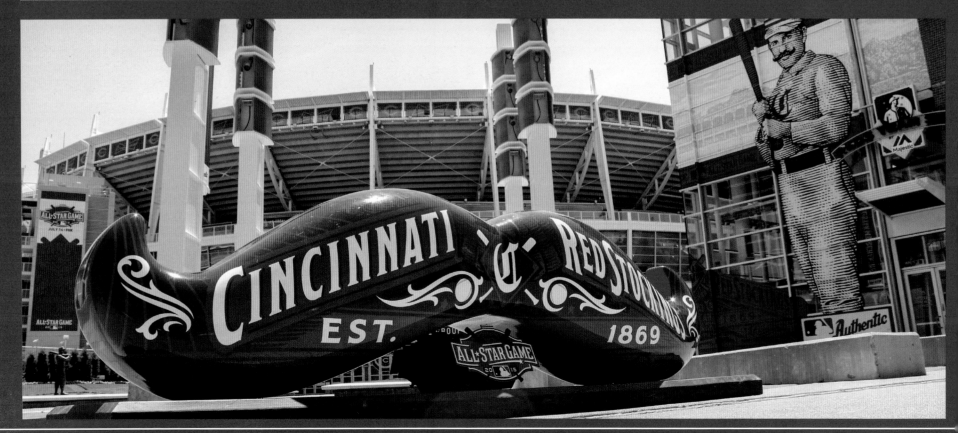

Real grass—five varieties of perennial ryegrass—is grown on site. Exposed white steel contrasts nicely with the sweep of red seats. A dozen toothbrush-shape steel-supported light towers dot the ballpark. Mosaics recognizing the 1869 Reds (baseball's first professional team) and the mighty Big Red Machine of the 1970s greet spectators at the main gate. In right field, an isolated bleacher section sits near the park's most unique features: a pair of riverboat smokestacks that fire for Cincinnati home runs and two steel light towers that evoke memories of Crosley Field.

Reds history is prominently featured throughout the ballpark. Crosley Terrace features statues of Ted Kluszewski, Ernie Lombardi, Joe Nuxhall, and Frank Robinson. Banners that hang all around salute historic moments.

The new park's playing dimensions are intentionally similar to those of Crosley. Like Crosley, for example, Great American has a 12-foot wall in left field that sits 328 feet from home plate. Beyond the fence is the park's 68-foot high scoreboard, which is topped by a clock that recalls the one at Crosley.

A "black-glass box" in Great American's center field, 404 feet from home, serves as a batter's background but also holds a party room. In right, an eight-foot wall stands 325 feet from home plate; it is as short a porch as is allowed by Major League Baseball. Sluggers found a paradise, while fantasy baseball enthusiasts quickly learned to avoid Cincy pitchers. "I'd love to hit in this ballpark," Reds legend Johnny Bench said.

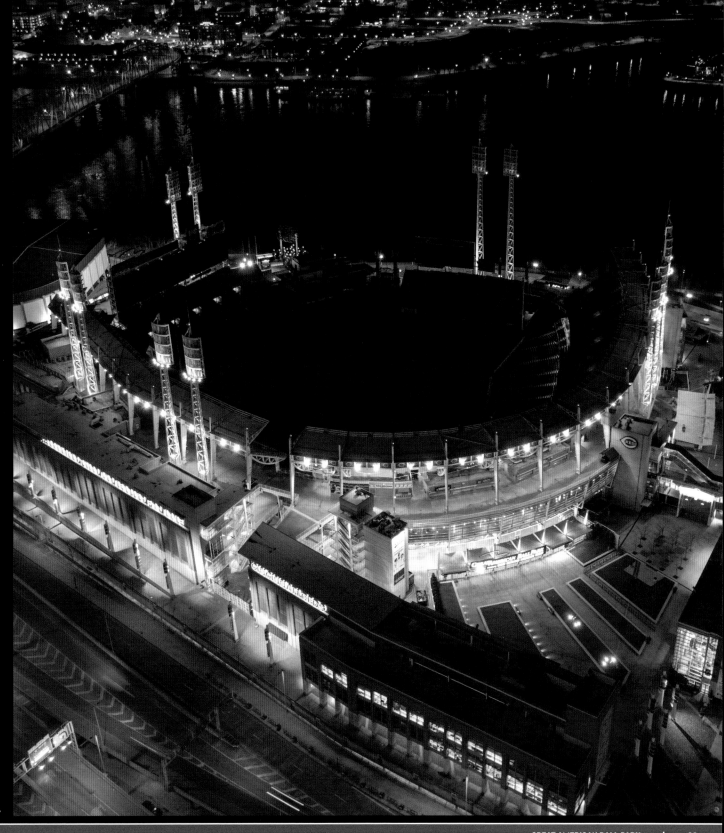

On the west side of Great American Ball Park you'll find the Reds Hall of Fame, the biggest team Hall of Fame in baseball with 89 members. In 2018, Adam Dunn, Dave Bristol and Fred Norman became the most recent class of inductees.

Making its debut in 2021, the TriHealth Family Zone is a can't-miss destination for families at Great American Ball Park. This area in the right field corner features activities for kids, a nursing suite, a lounge area with spectacular views of the Ohio River, and more. Visit the slides in the playground, swing for the fences in the batting cages, or if your child is so inclined, enjoy a peaceful time in the reading room.

Save for the 1966 and 1990 seasons, Cincinnati has hosted each Opening Day. In 1966, three straight rainouts forced the Reds to open on the road; in 1990, a lockout delayed the start of the season, so the Reds opened the campaign in Houston. Opening Day is a holiday in the Queen City. A parade—featuring bands, floats, and fireworks—seems to have always been a part of the attraction. Beginning in 1920, the annual event started at Findlay Market. In the late 1980s, during owner Marge Schott's era, zoo animals became part of the celebration. The parade was canceled in 2020 and 2021 because of the COVID-19 pandemic.

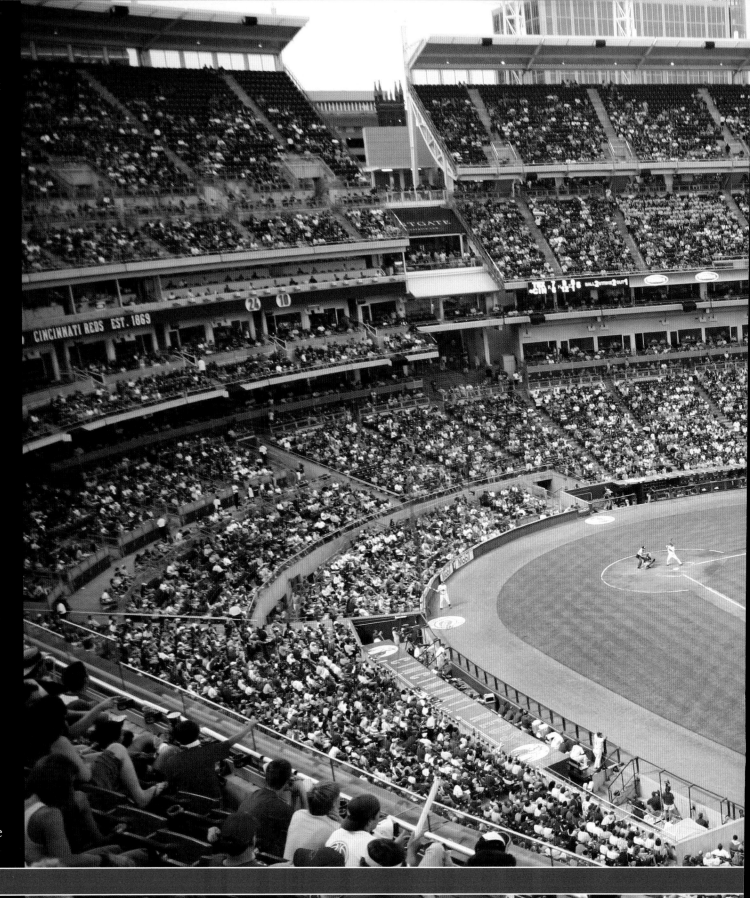

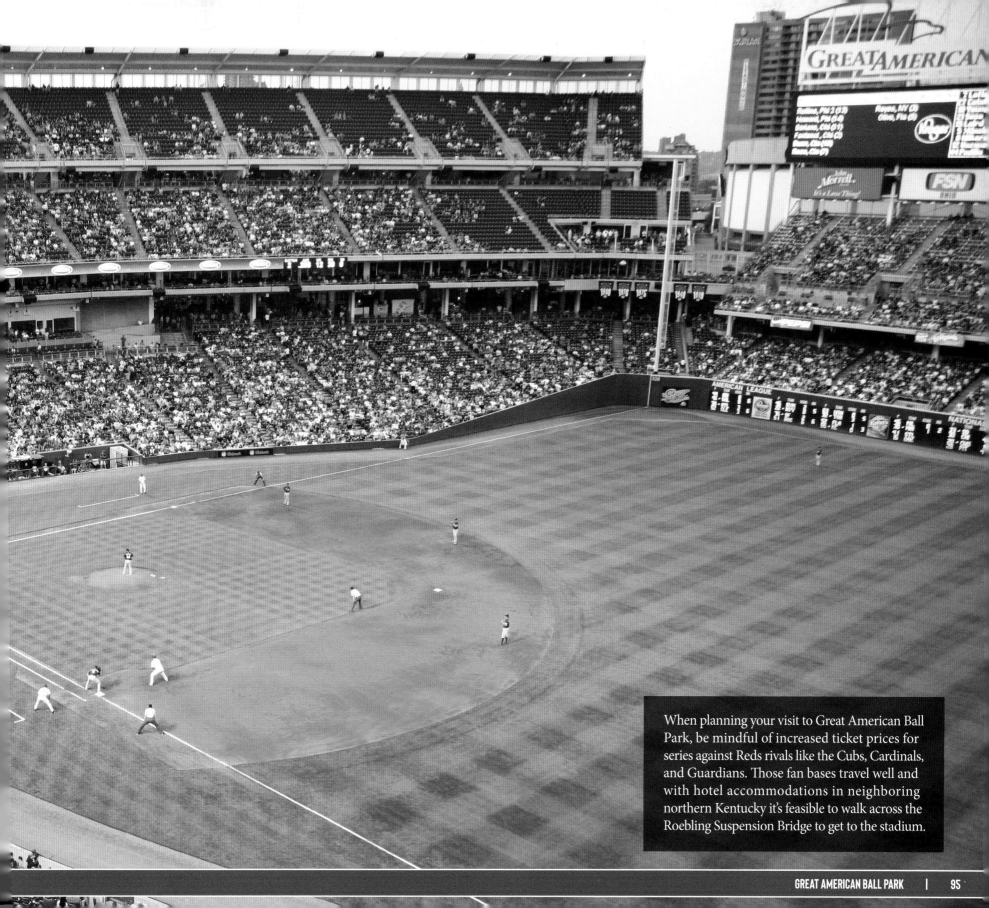

When planning your visit to Great American Ball Park, be mindful of increased ticket prices for series against Reds rivals like the Cubs, Cardinals, and Guardians. Those fan bases travel well and with hotel accommodations in neighboring northern Kentucky it's feasible to walk across the Roebling Suspension Bridge to get to the stadium.

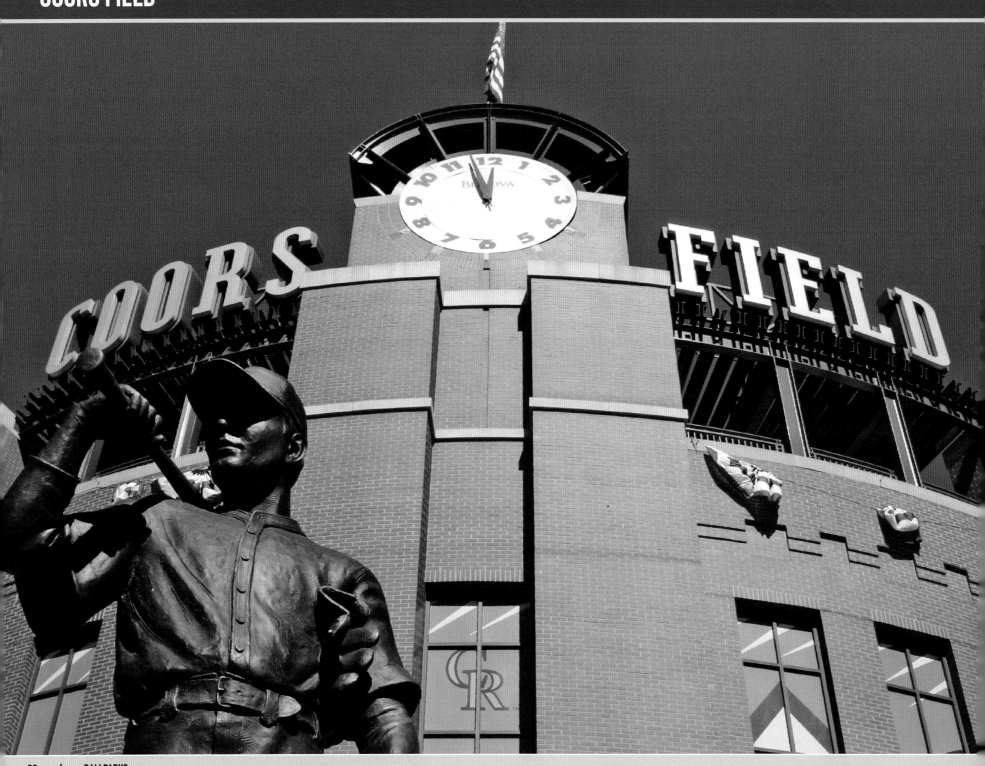

COLORADO ROCKIES
COORS FIELD

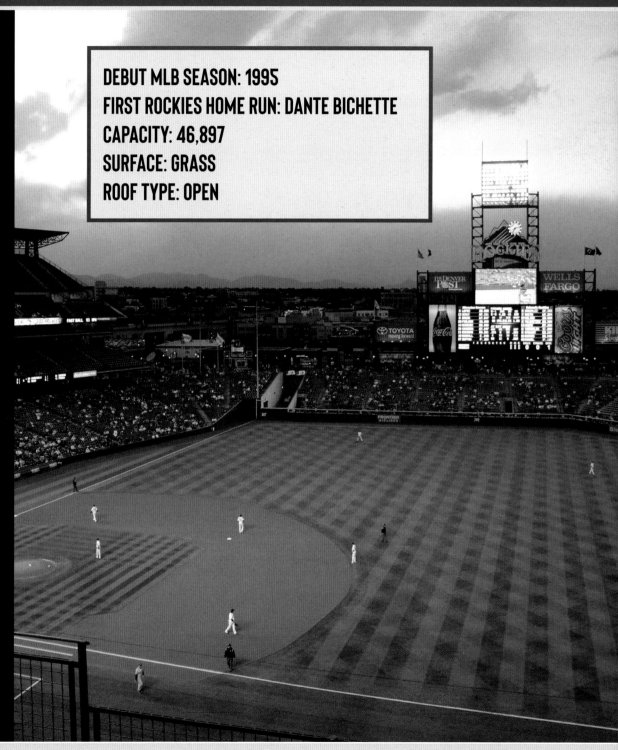

DEBUT MLB SEASON: 1995
FIRST ROCKIES HOME RUN: DANTE BICHETTE
CAPACITY: 46,897
SURFACE: GRASS
ROOF TYPE: OPEN

Pitchers have come to embrace the one area of Coors Field where it's always a pleasant 70 degrees: the humidor. Hurlers can thank the boots of Tony Cowell for this nerve-calming, ERA-saving space. We all know why Denver is called the Mile High City, and we've learned what thin air in high altitude does (or doesn't do) to a flying baseball—it's a hitter's heaven, a pitcher's pain.

It took just three innings before the first home run sailed out of Coors Field after it opened in 1995. The dingers didn't stop. One season, teams combined to average 15 runs a game there while knocking 303 four-baggers in 81 games. Ordinary hitters became Ruthian while pitchers ducked for cover.

Enter Cowell, a Rockies engineer, who happened to notice the effect that Denver's low humidity had on his leather hunting boots, which had become tight and dry. If the air affected his boots, he thought, imagine what it must do to baseballs. Pitchers at Coors also complained of balls that were cold and difficult to grip. With this in mind, major-league baseball's first humidor was installed in 2002 at Coors Field. The climate-controlled shed with 50 percent humidity can store 576 baseballs and is considered a Colorado-bound pitcher's best friend.

An expansion team that began play in 1993, the Colorado Rockies played their first two seasons at Mile High Stadium, which they shared with the NFL's Broncos. The Rockies' attendance was mind-boggling— nearly 4.5 million came out that first season. As a result, planners of Coors Field expanded seating by more than six thousand before it opened, giving the ballpark room for more than 50,000 fans.

Coors opened on April 26, 1995, in the city's historic downtown "LoDo" neighborhood, which is filled with 19th-century brick structures. The ballpark fit right in. Its facade is comprised of both terra-cotta tile and exposed steel and red brick.

The stadium is topped by a classic clock tower, but it also bears amenities typical of the modern era, including more than 4,500 club-level seats, 63 luxury suites, a restaurant and brewery, a children's play area, and batting cages.

Seats along the first-base line offer spectacular views of the Rocky Mountains. Water fountains beyond the outfield fence erupt after home runs. "The Rockpile," a set of 2,300 bleacher seats, is perched above the center-field backdrop. And to remind everyone of the thin air, a row of purple seats extends around the upper deck to mark the exact point at which the park is one mile above sea level.

The SandLot Brewery has been a Coors Field staple since opening in 1995, along with the stadium. You can enjoy their award-winning beers in the taproom during any Colorado Rockies home game. Perhaps you'll recognize a certain Belgian-style wheat beer that was invented there, Blue Moon. It's now produced by Coors who signed a lease agreement in 2017 to remain the stadium's namesake through at least 2047.

In their first year at Coors, the Rockies qualified for the playoffs for the first time. In 2007, five years after the humidor began softening baseballs, the Rockies battled into the World Series. Since then, they've reached the wild card twice, but failed to win a single game in their division series in 2018.

THE PLAYER

"IT IS NOT THE HONOR THAT YOU TAKE WITH YOU BUT THE HERITAGE YOU LEAVE BEHIND."
~ BRANCH RICKEY

PLACED HERE BY THE ROTARY CLUB OF DENVER
JUNE 2, 2005

GEORGE LUNDEEN SCULPTOR

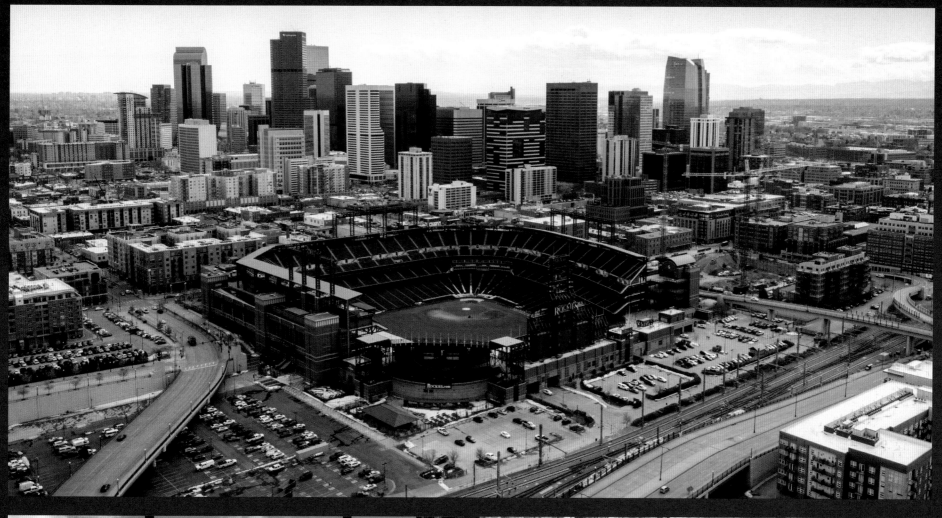

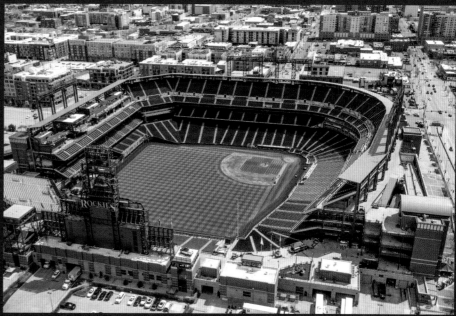

LOS ANGELES DODGERS

DODGER STADIUM

DEBUT MLB SEASON: 1962

FIRST DODGERS HOME RUN: JIM GILLIAM

CAPACITY: 56,000

SURFACE: GRASS

ROOF TYPE: OPEN

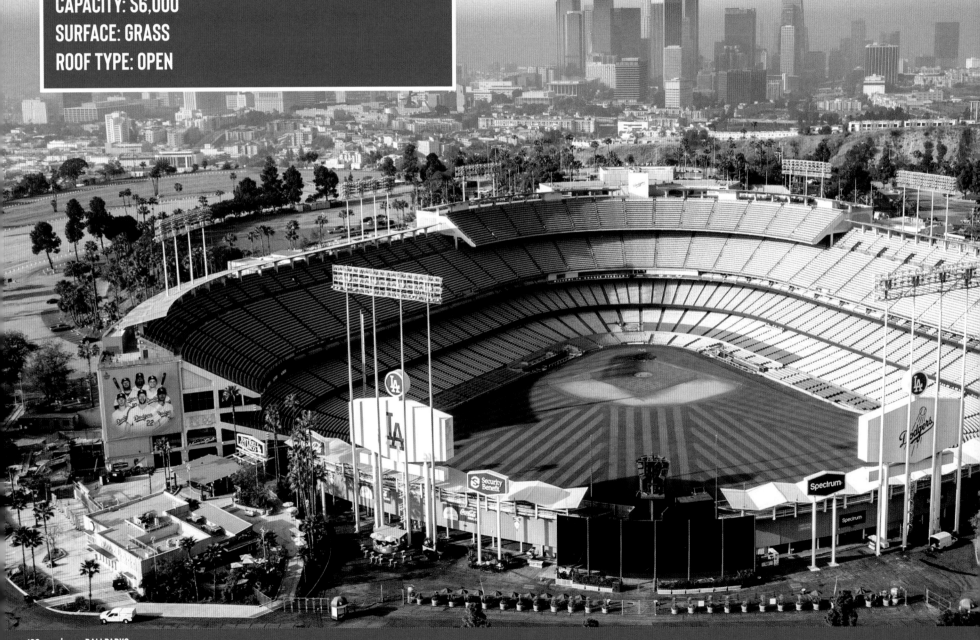

Walter O'Malley's goal for his Los Angeles ballpark was rather simple: "I want to build the perfect park," the Dodgers owner asserted. Over 60 years later, Dodger Stadium remains pristine—an enduring, fan-friendly ballpark that has been left largely untouched since its gates opened in 1962. It is baseball's third-oldest ballpark (behind Fenway Park and Wrigley Field), but it remains exactly what O'Malley envisioned decades ago. O'Malley was scouting Southern California locations for his ballpark from inside a helicopter when he spotted the perfect swath. Amid meager houses—with children, dogs, and goats running loose—he found his diamond in the rough hills of an area nicknamed "Chavez Ravine."

O'Malley nearly went broke acquiring the 315 acres of real estate—Dodger Stadium was, after all, the first privately financed park since Yankee Stadium. Its price tag was at least $23 million, but "Taj O'Malley," as the facility has been called, exceeded even its owner's expectations.

In the 1950s, America's love affair with the automobile was in full swing. More and more highways were paved as Americans headed for the suburbs. O'Malley recognized this shift—his ballpark was built with its customers in mind, featuring easy highway access, nearby parking for 16,000 cars, wide concourses, and open concession stands that offer Dodger Dogs and views of the diamond. There is nary a bad spot in the 56,000-seat venue.

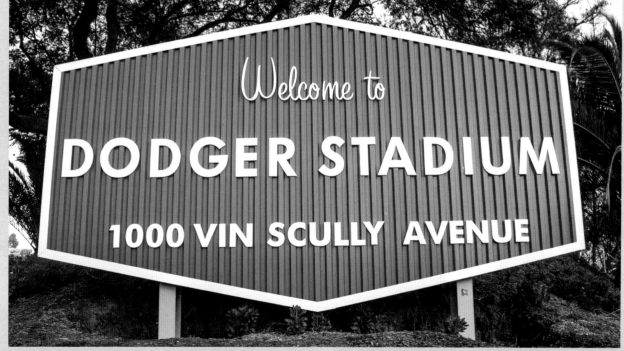

Dodger Stadium presents views of mountain peaks and palm trees beyond center field and a wave of pastel seats that unfurl over five decks. Often known as baseball's cleanest park, Dodger Stadium is meticulously washed and freshly painted every off-season. But it wasn't exactly perfect that first season: The foul poles were askew and completely in foul territory, and drinking fountains were somehow left out of the design.

Dodgers fans passed through the turnstiles to the tune of 2.7 million attendees that first season, and the team returned the favor on the diamond. After finishing second in the NL in 1962, the Dodgers swept the Yankees in the World Series in 1963. Manager Walter Alston's team was built on pitching, speed, and defense, taking full advantage of Dodger Stadium's deep symmetrical outfield.

Dodger Stadium's prestige only grew as more pennants and record-shattering attendance followed in ensuing years. O'Malley turned over daily operations of the team to his son, Peter, just before the 1970 season, but he stayed on as chairman until his death nine years later. Both former owner Frank McCourt and current ownership group Guggenheim Baseball Management launched massive renovation projects that have spiffed up the stadium, including the unveiling of hexagonal video boards in 2013.

Other fun changes in recent years have included the addition of a play area for kids as well as oversized bobble heads and replica World Series rings in left and right fields. Seating was added overlooking both bullpens, allowing fans a chance to watch their favorite pitchers warm up. There are multiple team stores, cap stands, and kiosks around the park selling exclusive items only available at Dodger Stadium, as well as game used memorabilia.

The team's rich history is celebrated throughout the park. Notable spots include: the "Legends of Dodger Baseball" plaques—along with a new statue of Sandy Koufax—in the center field plaza, a bronze statue depicting Jackie Robinson sliding into home, the "Kirk Gibson Home Run Seat," giant bobbleheads of former Dodger greats, as well as actual World Series trophies, gold glove awards, MVP awards, and so much more.

Having hosted millions of fans since opening in 1962, Dodger Stadium achieved a franchise record for single-season attendance in 2019, topping the 3.97 million mark.

Welcome to Dodger Stadium!

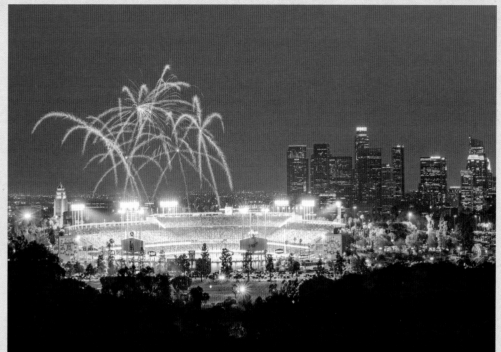

MIAMI MARLINS
LOANDEPOT PARK

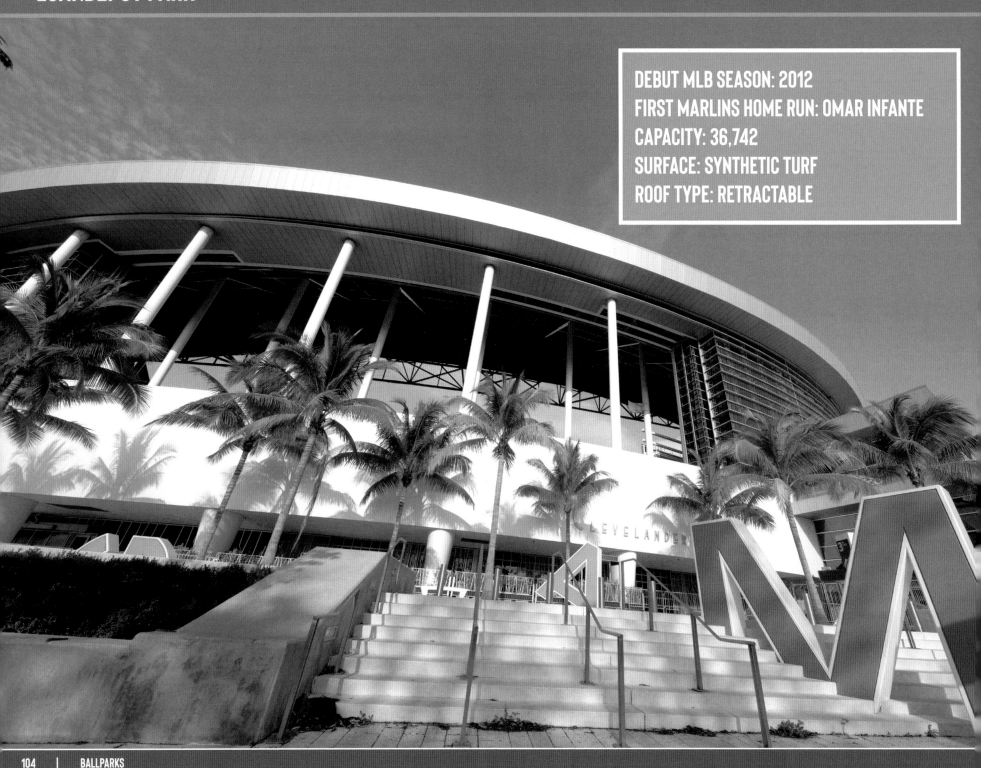

DEBUT MLB SEASON: 2012
FIRST MARLINS HOME RUN: OMAR INFANTE
CAPACITY: 36,742
SURFACE: SYNTHETIC TURF
ROOF TYPE: RETRACTABLE

A "surprise" storm while the retractable roof was agape on Opening Day 2015 soaked the field before a game against the Braves, forcing the first rain delay in the brief history of Marlins Park. It lasted just 16 minutes until the roof was closed, but it had Miami Marlins owner Jeffrey Loria sitting in disbelief with his head in his hands. "I thought we had a roof," Loria quipped to his club president, David Samson.

They do, of course, have a roof. And an impressive decade-old stadium that includes aquariums behind home plate, a bobblehead museum, free Wi-Fi and some of the best food choices in the Majors—among other amenities. The park, resembling some kind of space-age cruise ship on the former site of the Orange Bowl in the Little Havana neighborhood, cannot remove the human error of misreading the weather radar on one particular Opening Day.

Even when the roof is closed—the norm in the sweltering South Florida summer—there are stunning views of the Miami skyline through 60-foot-tall windows. Two 450-gallon aquariums provide a distinct Miami flair, as does a tribute to the Orange Bowl that includes reproductions of that stadium's old letters. A 360-degree promenade level ensures that fans never have to miss a pitch, even while ordering ceviche, a Cuban sandwich, or a plate of tacos.

The team's old home, Sun Life Stadium, formerly Joe Robbie Stadium, was primarily a football venue. It was adjusted to support baseball in time for the Marlins' arrival as an expansion team in 1993, but it was never going to compete with the new, state-of-the-art, "retro-feeling," baseball-only parks that would spring open to rave reviews in cities like Cleveland, Seattle, Pittsburgh, and many others in the late 1990s and early 2000s.

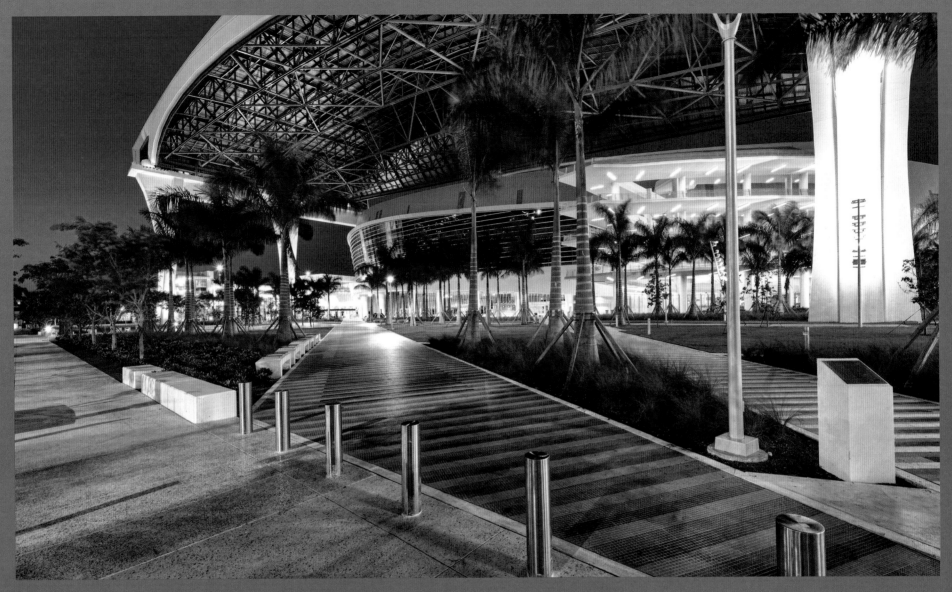

In fact, Major League Baseball took it a giant step further. Not only was Sun Life less than ideal as a baseball venue; according to the powers-that-be, it needed to be replaced or Miami risked losing its team. A battle ensued over funding until the parties came to an agreement in 2007. The $634 million project—$515 million for the stadium itself—was funded mostly with taxpayer money, with the Marlins also kicking in more than $150 million.

Building was delayed by a lawsuit challenging the public funding. Finally, after 33 months of construction, the Marlins celebrated the grand opening on April 4, 2012, with a loss to the St. Louis Cardinals. The park's capacity of 37,000 is among the smallest in the Majors. But with the trouble the team has had drawing fans over the years, "cozy" suits the franchise just fine.

Inside the intimate venue is state-of-the-art, from its eco-friendly retractable roof to its massive, high-definition scoreboards, it is also a showcase for art—actual art. LoanDepot Park doubles as an art museum of sorts. Loria is an avid art collector and dealer, and it shows in the décor. World-renowned artists have their paintings and sculptures displayed around the stadium—a nod to the area's Art in Public Places program.

The pièce de résistance, so to speak, sits just left of center field and has polarized fans like few other spectacles in baseball. It's a $2.5 million sculpture by well-known pop artist Red Grooms. It lights up and springs into motion every time a Marlins player socks a home run. Marlins fly, other fish bob in the water, and seagulls soar around the sun in a display

unlike any other home run tradition in baseball. Grooms, from Nashville, said he drew inspiration from childhood trips to Daytona Beach, recalling the excitement of seeing the ocean. Home Run Sculpture is the official name, but patrons have called it any number of things—not all of them printable. "That thing out there is pretty garish. I'm not sure what it is," said Lance Berkman of the Cardinals at the grand opening. "The stadium itself is really pretty. I enjoyed the architecture."

What no fan can argue is that LoanDepot Park offers a South Beach flavor everywhere you turn. From 200-foot LED columns that flicker in rhythm to music, to the vibrant colors everywhere and truly international dining options—with a Cuban flair, of course—the stadium reflects its surroundings in an authentic if somewhat kitschy way. "It's lively, it's entertaining, and it's so Miami," said former Marlins relief pitcher Heath Bell.

Though the Marlins don't exactly have the national following of teams like the Yankees, Red Sox, or Dodgers and have struggled to fill the seats, baseball fans around the world got a chance to check out their distinctive park during the 2017 Major League All-Star Game. And what an exciting showcase they witnessed, as Robinson Cano won it for the American League on the first extra-inning home run in an All-Star Game since 1967.

"More important than the $100 million in economic benefit, more important than the 75,000 rooms in our hotels, more important than the viewing audience throughout the world is that this game is of great importance for the soul of the City of Miami," said Miami mayor Tomas Regalado.

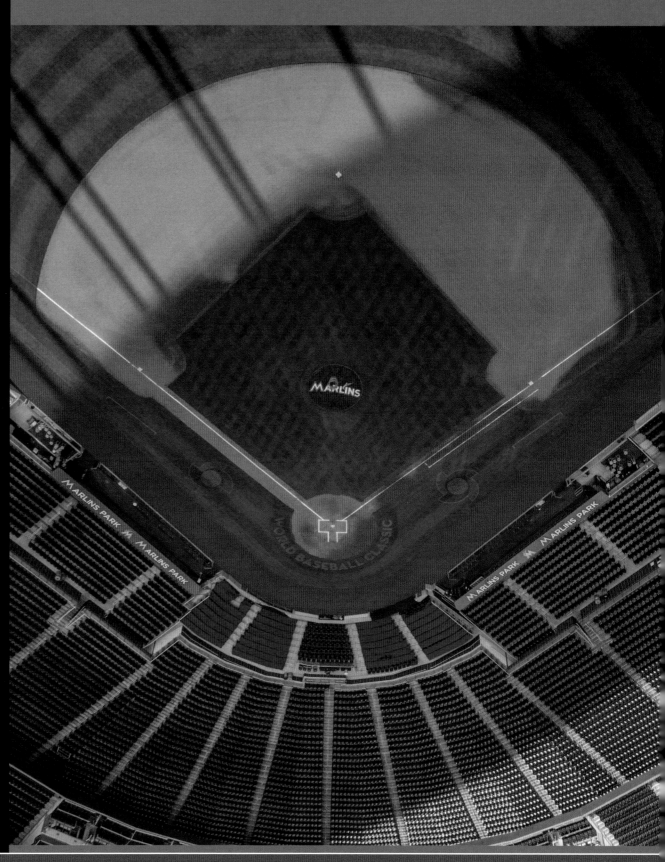

MILWAUKEE BREWERS
AMERICAN FAMILY FIELD

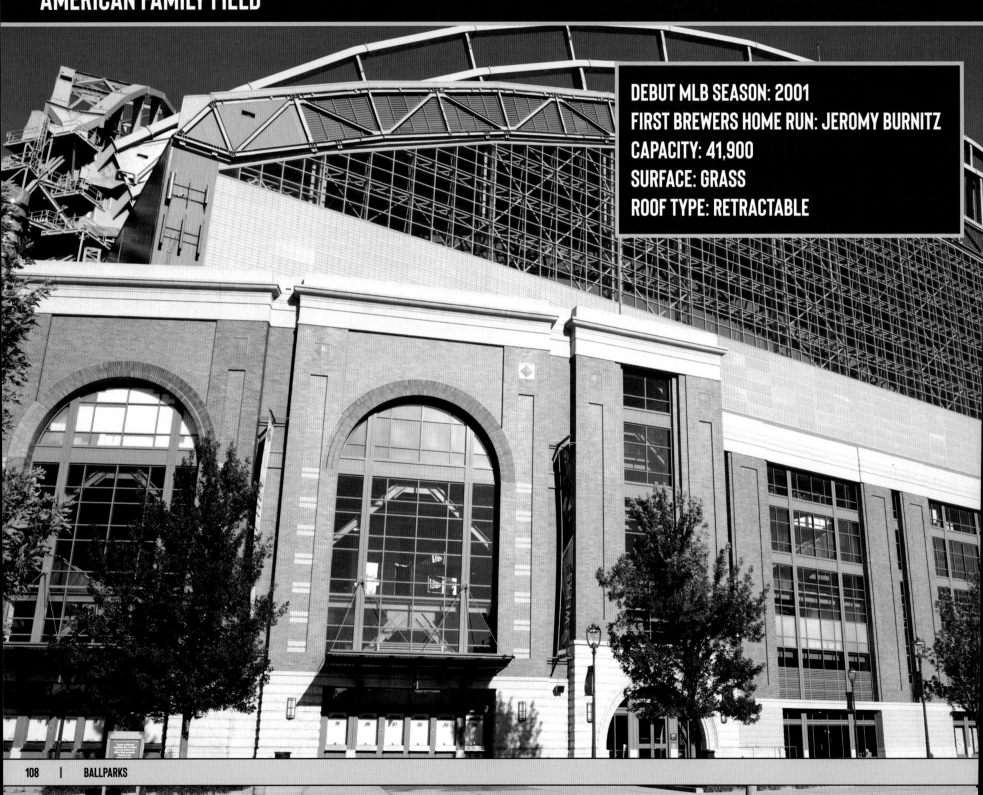

DEBUT MLB SEASON: 2001
FIRST BREWERS HOME RUN: JEROMY BURNITZ
CAPACITY: 41,900
SURFACE: GRASS
ROOF TYPE: RETRACTABLE

Broken promises, construction delays, cost overruns, a recall election, even death—all surrounded Miller Park before the Brewers opened its doors. Such is the not-so-charming story of Milwaukee's modern ballpark odyssey.

Starting in the mid-1980s, Brewers owner Bud Selig spent a decade trying to build a new facility. First he pledged to pay for it himself, then he sought help from taxpayers. Despite the voters' rejection of his funding plan, Selig lobbied the state for financial aid. He received it, with the decisive vote coming from a state senator, George Petak; that vote cost the Racine native his job, as his constituents made him the target of the state's first-ever recall election. The Brewers broke ground on the park in the fall of 1996.

In July 1999, with the park less than a year away from opening, a crane hoisting a 400-ton roof section collapsed, killing three workers. The unfinished ballpark sustained more than $100 million in damage (most of which was covered by insurance) in the accident. Still, the ballpark's price, originally budgeted at $250 million, rose to over $400 million after the costs of infrastructure improvements were calculated. The Brewers funded a fraction of the additional cost, and nearly half of the difference was recouped by selling the ballpark's naming rights to Miller Beer.

In the end, the Brewers got a new 41,900-seat ballpark, retractable roof and all, to replace the outmoded and obsolete County Stadium, which sat across the parking lot until it was demolished. President George W. Bush tossed the ceremonial first pitch at Miller Park in 2001.

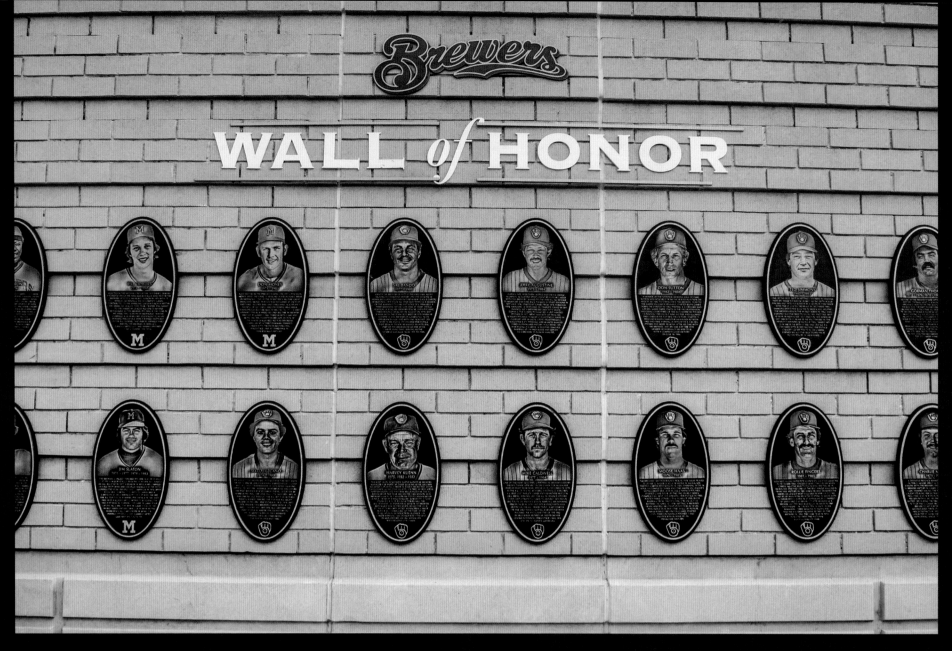

Despite its brick facade and structural elegance, early reviews of Miller Park were mixed. Some complained that its location—two miles from downtown—precluded the urban revitalization witnessed in other cities with new parks. Others missed mascot Bernie Brewer's slides into a giant mug of suds, which were beloved at County Stadium. Still others criticized the fan-shape roof—its awkward design, its high cost of maintenance, and its occasional leaks. On the upside, the glass windows incorporated in the roof's design provide openness and sunlight, which allows grass to grow.

Prior to the 2021 season, naming rights for the stadium changed hands. Gone was the all too appropriate Miller moniker, in favor of sponsorship from

American Family Insurance, onboard for a 15-year deal. Brewers fans are a tailgating bunch, and the American Family Field parking lots provide ample space for the roasting of brats, as well as portable toilets and places to stash hot ashes.

Fans cheer a bratwurst, Polish sausage, Italian sausage, hot dog, and chorizo during the Klement's Famous Racing Sausages sprint. This on-field between-innings entertainment is a hit with kids and adults. Bernie Brewer, the team mascot, has a chalet above the left field seats. Following every Brewers home run and victory, Bernie Brewer gleefully rides down a long, twisting slide and then proudly waves a Milwaukee Brewers flag.

The Brewers drew 2.8 million fans during their first season at their new ballpark. Later, *Sports Illustrated* rated the park as baseball's best value for fans. American Family Field plays as a hitter's delight: So prevalent were home runs that a gas-pump counter that tallies dingers was added to the scoreboard during the 2007 season.

"It flies out of here," Brewers slugger Richie Sexson told reporters. "We're happy; the pitchers aren't." The "hitter's park" reputation has remained, and the Brewers embraced it by filling their lineup with young sluggers, first with Prince Fielder, then with Ryan Braun. In 2008, the team made its first playoff appearance in more than two decades. The Brewers drew more than three million fans in 2008, '09 and '11.

The Brewers have a pair of statues devoted to legendary Milwaukee Hall of Famers Robin Yount and Hank Aaron outside the front entrance of American Family Field, as well as a statue of former team owner and MLB commissioner Bud Selig, and one for longtime Brewers radio broadcaster Bob Uecker. The Brewers Wall of Honor was created to commemorate Brewers players, coaches and executives. The Wall of Honor is a permanent exhibit on an exterior wall of the ballpark adjacent to the left field gate entrance.

Winning has become a more regular thing in Milwaukee, of late. Although they've failed to reach the World Series—since 1982—the Brew Crew have partaken in postseason baseball each year from 2018 to 2021.

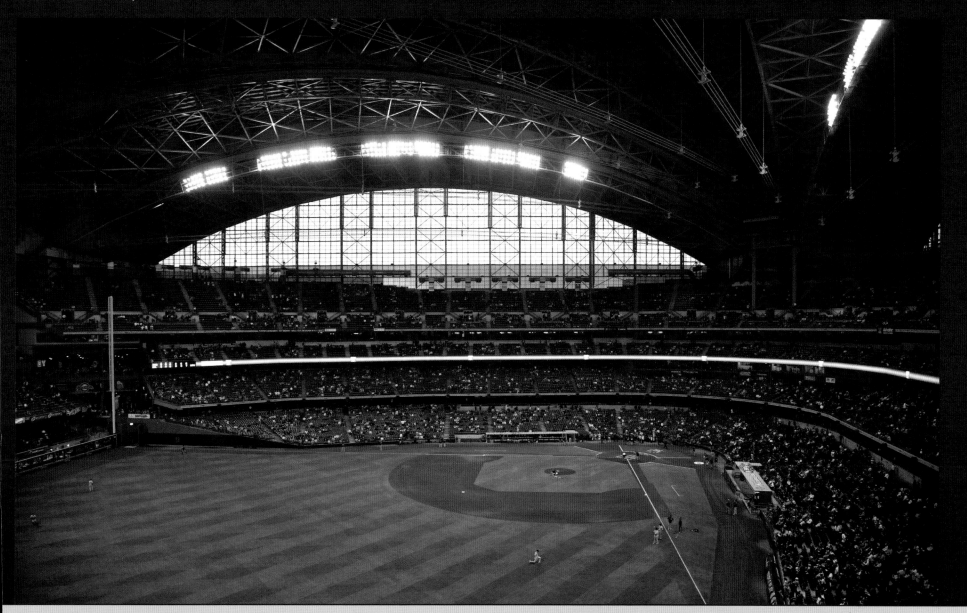

NEW YORK METS

CITI FIELD

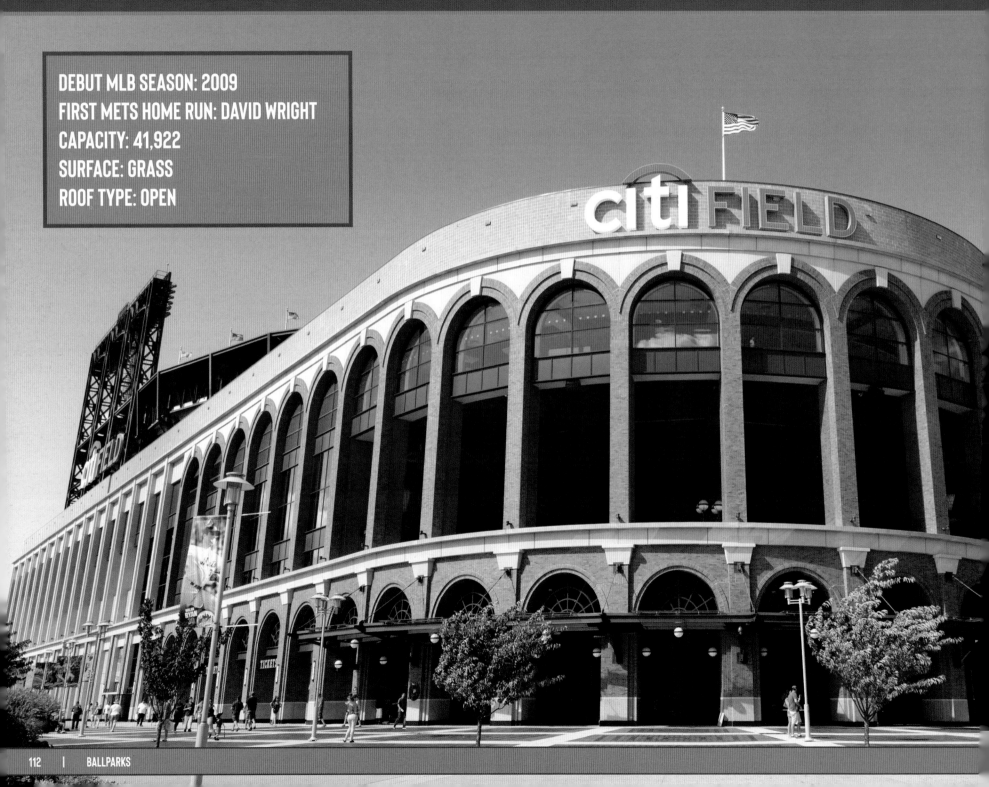

DEBUT MLB SEASON: 2009
FIRST METS HOME RUN: DAVID WRIGHT
CAPACITY: 41,922
SURFACE: GRASS
ROOF TYPE: OPEN

When the Mets were born in 1962, they inherited pieces of the departed Dodgers and Giants franchises, with a smidgen of the Yankees thrown in. Mets caps borrowed their "NY" insignias from the Giants, the team's blue and orange colors were those of both the Giants and the Dodgers, and their pinstripes mimicked those of the Yankees. What's more, their roster that dreadful first season included castoffs from all three teams.

So when it came time to design Citi Field—which replaced dilapidated Shea Stadium as the home of the Mets in 2009—the team "borrowed" the face of Brooklyn's Ebbets Field, perhaps the most beloved ballpark ever. And all around Citi Field, the Mets show proper reverence to New York baseball history while showcasing modern marvels and providing necessities that were just rumors at Shea.

Citi Field's $800-million sticker price shocked many New Yorkers, particularly because they would be footing most of the bill. Additionally, the naming rights to the ballpark were sold to Citigroup just before its role in the nation's banking crisis was exposed. Still, most Mets fans—at least those who can afford the expensive tickets—enjoy its comforts, theme-park atmosphere, and amenities.

Built in the shadow of Shea Stadium, Citi Field is a natural grass ballpark designed by Populous, the former HOK Sport group. The stunning venue includes 41,922 dark-green seats, all of which face the infield. Fans who arrive on the elevated No. 7 train pass through a handsomely decorated plaza to the ballpark's numerous arched windows, which bend into a grand brick facade. At the main gate is the park's signature rotunda, which is named in honor of Jackie Robinson. Engraved into the rotunda's 160-foot-diameter floor and etched into the archways are words and images that defined Robinson's nine values: Courage, Excellence, Persistence, Justice, Teamwork, Commitment, Citizenship, Determination, and Integrity.

Exposed dark-blue structural steel finished in a bridge-like motif is prominent throughout the park. The same steel composes trusses, traditional light towers, and the roof's canopy, which evokes an elevated train stop. A pedestrian bridge—a miniature version of the Hell Gate Bridge—spans the bullpen behind right-center field.

Citi Field's spectator-pleasing openness is a product of expansive concourses that open to the playing field and provide peeks of Queens and Flushing Bay. In some spots, fans can even espy the Manhattan skyline. From the visitors' bullpen, one can see timeworn buildings and shops along 126th Street. While its dimensions are similar to those of Shea, a porch seating 1,200 shoots into fair territory in right field, a design that was modeled after the stands at old Tiger Stadium. Beneath the overhang, things get no easier for outfielders: The fence rises from eight feet at the foul pole to 18 feet under the porch.

The nine-foot apple that rose and lit up for Mets home runs at Shea resides outside of Citi Field, while a new, larger model sits poised behind Citi's center-field wall. When a Mets player hits a home run, a giant apple, which has a Mets logo on the front that lights up, rises from its housing in the center field batter's eye.

With fewer seats and a disappointing team, attendance actually fell from more than four million in 2008 to just over three million that first season at Citi Field. The Mets still managed to finish fifth in the NL in attendance, however. More recently, in 2019 there was an average of 30,531 fans per game with about 2.44 million total for the season. That year, rookie phenom Pete Alonso hit 27 of his record-breaking 53 homers at Citi Field. Fans should be flocking for years to come to see Alonso.

Citi Field tries to be a ballpark for all New Yorkers, be they fans of Ebbets Field or the Polo Grounds—or even Shea Stadium. While its classic brick facade is clearly linked—at least in spirit—to that of Ebbets Field, the park's dimensions and seating are far more modern. Its deep outfield alleys, the home-run Big Apple, and the roars of jets flying overhead remind one of Shea. Many of the things that made Ebbets Field charming—the nooks, the zany bounces off an outfield fence—were left out of Citi Field's designs; not so the famed Ebbets rotunda, however.

To pay homage to the Giants and the Polo Grounds, there is an orange stripe that runs along Citi Field's outfield wall and up the park's foul poles. Otherwise, New York baseball fans who yearn for the good old days have found no links to the Giants in the Mets' new stadium, despite the fact that the Mets' first home was abandoned by the team that took New York's heart to San Francisco.

Several nights each season Mets fans are treated to a unique, postgame fireworks show. Each evening has its own theme and features synced music and visuals on the Citi Field video boards. The fireworks display on September 2, 2022 celebrated the 60th anniversary of the New York Mets.

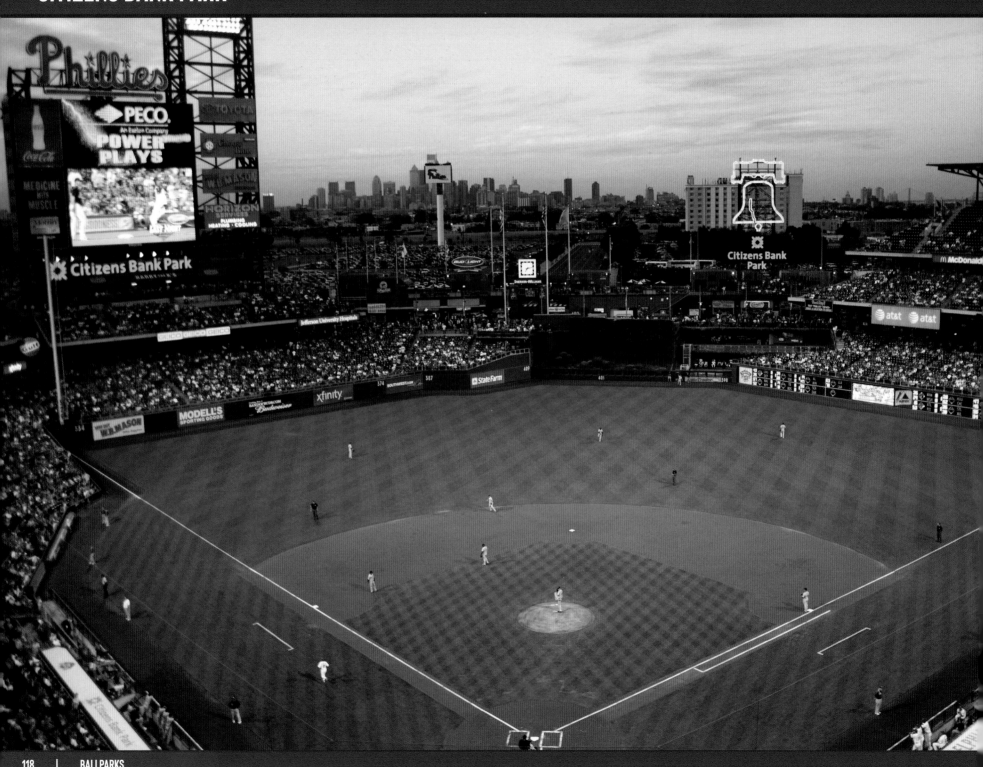

Boos showered down from a half-empty upper deck almost as if they were racing the chilled raindrops that splashed onto Philadelphia's new baseball park on Opening Day. Chants of "Let's Go Flyers" filled the air. Jeers at a home opener? Cheers for a hockey team? It could only happen in Philly. Indeed, the city's supposed brotherly love rarely extends to its sports teams. "You can't get on the fans," former Phillies manager Larry Bowa said. "They can boo. They're frustrated. They want to see a winner."

This is how Citizens Bank Park was christened on April 12, 2004. Fortunately for everyone's sanity, there were much better days ahead for the Phillies and their new home—the team would soon reach baseball's pinnacle, and its stadium would win acclaim as one of the most exquisite embodiments of the "retro- classic" ballpark era.

Situated at 11th and Pattison, the $346-million facility was publicly and privately financed. It rose in the shadow of the sterile Veterans Stadium, which had been the home to the Phils since 1971. Citizens, popularly called "The Bank," holds nearly 43,000 fans in a seating arrangement inspired by the Baker Bowl and Shibe Park—the Phillies' former homes—where the upper and lower decks sometimes didn't connect and the cantilevered design provided open seating areas.

To evoke more nostalgia, 199 rooftop bleacher seats, similar to those sold at old Shibe Park, are available to fans looking to enjoy a unique ballpark experience under the Liberty Bell. Citizens has a triple-deck grandstand in right field and natural grass turf. Luxury suites can be leased for seven or ten years at a time.

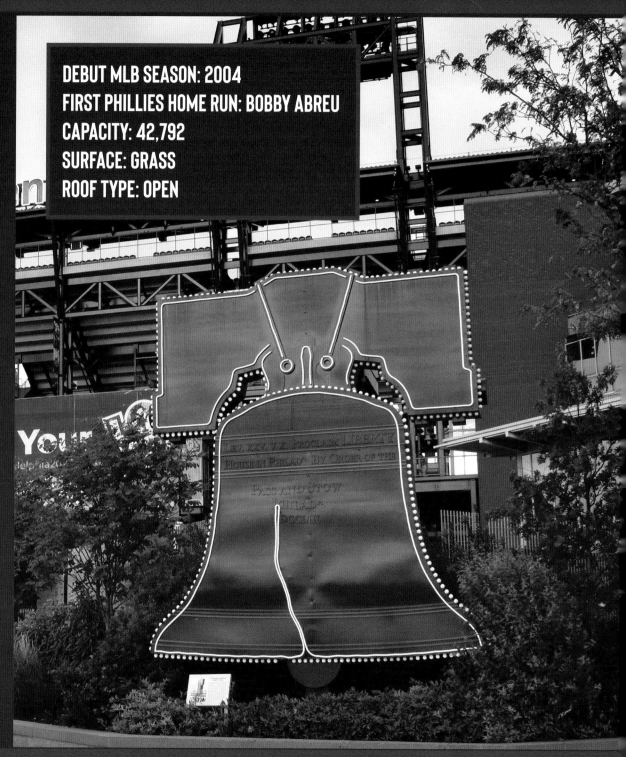

DEBUT MLB SEASON: 2004
FIRST PHILLIES HOME RUN: BOBBY ABREU
CAPACITY: 42,792
SURFACE: GRASS
ROOF TYPE: OPEN

The ballpark's facade is composed of red steel, brick, and stone. Ten-foot-tall bronze statues of Hall of Famers Mike Schmidt, Steve Carlton, Robin Roberts, and Richie Ashburn stand at the entrances. In April 2011, the Phillies accepted a gift of a fan-underwritten 7.5-foot-tall bronze statue of legendary broadcaster Harry Kalas. It was placed near the restaurant that bears Kalas' name, behind section 141.

Behind center field, Citizens Bank features "Ashburn Alley," which offers a range of Philadelphia cuisine and retail shopping spots, as well as the "All-Star Walk," a path that pays tribute to Phillies All-Stars. Fans who want to remember yesteryear can visit "Memory Lane," an illustrated history of Philadelphia baseball that spotlights the Phillies, the Athletics, and the city's Negro League teams.

Philly fans can take out their frustrations on opposing pitchers who are warming up in the upper bullpen, which is adjacent to Ashburn Alley. Originally, the upper pen was meant for Phillie flingers, but a switch was made after heckling fans caused too much grief for the hometown hurlers.

A replica of the Liberty Bell stands 100 feet above the outfield; it lights up and tolls for every Phillies homer. And there were dingers aplenty that first season, as Phils hitters cranked 49 more homers than in 2003 at the Vet, topping the 200 mark for the first time in team history. Long balls were so common that in 2006 the left-field power-alley fence was pushed back five feet to 374 feet and raised to ten-and-a-half feet. In recent years, the Phillies have promoted the hashtag #RingTheBell.

The park's left-center-field wall sits, at its farthest, about 409 feet from home plate; it is aptly named "The Angle." At Washington's Griffith Stadium, a similar outfield wall was bent to accommodate trees that grew outside the park; in Philadelphia, The Angle was added for quirkiness. The fence has heights that taper from 19 feet to nearly 13 feet. Balls that are hit off the wall shoot back toward the field in all sorts of directions.

For the kiddos, make your way to "The Yard." Located in right field, this 13,000 square foot interactive fan experience is highlighted by a 30-foot climbing wall, a playable miniature Wiffle ball stadium, and a bullpen where kids can have their pitches measured by a radar gun.

The Phillies' massive Daktronics video display features Sony HD production technology and includes a dedicated closed-captioning display to assist hearing-impaired fans. The mammoth display measures 76 feet high and 97 feet wide, for a total of 7,372 square feet of digital space. If it were a consumer television, the Phillies display would be considered a 1,478" screen.

The Phillies found success at their new ballpark. In 2008, they hushed The Bank's boo-birds (at least temporarily) by winning their first World Series since 1980.

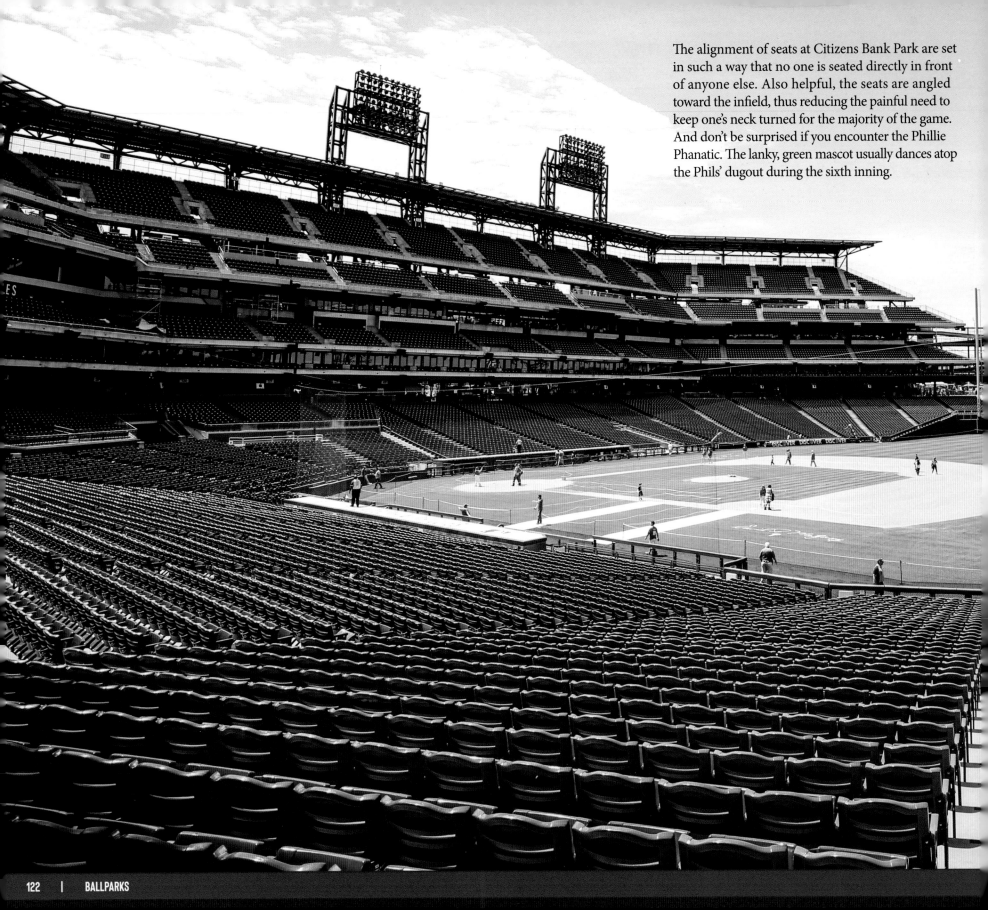

The alignment of seats at Citizens Bank Park are set in such a way that no one is seated directly in front of anyone else. Also helpful, the seats are angled toward the infield, thus reducing the painful need to keep one's neck turned for the majority of the game. And don't be surprised if you encounter the Phillie Phanatic. The lanky, green mascot usually dances atop the Phils' dugout during the sixth inning.

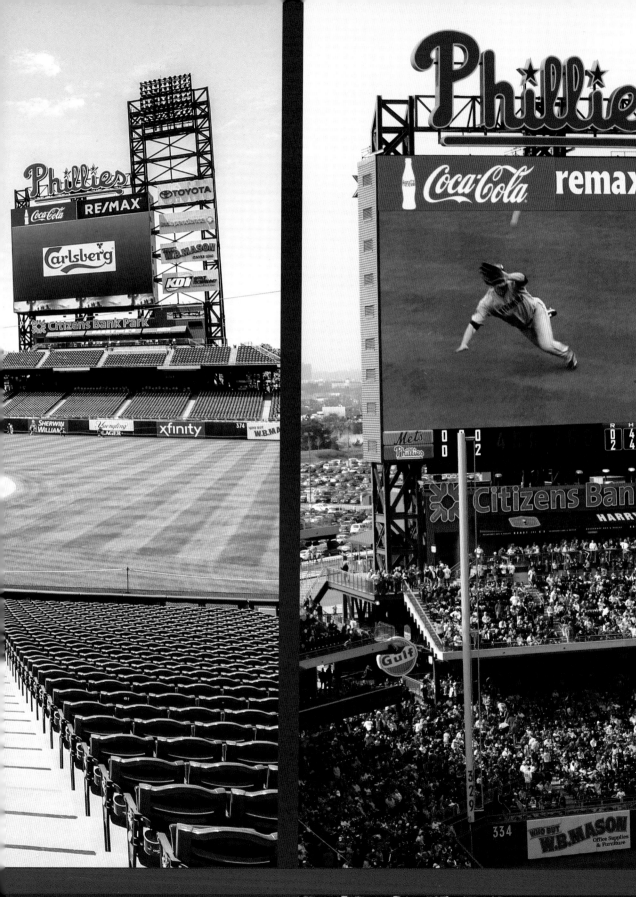
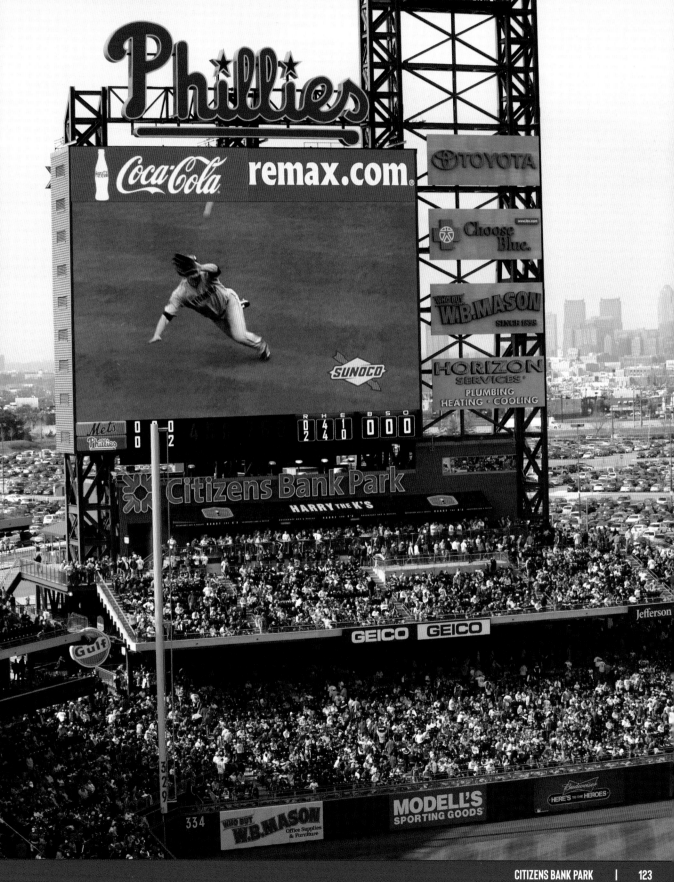

PITTSBURGH PIRATES

PNC PARK

With PNC Park, the Pirates raised the bar, setting a new standard against which other stadiums would be measured. Thanks to its location on the Allegheny River, its reverence to history, its attention to detail, and the comfort delivered to its fans, Pittsburgh's park is a jewel.

HOK designers did more than just copy the styles of classic venues and their retro descendants when planning PNC Park. The stadium, which was built for $262 million (including land acquisition), is a picturesque vision on the riverfront. Fans can approach on foot from the Roberto Clemente Bridge (which is pedestrian-only on game days). At the bridge's edge, they are met by shops, restaurants, and a sports pavilion with attractions for young and old alike.

The designers of PNC paid homage to Pittsburgh's first baseball palace, Forbes Field, when planning the facility. Archways at the entrance level greet fans, while decorative terra-cotta-tile pilasters and blue steel light posts stimulate memories of the former ballpark. PNC Park features a striking limestone façade topped by a green steel roof that partially covers a two-deck grandstand. This stadium's sight lines are unsurpassed. And with the most distant seat a mere 88 feet from the field, its confines are stunningly intimate.

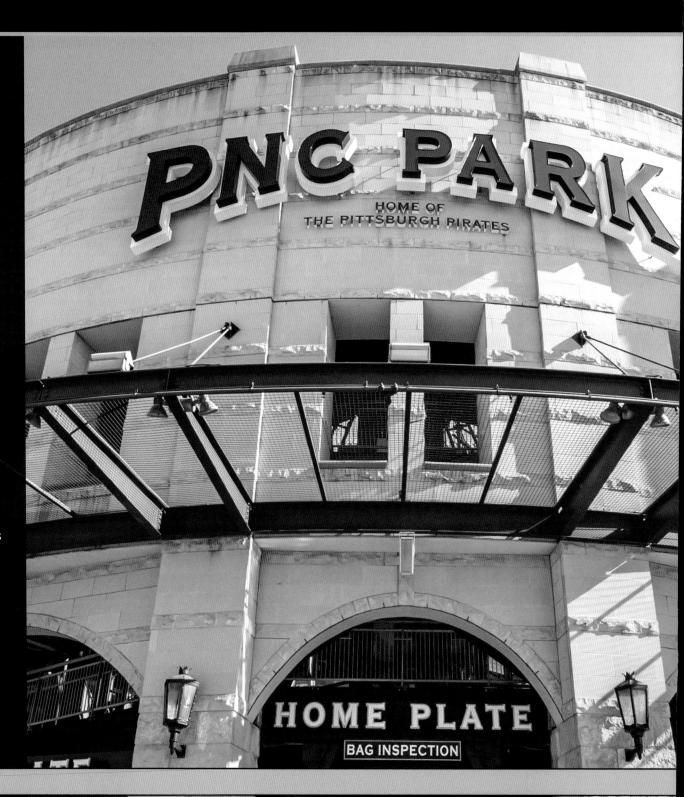

DEBUT MLB SEASON: 2001
FIRST PIRATES HOME RUN: JOHN VANDER WAL
CAPACITY: 38,747
SURFACE: GRASS
ROOF TYPE: OPEN

Inside PNC Park, natural grass spans an asymmetrical outfield. A 21-foot fence in right field accommodates a scoreboard while a set of bleachers rises above the fence. Around the infield, limestone walls front the lower grandstand, providing a classic backdrop on TV. A striking view of the Pittsburgh skyline and the Clemente Bridge is revealed beyond the outfield fence.

Double-deck bleachers in left give way to one of baseball's most informative scoreboards. A ramp near the foul pole offers more than access to the upper deck—it gives fans immaculate views from four perches.

Wide concourses give open perspectives all around the infield, which allow spectators to walk around and take in the game. The Riverwalk beyond the right-field fence is a popular destination. This outer promenade provides a unique panorama of the playing field and outstanding views of downtown Pittsburgh and the Allegheny River.

Sixty-nine luxury suites wrap the field, and club seating on two levels comes with its own lounges; there are 38,747 seats in all. The park offers a variety of food, including Pittsburgh's signature Primanti Brothers sandwiches that feature fries and slaw stuffed inside. If pulled pork nachos sound tasty, head to Manny's BBQ, which is run by former Bucs catcher Manny Sanguillen. Sanguillen is regularly on-site, so be on the lookout!

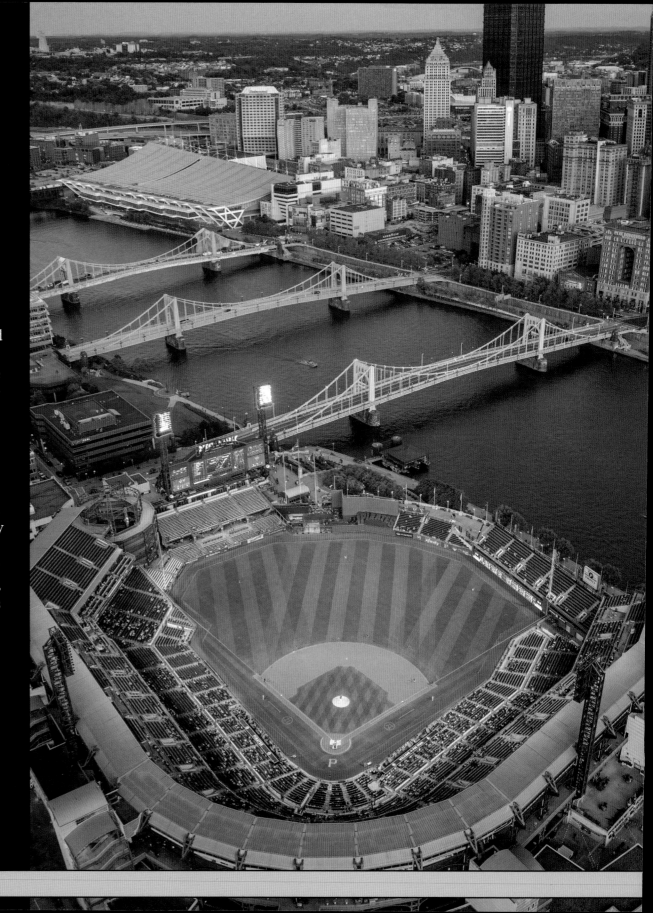

Great players from Pirates history are acknowledged by statues, some of which have moved from Forbes Field to Three Rivers Stadium and finally to PNC Park. Honus Wagner meets fans at the home-plate entrance, Clemente stands at the bridge named in his honor, and Willie Stargell's likeness is at the entrance in left field. Added in 2010, a statue depicting Bill Mazeroski, helmet in hand and arms outstretched as he rounds the bases following his game-winning blast, is located at the end of Mazeroski Way near the right-field entrance of PNC Park.

After spending some 30 seasons at the concrete doughnut that was Three Rivers Stadium, Pirates fans found PNC Park to be a breath of fresh air. On April 9, 2001, as fans mourned the death of Stargell (which occurred that morning), there weren't many dry eyes in the house when the new ballpark was unveiled.

Unfortunately for Pittsburgh fans, they watched the Pirates set a record for the longest streak of losing seasons in the history of North America's four major professional sports (1993–2012). Following that long slump, the Pirates did put together three straight playoff seasons from '13 to '15, but haven't returned since.

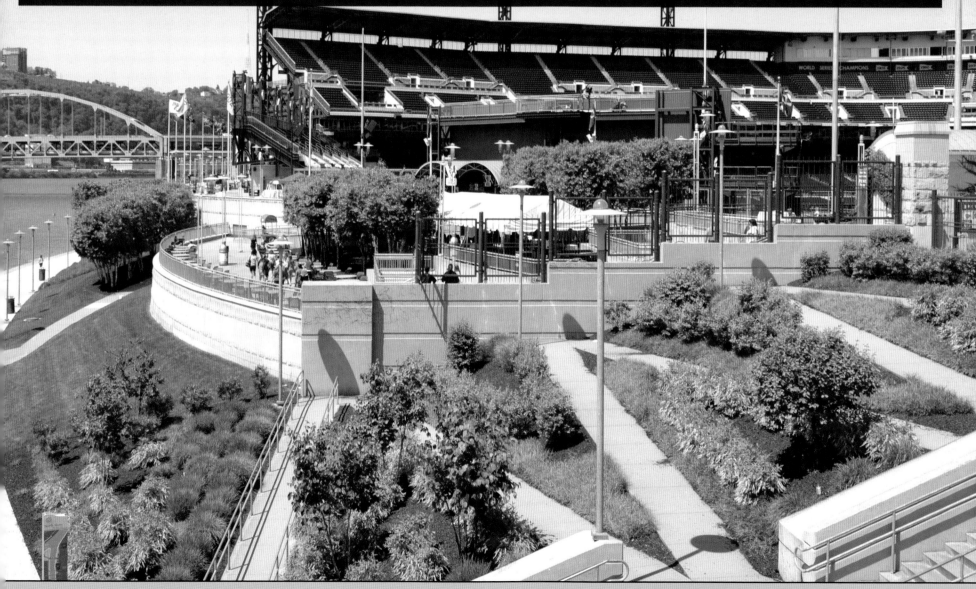

ST. LOUIS CARDINALS
BUSCH STADIUM

DEBUT MLB SEASON: 2006
FIRST CARDINALS HOME RUN: ALBERT PUJOLS
CAPACITY: 46,000
SURFACE: GRASS
ROOF TYPE: OPEN

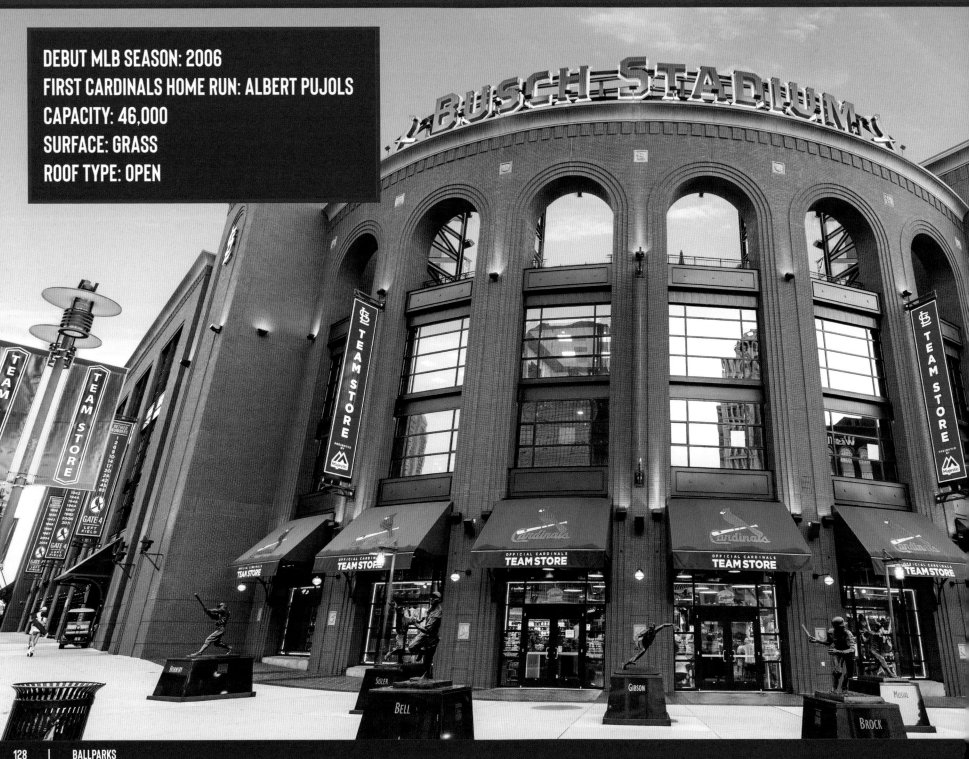

I n St. Louis, fans like to say that baseball heaven opened its gates in the spring of 2006 when shiny new Busch Stadium was unveiled. And it certainly appeared as though the gods of the national pastime were smiling on the Gateway City, as every red seat seemed stuffed for every contest that first season, right up to the clinching game of the World Series.

The Cardinals' 2006 season was a campaign for the ages: The inauguration of a new ballpark served as a prelude to an unlikely championship run. Twenty minutes after Cards closer Adam Wainwright fired strike three past Tiger Brandon Inge to clinch the title, St. Louis fans were still whooping it up inside Busch Stadium. "I'm looking around at all the confetti, and the fans are still here," Wainwright said. "This is such a great town and a great team. We fought so hard to be here. We deserve it, and they deserve it."

The Cardinals and their fans also deserved the new Busch Stadium. The club is one of baseball's most storied franchises, ranking behind only the Yankees in terms of World Series titles. Since 1966, the Redbirds had played at Busch Memorial Stadium, which was built as a multipurpose facility but rarely hosted anything other than baseball after the NFL's Cardinals left town in 1988.

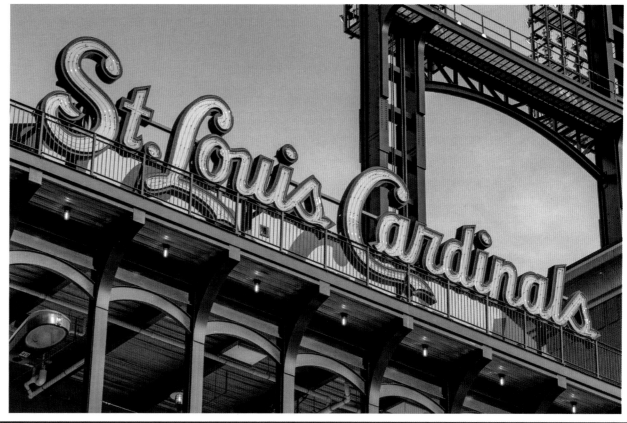

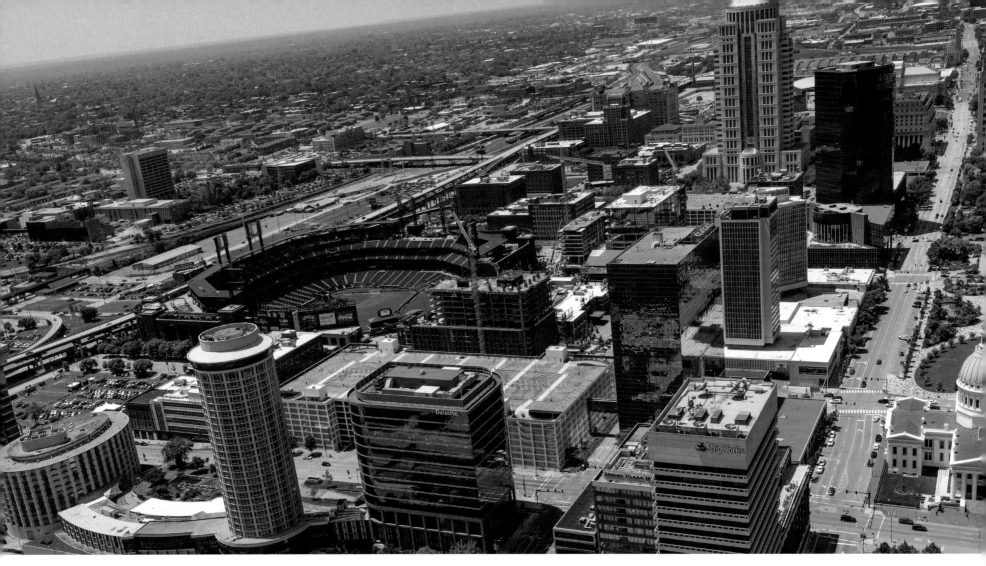

When the new Busch Stadium was proposed, the Cardinals had visions of a development called "Ballpark Village" that would jump-start a new downtown neighborhood. As is the case with many proposed ballparks, controversy boiled over the funding of the $365-million palace. In the end, the facility was privately financed, save for a government loan. There was no debate over the city's need for an economic boost, however—nicknamed the "Gateway to the West," St. Louis had seen its population decline over five decades, a trend that was symbolized by a listless downtown.

The opening of Busch Stadium promised to change the mood of the city. And indeed, by the time the ballpark opened, the former garment-district neighborhood—with its upscale condos, shops, and restaurants—was already in the midst of a transformation; in point of fact, the population in the city and downtown has risen in recent years.

And as promised, Busch Stadium was pure St. Louis in terms of character, history, and style. Its red-brick facade with arched passages and an exposed steel canopy complement the nearby Cupples Station warehouses and the historic Wainwright Building (coincidentally enough).

The ballpark's pedestrian walkway and the steel incorporated into the exterior are fashioned after the nearby Eads Bridge, which spans the Mississippi River. The walkway leads to an entrance that bears the pennants of St. Louis's championship clubs and a statue of Hall of Famer Stan "The Man" Musial. With its natural grass field resting below street level and no grandstand blocking the view, the buildings of the St. Louis skyline—most notably the fabled Gateway Arch—rise impressively beyond the green outfield fences.

After old Busch Stadium was bulldozed, Clark Street was reopened, giving some a free peek inside the new ballpark from knotholes in fences beyond the outfield. While the outfield dimensions are similar to those of old Busch Memorial, new Busch's foul-ball areas are smaller, which allows lower-deck seats to be at least 40 feet closer to the infield. Every single seat is colored Cardinal red. A retro clock with two cardinals perched above a Budweiser sign sits atop the right-field scoreboard.

Cards fans embraced the new ballpark, buying 3.4 million tickets that first season in the venue. The Cardinals responded with a mediocre 83 wins, which was still enough to win the mediocre NL Central. The Redbirds caught fire in October, however, and ended up winning the World Series. In 2011, the Cards repeated the feat, defeating Texas in seven games to clinch the franchise's 11th championship.

The ballpark added the Budweiser Terrace in 2018, after removing 1,000 seats in the upper right field seating area. The 20,000 square foot space has two full-service bars, standing areas and lounge seating within the bowl of the stadium, and cabana seating with urban garden accents. An open-air barbecue grill and covered performance stage round out the Budweiser Terrace.

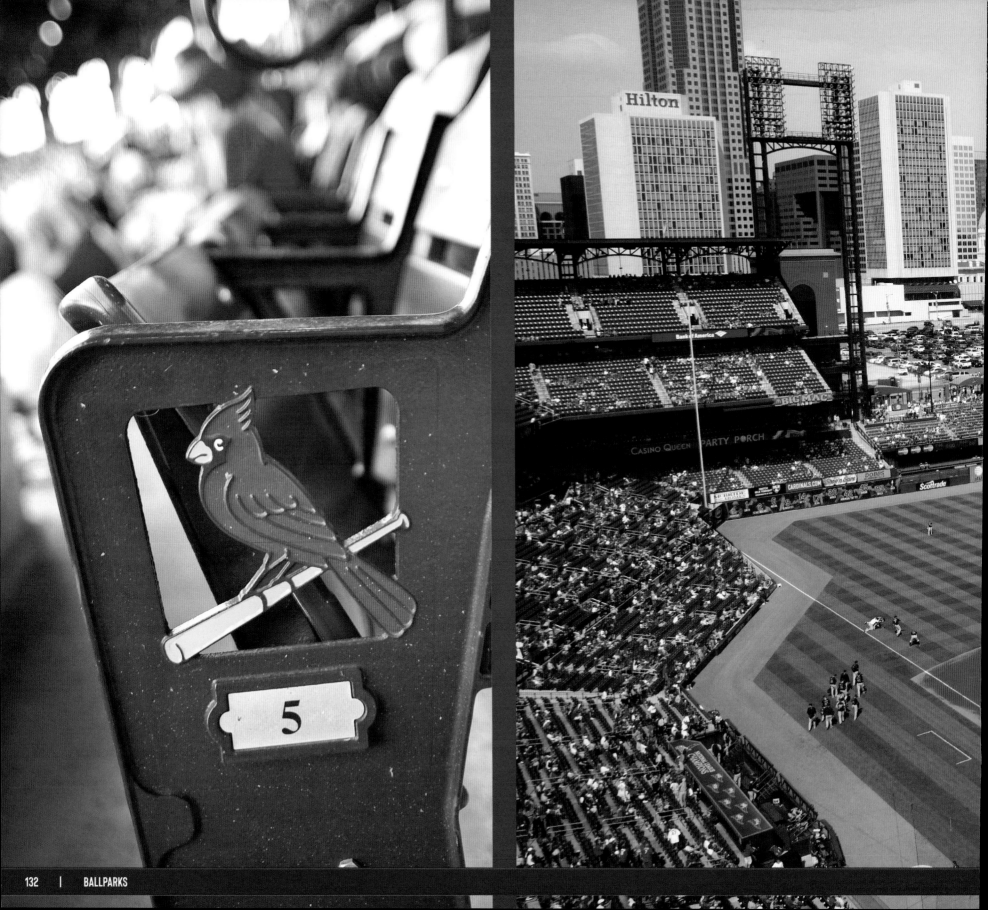

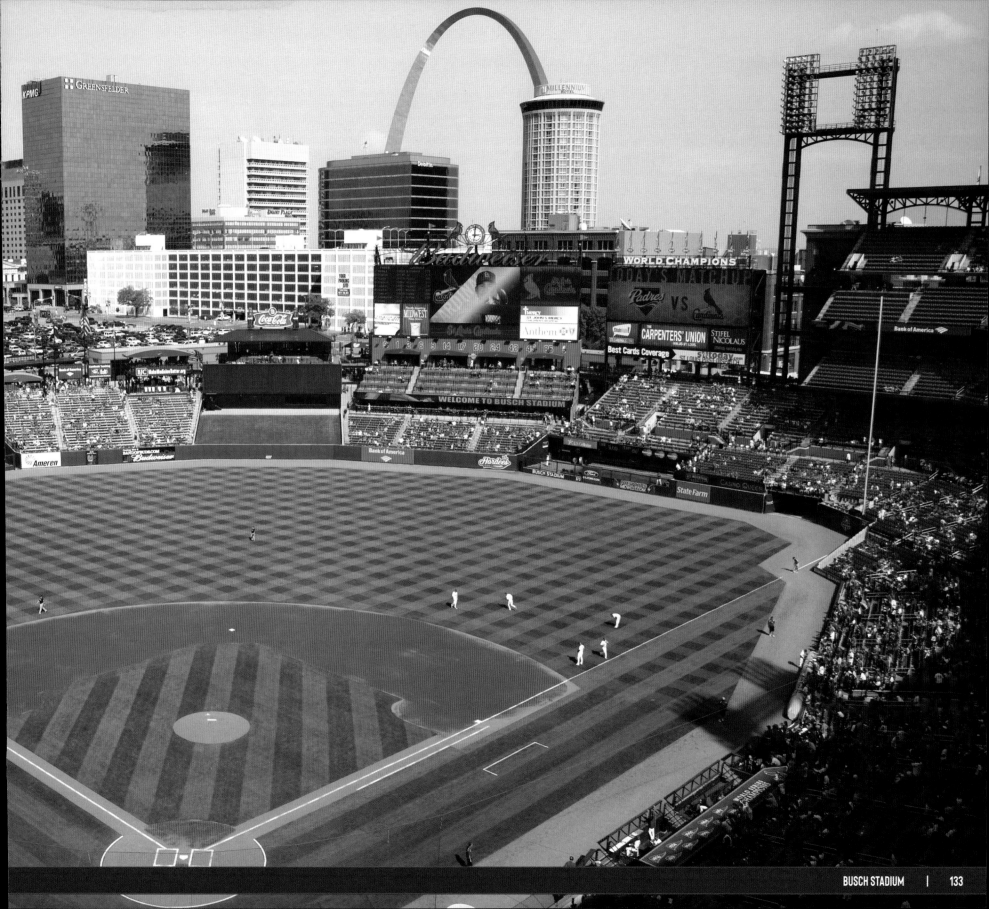

SAN DIEGO PADRES
PETCO PARK

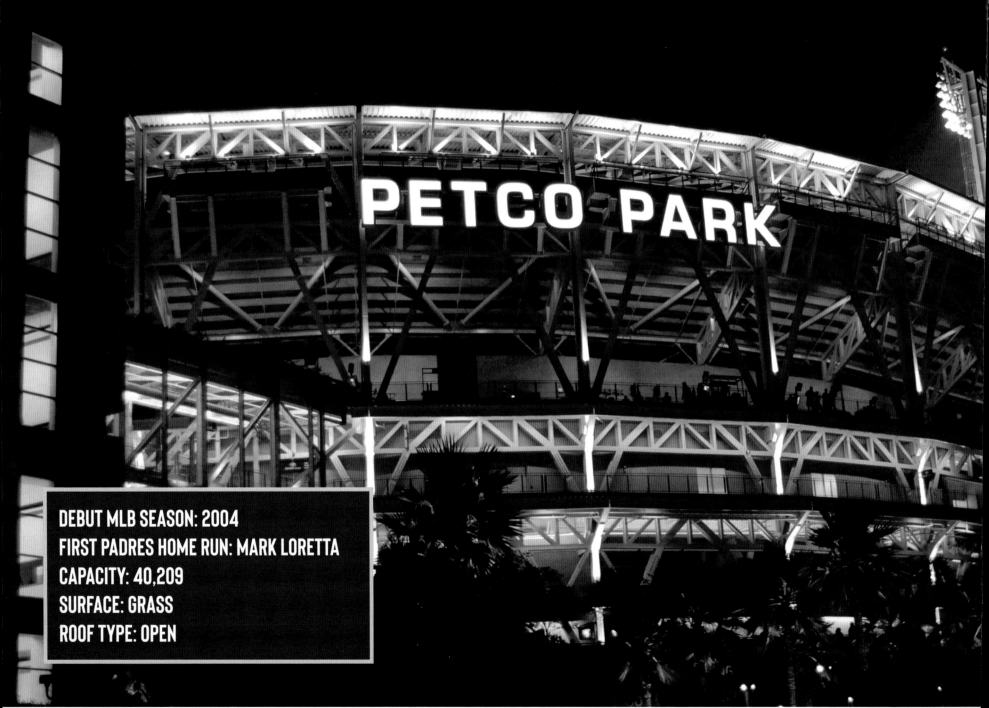

DEBUT MLB SEASON: 2004
FIRST PADRES HOME RUN: MARK LORETTA
CAPACITY: 40,209
SURFACE: GRASS
ROOF TYPE: OPEN

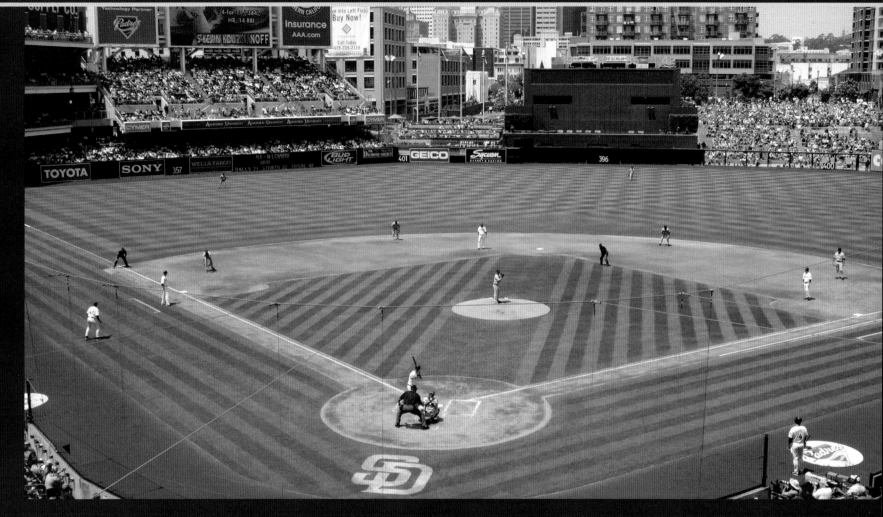

Success in the San Diego real estate market comes down to location, location, location. The centerpiece of the city's historic waterfront Gaslamp Quarter district, Petco Park opened in 2004 to effusive reviews; it was hailed as an architectural masterpiece and the key to the neighborhood's renaissance.

San Diego's Gaslamp Quarter dates back to the 19th century, when the city was booming and Wyatt Earp ran the neighborhood gambling house. After World War II, the Quarter fell into disarray as urban sprawl took hold. Petco Park designers didn't forget the neighborhood's history. In much the same way that a railroad

warehouse is featured at Camden Yards, planners incorporated the long-abandoned Western Metal Supply Co. building right into Petco Park's left-field corner. Its painted white lettering is visible from most areas of the park. There are 180 seats on its roof, and inside are two floors of chic specialty suites with balconies that overlook the diamond, as well as a top-floor lounge. A team souvenir shop can be found at field level.

Petco Park is named for a chain of pet supply stores, a fact that led to early nicknames like "Bark Park" and "Animal House." Every detail was carefully planned to ensure that the Padres' new park blends

with and bolsters its surroundings. Its facade is adorned with imported Indian sandstone to reflect nearby sandy beaches and cliffs. Inside the park, one sees a sea of navy-blue seats, as well as vistas of San Diego Bay, the city skyline, and Balboa Park. Even the white-painted exposed steel is intended to evoke images of watercraft floating in the bay. Erik Judson, former Padres' vice-president of development, said the Padres wanted "a ballpark that looks and feels like San Diego."

Petco Park's arrival was slow in coming. For many years, former Padres owner John Moores had sought a more intimate and profitable home than Qualcomm Stadium. Even after ground was broken, the new park was beset by scandals, delays, and lawsuits. In fact, for one 15-month spell, all work on the half-completed ballpark came to a halt. Finally, in 2004—after more than five years had passed since voters approved a ballot measure to fund the $450 million ballpark—Petco opened for business.

Visitors can hop aboard the San Diego Trolley, a bus, a train, a water taxi, a ferry, or even a pedicab to get to the ballpark. With a $15 lawn seat, fans young and old can romp the rolling grass of the 2.7-acre Gallagher Square (aka Park at the Park) beyond center field. This area includes a mammoth video screen that allows fans to watch the game while children run around a playground or build sand castles on the manufactured beach. Don't miss the opportunity to snap a selfie with a statue of Padre great Tony Gwynn on your way out.

On the other side of the fence that supports the video screen is the "Jury Box," a small set of bleachers that bends into right field along the foul line. Upper-deck seating, which at most new ballparks puts fans farther away from the field than they were at older stadiums, is actually closer at Petco than at Qualcomm thanks to a modern cantilevering design.

Petco Park quickly gained a reputation as a pitcher's palace, as hitters struggled to break through the thick salty air. In the first-ever series at Petco, the Padres and the Giants combined for a single home run in 214 at-bats. San Diego slugger Ryan Klesko was frustrated after smacking a ground-rule double and two long fly balls that fell innocently into an outfielder's mitt. "Anywhere else in the National League and I'm 3-for-3 with three homers," he told reporters.

TONY GWYNN
"MR. PADRE"

This frustration may have been overstated. The Padres hit 11 more team home runs in that first year than they did in their last at Qualcomm. San Diego fans, meanwhile, saw their team's ERA dip by nearly a run a game.

Every time the Padres hit a home run and/or win the game, a ship's whistle is sounded, four torches alight, and fireworks are shot off in center field. The ship and whistle are a reference to the USS *Ronald Reagan*, a Naval aircraft ported in San Diego.

The Padres successfully adjusted to Petco and captured back-to-back division titles in 2005 and '06. It wasn't until 2020 that the Pads returned again to postseason play. The future is bright, however. In 2021 San Diego inked a 14-year contract extension with superstar shortstop Fernando Tatis Jr.

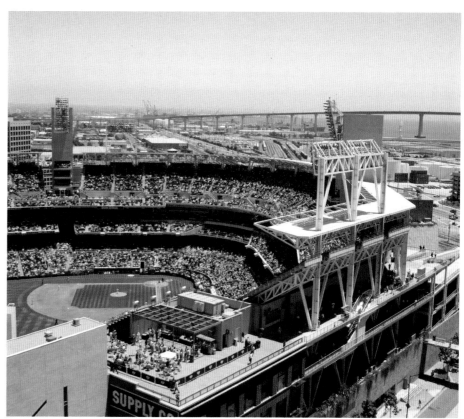

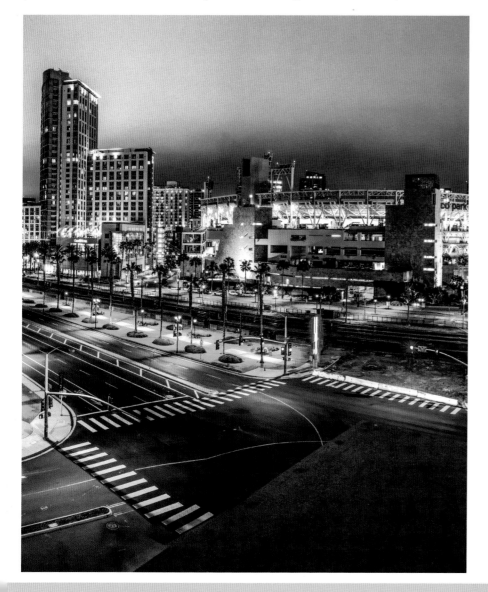

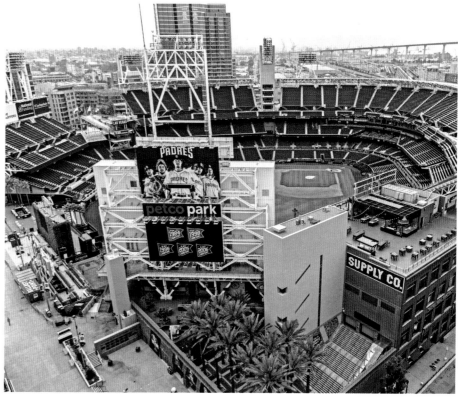

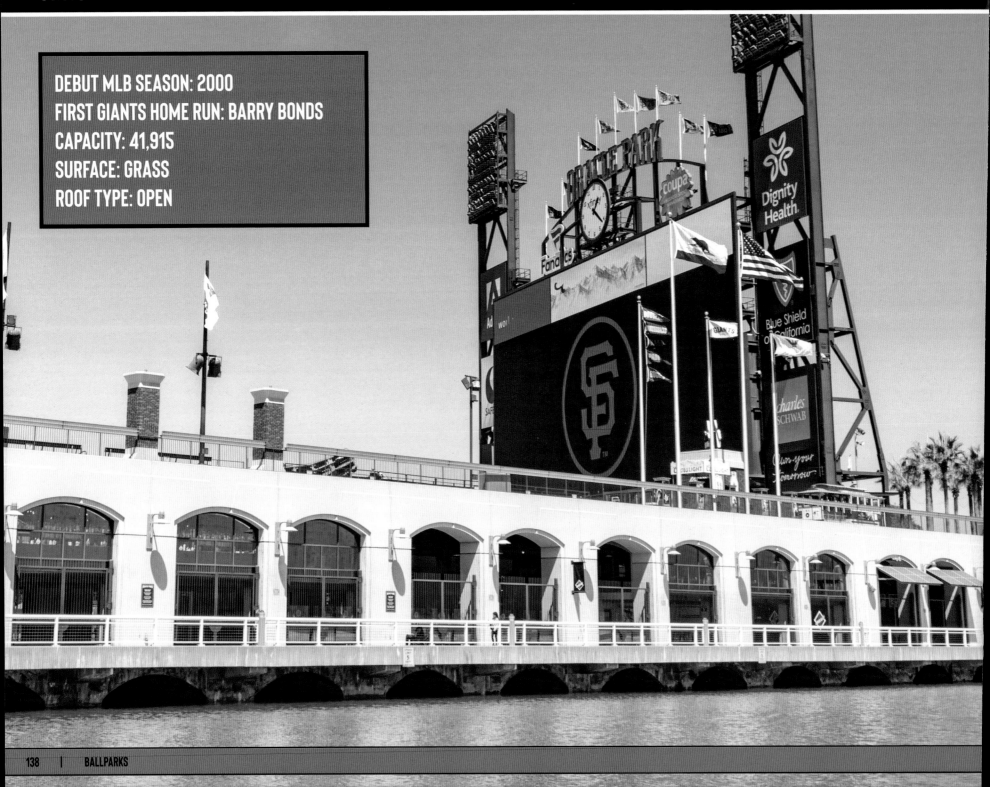

SAN FRANCISCO GIANTS
ORACLE PARK

DEBUT MLB SEASON: 2000
FIRST GIANTS HOME RUN: BARRY BONDS
CAPACITY: 41,915
SURFACE: GRASS
ROOF TYPE: OPEN

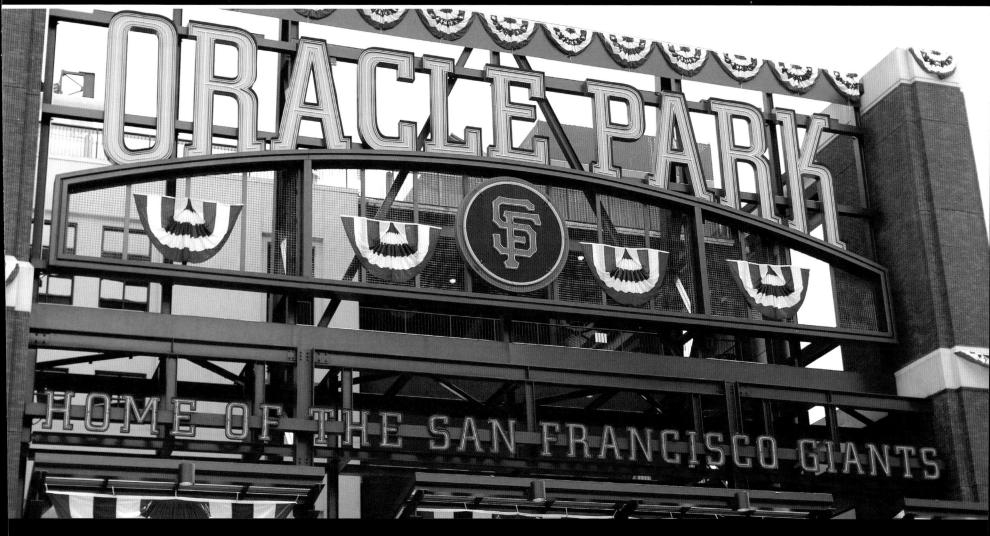

Of all the ballparks to emerge in the "retro-classic" era, Oracle Park—with its iconic location along the San Francisco Bay—may be the grandest of them all. Its setting's natural beauty is unsurpassed, its views unparalleled, and its quirkiness unpredictable. Even the advertising inside the ballpark draws aesthetic praise.

The stadium features tributes to the Giants' rich tradition, including a nine-foot statue of Willie Mays at the entrance. A children's playground, a giant baseball-glove sculpture, and a miniature version of the ballpark behind left field are popular attractions.

Still, much of Oracle Park's allure to ballpark enthusiasts lies beyond right field in the inviting waters of McCovey Cove, where boaters tailgate and mammoth home runs plop. Perhaps no ballpark fits its hometown better.

Critics and historians routinely place Oracle Park atop lists of baseball's brightest and most fan-friendly ballparks. Credit for its design and its adherence to baseball tradition falls to Giants owner Peter Magowan, who saved San Francisco baseball in the early 1990s and delivered Oracle Park in 2000.

Giants fans escaped the dark, gloomy confines of Candlestick Park for a waterfront palace. Gone, for the most part at least, are the cold, gusty winds that marred old Candlestick. In an age in which taxpayer dollars are routinely used to build new stadiums, Magowan secured financing that covered much of Oracle Park's $357 million price tag and led a season-ticket-marketing campaign that helped the ballpark become the first privately funded baseball-only facility constructed since Dodger Stadium was completed in 1962.

Originally named Pacific Bell Park, then SBC Park, then AT&T Park, Oracle fit Magowan's vision of a classic baseball facility, which was inspired by Fenway Park and Wrigley Field. Architects followed the designs of newer parks in Baltimore, Cleveland, and Denver to draw its marvelous blueprint. Every view that causes a diehard to stare, every outfield nook that causes a baseball to ricochet, and every amenity that causes a patron to celebrate was calculated and measured with the fan in mind. Magowan, an aficionado of the game himself, made sure of it.

For a fan, it may be the best park ever built," said baseball writer Peter Gammons. "But then, it takes a fan to understand one."

Oracle Park sits in a once-desolate warehouse section of San Francisco, sandwiched between the bay and the downtown skyline. Whether patrons travel by foot, bike, car, subway, ferry, or one of San Francisco's famed streetcars, no other ballpark offers such easy access, which is shown by the three million fans the Giants attracted during each of the first eight seasons they played at their new home.

Every game at the ballpark takes on a carnivallike summer atmosphere. Fans congregate in a waterfront promenade along the bay. Boats, kayaks, canoes, and surfboards—numbering in the dozens and often equipped with radios or TVs—await well-struck baseballs from inside the stadium. China Basin, where the watercraft gather, has become known as McCovey Cove, in tribute to famed Giants' slugger Willie McCovey.

Inside, Oracle Park has one of baseball's most unique playing fields, from its naturally blended grass to its jagged outfield fence, which drives outfielders batty. Its nearest wall sits 309 feet from home plate down the right-field line; its most distant stretches 415 feet in right-center. Almost immediately, sluggers embraced the ballpark, none more so than Barry Bonds, the Giants' outfielder who eclipsed baseball's all-time home-run record there on August 7, 2007.

The park has upscale accommodations (including 67 luxury suites, 5,200 club seats, and 1,500 field seats), but the views from each of the nearly 42,000 seats are spectacular. These vistas include a huge sign featuring a Coca-Cola bottle pouring into an enormous baseball glove near the left-field bleachers. Both components of the ad arrived by barge.

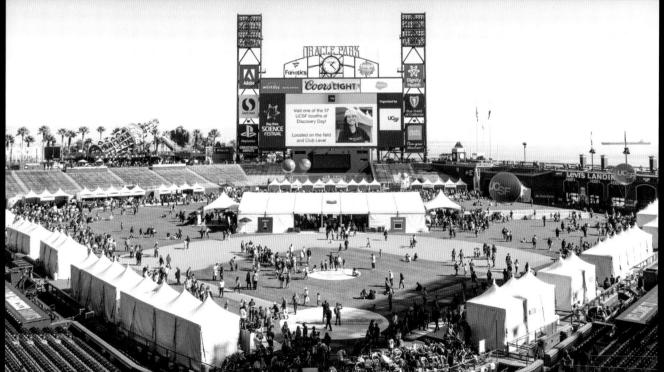

The foghorn—a holdover from Candlestick Park—was transferred to Oracle and hung underneath the scoreboard. It blows when a Giants player hits a home run or at the conclusion of a Giants win.

Located behind the center field bleachers, the walk-in Peet's @Café serves up coffee drinks in a tech-friendly environment. A 12-foot by 4-foot video wall displays Giants baseball social chatter throughout the world and across fans' favorite social media platforms.

The Giants excelled in their new park, capturing the NL West in 2000, their first season there. They went to the World Series in 2002, and won World Series titles in '10, '12, and '14.

WASHINGTON NATIONALS
NATIONALS PARK

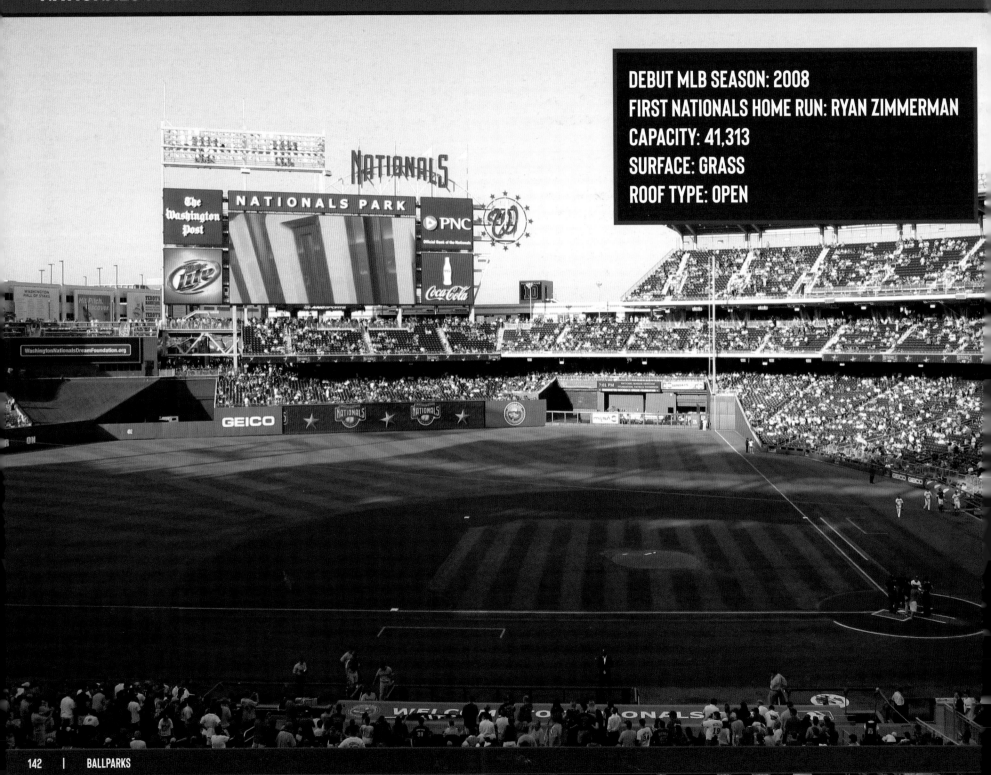

DEBUT MLB SEASON: 2008
FIRST NATIONALS HOME RUN: RYAN ZIMMERMAN
CAPACITY: 41,313
SURFACE: GRASS
ROOF TYPE: OPEN

S ix times in baseball history, Washingtonians had watched ball teams come and go—the last departure occurred when the Senators moved to Arlington, Texas, in 1972. But when Ryan Zimmerman smacked a walk-off home run at the new Nationals Park on March 30, 2008, it became clear that the Nats had finally settled into the comforts of a stable environment.

The Nats were once the Montreal Expos, a poorly financed franchise for which no buyer could be found. But instead of contracting the franchise as threatened, baseball owners collectively bought in, taking over operations while agreeing to move the club to Washington for the 2005 season. The relocation was contingent on the construction of a new ballpark, but gaining approval for funding for the stadium proved difficult. While most Washington voters disapproved of the proposed financing plan, the D.C. City Council—with the backing of Mayor Anthony Williams— pushed the deal through. Of the approved $611 million price (it ended up costing more), baseball owners would chip in a paltry $20 million.

After it opened, Nationals Park was met with ho-hum reviews. Its riverbank location was seen as a potential boon to a long-suffering neighborhood; ancillary development, unfortunately, has been slow in coming.

Ballpark designers opted for a modern design—incorporating glass, precast concrete, and steel—that emulates D.C.'s stately public buildings. The stadium can seat more than 41,000, and spectators are provided panoramic riverfront views of the Navy Yard and, in the distance, the U.S. Capitol and the Washington Monument. The East Wing of the National Gallery of Art, which was designed by renowned architect I. M. Pei, served as inspiration for the design.

Nationals Park has a natural playing surface that lies some 24 feet below street level; in fact, most spectators walk straight to their seats without using ramps or elevators. The ballpark offers deluxe club seating and 78 luxury suites—some of which are named for former U.S. presidents and adorned with leather chairs, marble-top tables, porcelain floors, and 42-inch flat-screen TVs.

The concourse features padded pillars that bear images of great players and local heroes, such as former Senator slugger Frank Howard and Hall of Famer Jackie Robinson. The diamond opens to an asymmetrical outfield that includes an oddly shaped jog along the right-center-field fence that is meant to evoke memories of the long-gone Griffith Stadium. And while it took the Nationals a while to build a winner on the field, their ballpark was the first major stadium to be honored by the United States Green Building Council.

Outside the ballpark is a sculpture of perhaps the greatest Negro League position player, catcher Josh Gibson. The bronze sculpture made its debut in 2009 and depicts Gibson at-bat. A perennial power hitter, Josh Gibson famously led the Negro Leagues in home runs nearly every year from 1930 to 1945.

For fun, Nationals Park stages a "Presidents Race" in the middle of the fourth inning; in it, caricatures of George Washington, Thomas Jefferson, Abraham Lincoln, and Teddy Roosevelt sprint for superiority.

In a true sign of the times, Nationals Park has its own sportsbook. Opened in 2022, the BetMGM Sportsbook became the first retail sportsbook connected to a major league stadium. Fans can bet on their favorite teams at this 4,000 square foot sports bar, or from their seats.

The Nats reached the postseason for the first time in 2012. They would, in fact, lose each first-round playoff series they played in 2012, '14, '16, and '17. Finally, in 2019, the Nationals won 12 playoff games, knocking out the Houston Astros and claiming the team's first title. (Never mind the fact that all three World Series games played at Nationals Park in 2019 were losses.)

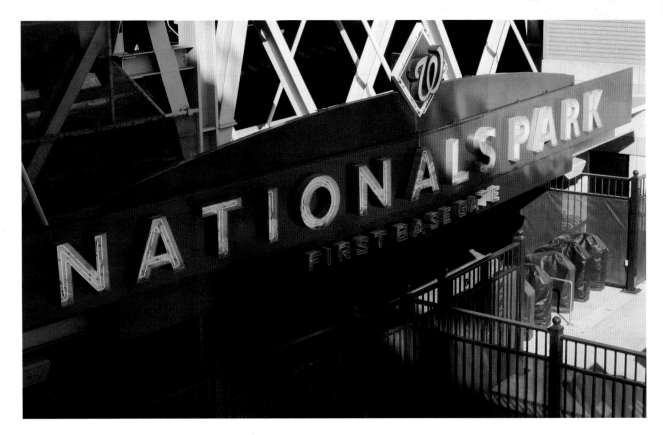

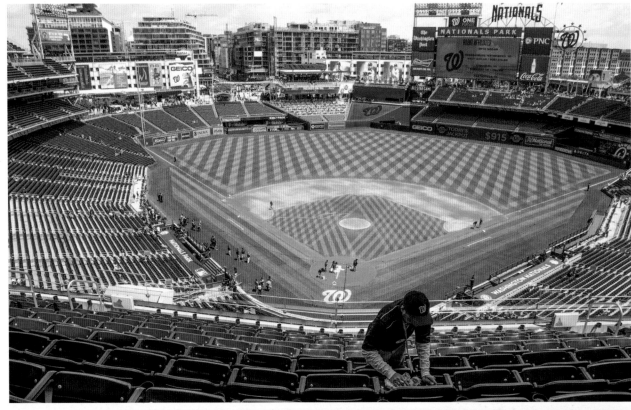

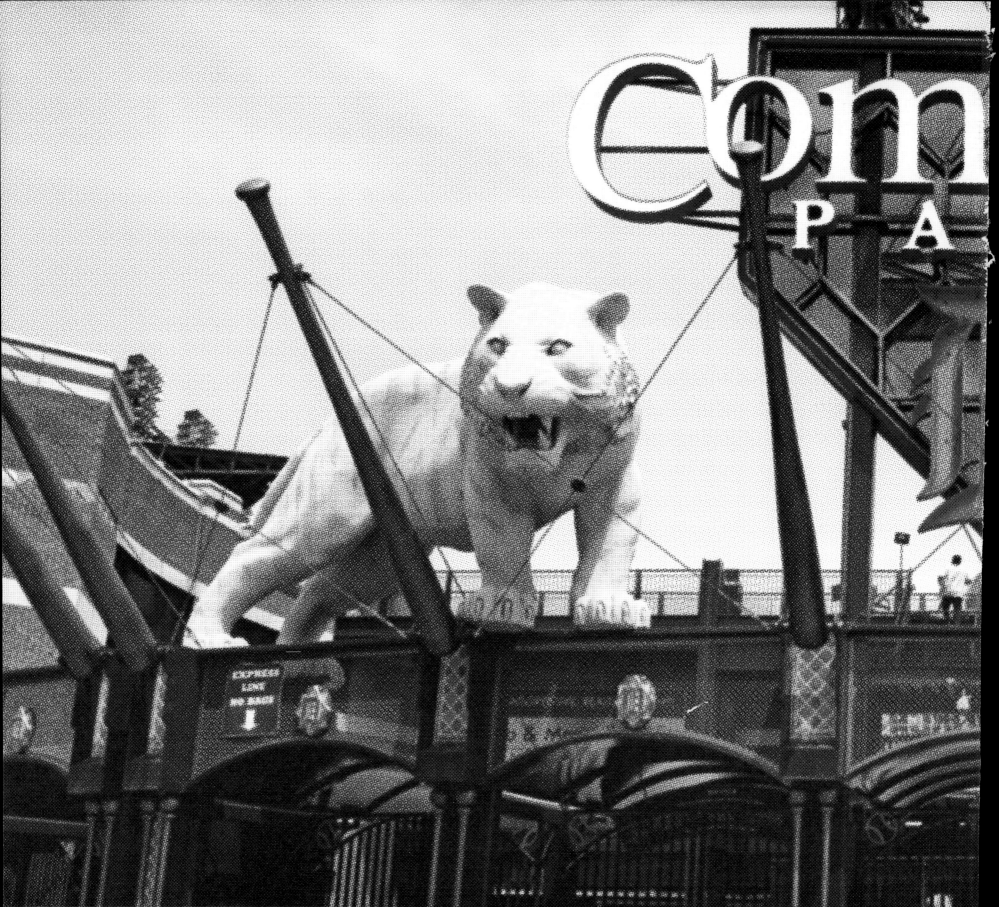